New Soviet Man

MANCHESTER
UNIVERSITY PRESS

New Soviet Man

Gender and masculinity in Stalinist Soviet cinema

JOHN HAYNES

MANCHESTER UNIVERSITY PRESS Manchester and New York

distributed exclusively in the USA by Palgrave

Published by Manchester University Press
Oxford Road, Manchester M13 9NR, UK
and Room 400, 175 Fifth Avenue, New York, NY 10010, USA
www.manchesteruniversitypress.co.uk

Distributed exclusively in the USA by
Palgrave, 175 Fifth Avenue, New York,
NY 10010, USA

Distributed exclusively in Canada by
UBC Press, University of British Columbia, 2029 West Mall,
Vancouver, BC, Canada V6T 1Z2

British Library Cataloguing-in-Publication Data
A catalogue record for this book is available from the British Library

Library of Congress Cataloging-in-Publication Data applied for

ISBN 0 7190 6237 3 *hardback*
 0 7190 6238 1 *paperback*

First published 2003

11 10 09 08 07 06 05 04 03 10 9 8 7 6 5 4 3 2 1

Typeset in Frutiger and Photina by
D R Bungay Associates, Burghfield, Berks

Printed in Great Britain
by Biddles Ltd, Guildford and King's Lynn

Contents

List of figures

All illustrations reproduced courtesy of BFI stills, posters and designs. Every effort has been made to obtain permission to reproduce the figures illustrated in this book. If any proper acknowledgement has not been made, copyright-holders are invited to contact the publisher.

Acknowledgements

Of all the ways of acquiring books, writing them oneself is regarded as the most praiseworthy method. (Walter Benjamin)[1]

With all due respect to Walter Benjamin, my first acknowledgement has to be that the writing of this particular book could never be considered the work of just one person. Praise is therefore due to a vast number of people and institutions for their continuing support and encouragement over the years. To begin with the institutions, all credit is due to the Department of Russian Studies at the University of Manchester, the Russian Department at the School of Slavonic and East European Studies, UCL, and the Department of History at the University of Essex – if a person is a product of their environment, then I can afford (for any number of reasons) the luxury of being proud of myself. Credit is similarly acknowledged from the British Academy for their generous funding of my research between 1995 and 1999; from the *Modern Language Review* for permission to reprint substantial sections of chapter 5; and my thanks also go out to Matthew Frost and all the staff at Manchester University Press.

A number of academics both within and beyond these institutions have contributed greatly to this book, most of all through inspiration, extended dialogue and the generous sharing of resources and insights. Special mention must be made of Lynne Attwood for her stoic encouragement in the face of extended silences, and, in roughly chronological order, Graham Roberts, Richard Taylor, David Gillespie, Amy Sargeant, James Aulich, Margaret Littler and Julian Graffy, all of whom have selflessly devoted much more time than one might reasonably expect towards the shaping and finalisation of this project. My earlier disclaimer

notwithstanding, all responsibility for errors and oversights has to be laid squarely at my own feet.

On a more personal note, my heart goes out first and foremost to Sarah Cretch for her moral support and emotional investment in what undoubtedly proved to be, at times, a somewhat trying period of gestation in the production of this work. Good times and bad were also shared with the best of humour by Matthew Talbot, Trevor Brown, Jimmy Mann, Laura Turney, Kiran Kamat, Danny Bates (and the staff and customers of the Marble Beer House), Mark Banting, Ciaran Dillon, Trisha McGuinness and Dylan Attenborough, Jim Cooper and Clare Marshall, Roni and Derek Cretch, Jeremy Gilbert, Jo Littler, John Gladney, Simon DeVille and all the extended Bushwood family, Catherine and Michael Haynes and of course my parents. You know I could never have done this without you guys: your love over the years has been, quite simply, overwhelming. This book is gratefully dedicated to David Holohan – a truly inspirational force.

This list is far from exhaustive. I can only reiterate that this book was not, and never could have been, all my own work: so many people in so many ways have helped me to put it together by making practical suggestions, demonstrating the patience of any number of saints, or simply through offering their good company and support, that a complete list would more than double its length. The bottom line is that if you were there for me, then you know it, and I love you for it. If you weren't, read it anyway – I don't hold grudges.

Note on transliteration

The transliteration system used throughout the book is a modified version of the Library of Congress system, without character modifiers, but with concessions made to established usage with respect to names more or less familiar in westernised forms, and certain Russian words with accepted English equivalents. Hence, for example, 'Eisenstein', not 'Ēĭzenshteĭn'; and 'Bolshevik', not 'Bol'shevik'.

Notes

1 Walter Benjamin, 'Unpacking My Library', in Hannah Arendt (ed.), *Illuminations*, trans. Harry Zohn (London: Fontana Press, 1992), pp. 61–9 (p. 63).

Why men, and why Stalinist cinema?

> Patriarchy is the oldest layer in the masculine myth and therefore the one most resistant to change. Yet patriarchy and the phallic system are always changing, as they must do, for they are not part of nature but part of human culture. (Antony Easthope)[1]

Just who was the 'New Soviet Man'? Where did he come from, and where are we to look for him? From the pages of novels, from billboard posters, proscenium arches and silver screens, the shining eyes of the Soviet positive hero reflect our own gaze, whilst his mouth faintly smiles with the determination and resolve imparted to those who have glimpsed distant truths. Clean-cut and square-jawed, the New Soviet Man was the figurehead of the people's government of the revolutionary Soviet Union, the populist proselytiser of a qualitative change in human nature.

Such a qualitative change could never be left to accidents of birth, and in a country that had recently embraced Marxist social theory, with its championing of nurture above nature, it was widely held, as Lynne Attwood explains, that the forging of a new identity – a truly Soviet person – could and should be high on the agenda: 'The notion that it was possible to create a new type of person, fully committed to the socialist cause and willing to put the interests of society above his or her personal desires, was fundamental to the Bolshevik project.'[2] If the 1917 Revolution was to drag Russia into the twentieth century, then the famously backward population, still steeped in folk superstitions and the traditions of Orthodox Christianity, had to be re-cast into a dynamic force that would demonstrate to the world the success, and superiority, of the Communist experiment. The New Soviet Man, then, was to be socially constructed.

Education was to be the chief political tool of this reconstruction, but for the Bolsheviks education did not end with schooling in literacy and numeracy, however politicised such a schooling was to become. The Bolsheviks in fact defined 'education' in the broadest possible terms: if the Party was to raise the 'cultural level' of the Soviet population, then all kinds of cultural artefacts – including official rhetoric, printed, musical and visual media – were to play a role. On the other hand, if the Bolsheviks were keen to forge a new socialist human being of a specific type, then it follows that he or she was to be fed a diet of the 'right' kind of culture. However, in the immediate aftermath of the 1917 revolution – years of civil war, the subsequent tactical retreat to the New Economic Policy (NEP) and the factional struggles for power following the death of Lenin – the authorities were understandably slow to articulate a definite 'line' on culture. The result was a somewhat chaotic pluralism (nonetheless loosely circumscribed within certain constraints) of artistic schools and movements, many of which claimed the 'truly' revolutionary mantle for themselves, whilst others were happy simply to profit from the opportunities opened up by the NEP, that is, to make money by giving the people what they believed they wanted in the way of entertainment.

Such a general 'line' on culture in fact only emerged in any tangible form towards the middle of the following decade, after Stalin's defeat of both the 'United Opposition' of Trotsky and Zinoviev, and the 'Right Opposition' of Bukharin, Rykov and Tomsky; and at the end of a frantic process of forced centralisation of both industry (the first 'Five Year Plan') and culture itself (the 'Cultural Revolution'), with the establishment of socialist realism as the single method in all arts, including criticism, in 1934. Throughout this turbulent period, however, the Bolsheviks had always maintained (at the very least) that culture was an indispensable tool in the education of the masses, and (perhaps more importantly) that such an education was to involve unproblematically hefty doses of propaganda. It should be made clear, however, that although in the West the word 'propaganda' has an Orwellian ring of notoriety about it (largely, it has to be said, as a result of the Soviet Union's activities in this field), for the Bolsheviks themselves such activities were looked upon in a wholly positive light.[3]

In his survey of post-revolutionary and Stalinist cinema, Peter Kenez goes as far as to suggest that the Soviet authorities in fact placed too much faith in the power of propaganda, a situation which left them in a seemingly constant state of frustration at the unwillingness of the Soviet people to swallow their messages and reform their behaviour to conform with a more properly 'socialist' model of

humanity.[4] Especially towards the end of the first decade of Soviet power, the pages of the print media were overflowing with vicious polemics regarding the future direction of cinema, which for a number of reasons had come to be considered the most appropriately 'Soviet' medium of all.

Kenez is quite possibly right. In reality, the 'New Soviet Man' was only ever an exception rather than the rule, and where such specimens did appear (as in the case of the feted 'heroes' of the 1930s onwards – stakhanovite miners and engineers, daredevil aviators, record-breaking collective farm workers) their biographies were more often than not grossly embellished and distorted to fit into the grand narrative style of socialist realist discourse, so that the 'public' figure bore little or no resemblance to the actual personage on whom he or she was modelled. This study, on the other hand, does not set out to assess how successfully Stalinist films may be said to have moulded the population into the dynamic force mentioned above (they clearly failed); nor does it attempt to analyse the films involved in terms of their artistic merit as, measured against western categories of 'high art', they are equally clearly to be found wanting.

For to my mind, the problem with such analysis lies precisely in this kind of measuring process: there is always a danger that the rigorous academic analysis of specific films will be subordinated to the production of hierarchised value judgements organised around post-romantic western ideals of the sacredness of 'art' and the artist as a man (almost always a *man*) of vision. Following this line, the lack of creative freedom allotted to the director-as-*auteur* under the undoubted repression of the Stalin era results in the production of films that are deemed artistically unsatisfying, dull, or quite simply not worthy of ninety minutes in a darkened auditorium.

And yet these are films that people watched, and they are the subject of this book. Most importantly, there are a number of reasons why the films I am analysing here – the stock products of Stalinist socialist realism, the seemingly 'mindless' and formulaic musical comedies, for example, rather than the more 'worthy' exceptions to the rule – are in fact worth watching. It goes without saying, then, that I am not intending to operate a distinction between 'high' and 'low' culture – and not because I am advocating the folk-devil of contemporary academia, a postmodern 'free-for-all', but simply because such a distinction seems to me, for reasons I shall explain, wholly inapplicable to the products of socialist realism. For the same reason, I am not going to use this study to get myself overly involved in the general pillorying of Stalin as cultural ignoramus. There still exists in Soviet studies an outdated tradition which, despite having

accomplished much valuable research on the organisation of the Soviet 'culture industry' and its undoubted repression and marginalisation of (especially) those directors of the 1920s who did so much to forge the world-wide reputation of Soviet 'film art', nonetheless remains steeped in Leavisite terminology and withering Cold War rhetoric, and has a tendency simply to bewail the fate of this art and reputation over the ensuing decades, as Stalin tightened his grip on Soviet society in general, and the motion picture industry in particular.

Stalin's personal and abiding interest in the cinema has been more than adequately documented elsewhere. As the 'Kremlin Censor' – to borrow Mar'iamov's title[5] – he would organise private screenings on a regular basis, and technically had 'final cut' on all films produced during his lengthy period in office. At the same time, he also represented the highest court of appeal: just as he could (and did) use his authority to veto the release of any film he considered 'anti-Soviet' (in any number of interpretations), he could also sanction the release of films that were being held up further down the country's censorship apparatus. Such was the case, as we shall see, with both Sergei Eisenstein and Ivan Pyr'ev. The seemingly arbitrary and whimsical nature of the verdicts pronounced after these screenings has led a number of commentators, both in the West and the former Soviet Union, to conclude that Stalin was simply an ignorant dilettante with far too much power in matters of film production and distribution. For example, Peter Kenez postulates that 'Although Stalin was very much interested in movies, he had not the slightest understanding of this medium of art.'[6] Similarly, implicit in the subtitle of Herbert Marshall's canonical *Masters of the Soviet Cinema: Crippled Creative Biographies* (London: Routledge and Kegan Paul, 1982), is the idea that Stalin himself deliberately operated to stifle the production of what we in the West consider as 'film art'.

Once again, there is a danger here: the undisguised glee with which such commentators note, for example, that the first part of Eisenstein's *Ivan the Terrible* [*Ivan groznii*, granted a release in 1945] managed to slip its covert messages past even the 'supreme censor' is too often co-opted into bolstering up the argument that the Stalinist regime was morally bankrupt. Not only was this regime ruthless, cruel, and cold-blooded – but to cap it all, the man at its head was a complete philistine! This is not to say that I am offering a 'revisionist' history of the Soviet Union in a time of indisputable bloodthirsty repression, but as far as I can see such an argument is not only fundamentally flawed, but also incredibly unproductive. Question marks must be raised over the extent to which widely-distributed feature films – reliant on both substantial injections of capital and a

broad collective working style – can ever be considered as representative of 'autonomous creativity'. More fundamentally, however, I simply do not believe that the argument for the culpability of the Stalinist regime requires this characterisation of Stalin as wholly unversed in the principles of 'high art' – particularly when such principles are left poorly-defined and yet not open to question. The vast numbers of dead and bereaved are quite eloquent enough in and of themselves, without needing recourse to this, in the circumstances, rather trite line of argument.

One aspect of socialist realism that many critics appear to have found especially difficult to stomach, then, is its overtly political stance – the fact that the ideology underpinning the work of 'art' is put on such open display at the expense of more traditional (western) aesthetic categories of plot development and deep characterisation. And yet such a stance necessarily relies on the absolute dissociation of the fields of aesthetics and politics, and I would argue that this distinction is, in practice, highly problematic. The notion that 'ideology' (like 'propaganda') is only a product of extremism – a challenge to, rather than a force underpinning, the status quo – is itself a very effective propaganda tool in the hands of those who seek only to reproduce, rather than to challenge, the current sociopolitical order. Such a point of view not only legitimises the status quo, but also enshrines it as 'obvious', as 'common sense' – the (divinely-ordained) standard for comparison, which hierarchises 'others' by defining their difference. In this, as in much else, it resembles the operations of patriarchy which posit the masculine as the universal, whilst rendering the operations that maintain such an appearance invisible – and thus impervious to question or analysis. If, however, ideology is broadly defined as a body of ideas that lend a certain coherence to everyday life (and not just for those who willingly admit to 'subscribing' to any such body) then it becomes clear not only that even the staunchest conservatism is grounded in a specific ideology, but also that ideology is not some kind of repressive evil force, but in fact a highly productive category that, in one or more of its forms, gives shape to and permeates all cultural production. As such, the argument put forward by, amongst others, Peter Kenez, that the Stalinist art which actually made explicit its ideological underpinnings was 'counterfeit',[7] is quite simply untenable. Furthermore, the idea that audiences emerged from screenings of Aleksandrov's musical comedies feeling oppressed and cowed into submission ignores the primary role of such movies. This role was emphatically *not* to oppress, but to enlist the *active support* of the same people that Kenez characterises as 'victims of this ideological sleight of hand [who] were shown an entirely imaginary and yet

seemingly realistic and self-consistent universe again and again', in the building of a specific consensus.[8]

Perhaps what is at stake in this kind of discourse is not so much Stalin's failure to appreciate our received notions of what constitutes a work of 'great art', but a certain unwillingness on our part to engage with what Stalin's own ideas on the subject might entail. Surely the undisputed fact that, under Stalin, the role of the visual aspects of film was downgraded in favour of the carefully prepared script can tell us a great deal more about Soviet discourse of the time than simply that it produced poor quality films. It follows, then, that one of the reasons why these films are indeed worth watching is precisely because they do not necessarily correspond to canonical western definitions of 'art'. But if they are not 'art', then what are they?

In one of the first – and still one of the finest – full-length studies of socialist realism *as* socialist realism, Katerina Clark acknowledges the largely unhelpful nature of 'applying Western "highbrow" literary criteria in studying a literature that was not intended to meet them', and argues that the socialist realist novel in fact 'lends itself to a comparison with other varieties of popular formulaic literature, such as detective stories and serial novels.'[9] Clark is of course writing about socialist realist literature, but for reasons that will be explored in the next chapter, it is possible (although not entirely unproblematic) to view her work as an analysis of the 'single method' of socialist realism which may, *mutatis mutandis*, be mapped onto a study of Soviet cinematic productions. Throughout this study, I shall be following the line of thought proposed by Clark, that the products of socialist realism may be seen as crystallised around a formulaic 'master plot'.[10] Such an approach affords a useful prism through which to examine socialist realist films in terms, particularly, of their structure. At the same time, however, attention must be paid to Clark's cautioning against the reductionism implicit in even the most rigorous of structural analyses – as long as such analyses remain synchronic and thus fail to account for the ways in which two novels (or, in this instance, films) presuming to be works of socialist realism could in fact turn out very differently.

I do not wish to suggest, of course, that there were no occasions on which the Soviet State intervened fairly directly in both the production and distribution of culture: even the most cursory examination of the extensive censorship mechanisms at work in the field of cinema at the time make a mockery of such a claim; similarly, there were other, occasionally less obvious, instances of direct interference which serve to underline the fact that Soviet films were, first and foremost, explicitly political rather than aesthetic statements,

intimately bound up with problems of governance as and when they arose. The spectacular u-turn concerning portrayals of fascist Germany effected after the signing of the Nazi-Soviet pact in 1939, for example, led, among other things, to the withdrawal of Eisenstein's vitriolically anti-Teutonic *Aleksandr Nevskii*, which had been released in 1938 and earned its director the highest state prize then in existence, the Order of Lenin. The fact that Eisenstein was subsequently approached to produce the staging of Richard Wagner's *Die Walküre* at the Bolshoi Theatre may be read as an extreme exercise in cynical opportunism and ruthless pragmatics on the part of the dictators of Soviet cultural policy. On the other hand, considering that the production would by necessity be as much a work of socialist realism as the withdrawn film, this fact also very effectively destabilises received notions of the dogmatic, fixed essence of socialist realism itself.

Socialist realism was in fact far from the oft-portrayed mono-lithic structure, exercising its vice-like grip on all forms of art at all times and in all places, but rather a shifting discourse, defined more often than not negatively and relationally, and as such had to main-tain a degree of flexibility: the standard model of 'top-down' authoritarian control over socialist realist discourse misses the point that 'socialist realism' was rarely wholly determined by, but more often responsive to, the changing needs of the Soviet State over a period of many years and in varying locations. Clark demon-strates very effectively the ways in which the 'single method' drew on various pre-existing cultural codes and conventions;[11] more-over, in the field of cinema, the often harsh criticisms of films from the time of the Cultural Revolution onwards were largely justified on the grounds of audience response (although the convenience of such responses, and thus the reliability of the sources, remains open to question); finally, it must be emphasised that, although the grand narrative style of socialist realist texts may reflect the Soviet Union's declared path along the high road to socialism, there exists within such texts any number of side-issues pertaining to the more immediate practical and theoretical achievements or problems inherent in everyday life within the Soviet Union.[12] Thus, Grigorii Aleksandrov's musicals privilege the new architectural landmarks on the Stalinist Moscow skyline, whilst Ivan Pyr'ev's movies obses-sively return to the theme of national defence, and mythicise the cult of the border guard, at a time when antagonistic forces were re-arming in Germany.

It should be clear by now, then, that however attractive the notion that great 'art' hands down immutable truths from genera-tion to generation may be, the reality is that cultural production and

reception is by its very nature a social activity, and so all culture must be grounded in some form of social life. Such is, indeed, the insistence of the Soviet literary theorist Valentin Voloshinov, a close associate of the philosopher Mikhail Bakhtin (whose work will come under discussion later on in this book), in an article that first appeared in the journal *Zvezda* in 1926.[13] Voloshinov maintains that, in isolation, both formal and 'psychological' analyses of cultural artefacts are insufficient to the task of criticism, and he argues that they can only retain their significance when harnessed to a sociological analysis of the site of what he terms the 'utterance':

A concrete utterance (and not a linguistic abstraction) is born, lives and dies in the process of the social interaction of the participants in the utterance ... When the utterance is uprooted from this real sustaining medium, we lose the key both to its form and to its meaning; what remains in our hands is either an abstract linguistic shell or as abstract a schema of its sense (the notorious 'idea of the work' of the old theoreticians and historians of literature) – two abstractions which are not connected to each other because there is no firm basis for a viable synthesis.[14]

Voloshinov's insistence on the centrality of social context, as a means to bridge the gap between the humanist notion of subjective individualism – that the individual consciousness precedes and structures language and meaning – and the anti-humanist abstract objectivism more closely associated with the structuralist emphasis on the purely arbitrary connection between signifier and signified – the two sides of any of the linguistic signs which, in this view of language as a closed system, precede and structure our consciousness – is of importance to this study for a number of reasons. It could be argued that the films under discussion here – films produced with a specifically social purpose in mind – foreground their context to an unprecedentedly self-conscious extent: apart from Aleksandrov's glorification of the architectural achievements of the 'new' Moscow, his 1936 classic *Circus* [*Tsirk*], for example, is largely structured around the new Soviet constitution of the same year; furthermore, despite his claims that such films manufactured an 'artificial' reality, even Kenez admits that, with its pervasive references to traitors, wreckers, spies and saboteurs, and its constant reminders of the need for vigilance, 'Soviet cinema well reflected the peculiarities of [its] world'.[15]

It follows, then, that we need to begin by grounding Soviet cinema in its social reality – a reality that, I shall argue, Soviet cultural policy was aiming to restructure through a very specific type of discourse: that is to say, in a time of ferocious censorship and policing of meaning, not only what could be said, but also the way

in which it could be said, were both organised in response to the local and specific demands of the Soviet State. It is perhaps a little extreme to adopt the point of view that Stalinist cultural policy makers were effectively co-directors of the films produced under their aegis, but we can be sure that making socialist realist movies could never be an 'autonomous' artistic process – and that viewing them through such a prism does indeed render them 'uninteresting'. On the other hand, viewed as a nexus of politically-, sociologically- and cultur-ally-specific discourses, the same films become very interesting indeed, not only for what they have to tell us (as well as their con-temporary audiences) about Soviet society, but also for the ways in which these representations are organised.

Meanwhile, the foregrounding of context – in both the films themselves and in this study – implies one or two preliminary issues that need clarification. The first of these is, of course, the matter of those contemporary audiences. Any study of cinema should not ignore the reception of the films under analysis, but here we imme-diately encounter a major problem we have already touched upon: although it seems likely that the Bolsheviks were among the first groups in the world to carry out audience research in the field of cinema, the reliability of their testimony is somewhat shaky, to say the least. Very often the reports were purely anecdotal; these were also used quite selectively, and co-opted into near-slanderous attacks on the directors of the films in question (some of which will be considered in the next chapter); occasionally they ring true – but if we simply latch onto the ones we like the sound of, then surely we are just as guilty of selection and distortion as the cultural authori-ties of the time. We do know, on the other hand, that to a certain extent in the USSR literacy itself had become a 'bolshevised' domain, in response precisely to problems of propaganda, as Frank Ellis explains:

The divide between propaganda and its reception was especially sharp in the early years of the Soviet regime, since the learning and knowl-edge which characterized the Party élite separated it from the masses in whose name it claimed to speak, and particularly from the peasantry, whose very high rates of illiteracy barred the penetration of the Party's ideas at the most elementary level. This was where the function of 'agi-tation' (*agitatsiia*), as the supporter of 'propaganda', made itself felt.[16]

The Bolsheviks campaigned tirelessly to promote literacy, especially in the countryside, from the 1917 Revolution onwards. Whilst large proportions of the rural population remained illiterate, how-ever, the silent film – with its emphasis purely on the visual image – was regarded as a highly effective means of propaganda, although agitators were present at screenings to elaborate on the

messages being put across. This explanatory role undertaken by Party officials demonstrates that, alongside teaching the illiterate to write and read (a function that is packed with political/ideological potential in itself), they were also attempting to teach the population at large how to read films in line with Party doctrinal requirements. I do not wish to argue, however, that the Soviet population were mere passive receptacles for the ideological messages instilled into them by the Bolshevik propaganda machine – the audiences that watched these films would undoubtedly bring their own points of view into the auditorium – but nor do I wish to lose sight of the fact that there were far fewer contrasting narratives available to these audiences to juxtapose against the 'preferred readings' both implicit within the films themselves, and backed up explicitly by the agitators. Bearing this in mind, then, I shall offer both analyses of these preferred readings (because they have so much to tell us about the idealised self-image that the Soviet State was attempting to promote), and also readings 'against the grain' of the films – some, many or none of which may have been adopted by contemporary audiences.

The second of the preliminary issues thrown up by the question of context is closely related to this point. For both preferred and oppositional readings rely, to an extent, on an audience that is well-versed in cinematic codes and conventions, and this is almost certainly *not* the case in the Soviet Union of the 1930s. At the same time, however, crude as some socialist realist cinema undoubtedly is in terms of didactic propagandistic content, it would be naive to think that Soviet cultural commissars were unaware of the possibility of overloading their films with these elements.

At the beginning of 1928, in fact – the same year that Stalin emerged as individual dictator – the then Commissar for Enlightenment, Anatolii Lunacharskii, made clear his intentions for a genuinely popular Soviet cinema in a speech to film workers: 'Many of our people do not understand that our film production must stimulate the public appetite, that if the public is not interested in a picture that we produce, it will become boring agitation and we shall become boring agitators. But it is well known that boring agitation is counter-agitation.'[17] There is much at stake in this short quote: the issue of the 'stimulation of the public appetite' will play a key role in this study – and not least as a fundamental reason not to apply western 'highbrow' criteria to the films under analysis; it also articulates a key argument of the years of Cultural Revolution – whether Soviet cinema should be primarily a cinema of entertainment or education, and how the two aspects may be fused.

But these are questions for the next chapter. For the moment, we should note in particular that, just as the view that Soviet power imposed a specific type of cinema on its film-makers may be seen as an oversimplification, so too is the notion that the resulting films imposed meanings on an audience that ends up passive, and yet somewhat unwilling to accept them. Such an approach vastly underestimates the intelligence and resourcefulness of both the producers of these films, and the consumers who did, on occasion, flock to see them. A more fruitful approach, as I have already indicated, would be to recognise the purpose of Stalinist cinema in terms of the securing and maintenance of active consent – that is, in terms of the winning of the hearts as well as the minds of the population. To carry out this task it would never be sufficient to 'prove' the superiority of the Party line on any number of issues time and time again. The oft-lamented lack of popular domestic success accorded to 'classic' Soviet films of the 1920s – films structured around the active intellectual engagement of the audience – is testimony enough for the need to engage spectators in emotional as well as rational dialogue and, in fairness, the Party responded to this.

The point that, in order to win support from the people, ideological effect – the playing-out of situations and conflicts whose resolution demonstrates the 'correctness' of the Party – must be intimately bound up with emotional affect – the appeal beyond the rational to the spectator's deeper feelings, her or his hopes, aspirations, even fears – has not been lost on those critics who point out the reflection of the 'terror' in the paranoiac portrayals of omnipresent 'enemies of the people'. At the same time, however, cinema was called upon to illustrate one of the cornerstones of the new, mythologised Soviet Union (a super abundant world of titanic heroes and carefree citizens) enshrined in the constitution of 1936: Stalin's ubiquitous dictum that 'Life has become better, comrades, life has become happier!'[18]

Such a sentiment seems a million miles removed from, for example, Ivan Pyr'ev's *Party Card* [*Partiinyi bilet*, 1936], in which a woman unmasks her own husband as a traitor, and in fact the film did not go down at all well with the head of the central State cinema authorities, Boris Shumiatskii – a man who had asserted: 'The optimism of the stereotyped "happy ending" has nothing in common with socialist realism. On the contrary, the work as a whole, every character, theme and idea in a film must be permeated with optimism.'[19] Shumiatskii did much during his time at Soiuzkino to promote the musical comedy, which, for reasons to be discussed in chapter 3, is the genre not only best-suited to the requisite (and indeed, clichéd) *kheppi-end* as pointing in the direction of the glorious shining future, but also

one that was not, on occasion, afraid to depict that utopian self-projection of the Soviet State as existing in the here and now.

The fact, then, that so many of the films under discussion here are precisely such musical comedies – with their conspicuous (some would say structuring) absence of spies, wreckers and other enemies of the people – is again not an attempt to revise history by selectivity, and thus to demonstrate that everyone in Stalin's Soviet Union was in fact living a carefree life, punctuated at regular intervals by spontaneous outbursts of singing and dancing. Rather, given that the musical was the privileged genre of the era (although relatively few were made, one of Aleksandrov's musicals was said to be Stalin's favourite ever film), and that it lays bare most obviously not only its own devices, but also an exemplary pattern of the mythologisation of everyday life, I will be using the musical's fusion of effect and affect as a key to map the parameters of the 'promised land' of socialism – that is, the idealised self-image of the Soviet Union as a paradise on earth – and to locate the specific modes of masculinity deemed most appropriate to inhabit it.

And men?

All of the preceding will hopefully have gone some way towards answering the question of why a study of Stalinist Soviet cinema can facilitate a greater understanding of a terrible period of Soviet history. But what about the question of men? What do men have to tell us about culture in general – and what can the New Soviet Man tell us specifically about this cinema and society?

The immediate context of this book, the western academic study of men and masculinity – as distinct from the study of human beings and 'humanity', which had been overladen with masculine assumptions – is a fairly recent trend in sociology and cultural studies, which was established generally (although by no means always) as part of a collaborative project with feminist thinkers, within the discourse of gender studies, and only in the mid–late 1980s. Perhaps the most useful aspect of this reappraisal of just what constitutes 'masculinity' involves the recognition that it is not a fixed, universal and monolithic 'natural' given, impervious to analysis (however much such an appearance suits the workings of patriarchy), but rather a loose blanket term applied to a number of divergent attitudes, expectations and modes of behaviour adopted by specific groups of men in various social situations and at different times. What, if anything, does it mean to be a man? Ask a well-fed *Guardian* reader sitting in a vegetarian cafe on Beech Road, Chorlton, and then travel just a few miles down the road to ask a group of lads on a Moss Side street corner, and

you will receive very different answers – neither of which, of course, can be called 'wrong'. As Jonathan Rutherford, amongst others, has pointed out, masculinities (and in particular the modern, western standard of idealised 'masculinity') are, more often than not, constructed not through any specific combination of inherent 'essences', but rather negatively, in relation to what is considered as 'Other' – most obviously that which is discursively constituted as 'feminine' – which holds its own specific horrors for the masculine.[20] We are back, once again, to the question of context – to which we may add the issue of cultural values.

The broad context of this study, then, is the accumulated weight of centuries worth of institutionalised academic enquiry, within which the sex that has authorised itself to speak (and denied such speech to others) has been – until the latter half of the twentieth century – male. Meanwhile, the issue of just how the privileges accorded that sex in society may have coloured its observations, not to mention the fundamental organisation of its enquiries, have remained for the most part unaddressed. In a deeply entrenched patriarchal order, masculine assumptions have not only dominated this stage, but also operated to lend themselves the appearance of being the 'objective'/'natural' framework within which to address the objects of their enquiry. This is thrown into sharp relief when it comes to the study of culture where, once again until very recently, the privileging of males over the 'weaker' sex has led to a situation in which men are prioritised as producers of (high) culture, and thus the only cultural artefacts deemed worthy of serious study are precisely those created by men.

So, are all men always winners under patriarchy? The biological division of the two sexes is clearly only the starting point of patriarchal discourse, which then proceeds to assign certain attributes to either group (most pervasively activity to males, and passivity to females), and, more importantly, to privilege the 'masculine' set of attributes over those coded 'feminine'. At different times and places, however, and in varying social spheres, certain modes of thought, speech and demeanour are privileged not only over modes which are discursively constituted as 'feminine' (always the case in the dominant western patriarchal tradition), but also over other 'masculine' attitudes and practices which are hierarchised as somehow 'less manly' – or even, in a number of cases, simply 'unnatural'. There is clearly very little that is stable – let alone monolithic – in what it means to be a man, except that, over centuries of western patriarchal civilisation, men have been born into a position that is considered socially superior to that of women, and which has thus afforded a broader range of opportunities in life, but a range that nonetheless

retains its own complex priorities and constraints. This is a point that demands the separating off of masculinity and patriarchy, and which will recur throughout this study.

Clearly, then, this project is not intended as an ill-advised attempt to confront, repudiate or to 'redress the balance' concerning feminist analyses of culture in general, or Stalinist cinema in particular. Rather, it is geared towards the application of critical tools developed largely by feminist analysis to examine a local and specific masculine subjectivity, in the hope of a broader understanding of what constituted 'gender' in Stalin's Soviet Union. The debt owed to feminist film criticism by this study – and not least by many of the points already made in this chapter – is well illustrated by Teresa de Lauretis' comments on the discipline:

> [I]t is precisely the feminist critique of representation that has conclusively demonstrated how any image in our culture – let alone any image of woman – is placed within, and read from, the encompassing context of patriarchal ideologies, whose values and effects are social and subjective, aesthetic and affective, and obviously permeate the entire social fabric and hence all social subjects, *women as well as men.*[21]

I have emphasised the final words here because, whereas de Lauretis is making the point that men have, over time, spoken of 'humanity' with a certain 'blind spot' concerning half of its representatives,[22] I would like to underscore the fact that – entrenched as it is in 'the encompassing context of patriarchal ideologies' – men's discourse has largely been constructed with no apparent awareness of how their position as men within the same context may have inflected that discourse.

Obviously, we must proceed with a certain degree of caution here: it is all very well claiming that this study is analysing men and masculinities precisely because masculine values have remained in such a privileged position over time; but how are we to avoid merely reinforcing the privileging of these values? Why should we bother re-reading what men have to say about themselves – wittingly or otherwise – all over again? What I am proposing, then, is a re-reading, but also a reading of a different type: rather than skipping along the lines in the expectation that a stable, unitary 'content' will be revealed, I hope to pick away at a small section of the blank mortar work which holds the words in place, and which ultimately supports the edifice of patriarchal language. In this way, an analysis of a given patriarchal culture and society – by problematising the generic 'man' – may go some way to unpicking the informing values of that society and culture. From this perspective, it is important to note that the widespread mistranslation of *'novyi Sovetskii chelovek'*

as 'new Soviet *man*' (rather than the more correct '*person*') is in fact rather appropriate – and again this is precisely why I am retaining (and even capitalising) it throughout this study of the New Soviet Man *as a man*.

What this study is investigating, then, are the local and specific (rather than abstracted or universalised) attributes of a particular Soviet masculinity of the Stalin era – that is, the qualities considered as 'manly' – as well as the reasons why such qualities were deemed appropriate for the piecing together of an 'authentic' masculinity at various times and in various locations in Stalin's Soviet Union. As for the question of where we are to look for our New Soviet Man, and bearing in mind what we have already discussed regarding the constitution of 'gender' in discourse, it surely makes sense to isolate this figure in the discursive mechanism over which (for reasons to be discussed in the next chapter) the State had an almost complete monopoly, that of the cinema. If this State, seemingly fixated on centralised planning, had a specific plan for the psychic economy of its citizens, then the cinema would appear to be the site in which such a plan would be made most obvious.

Methodological considerations

One question, however, remains to be answered: how exactly am I – as a white, male, western European academic – to write about this subject? Perhaps appropriately for one concerned with ways of speaking and writing, I come to this topic neither as a sociologist, nor as a historian, but from a background in the study of languages. For this reason, amongst others, this book is underpinned by two methodological strands, both of which, in one way or another, are concerned with the operations of language. The passages that deal specifically with film analysis rest largely on psychoanalytic film theory. Although some might argue that the abiding interest of the celebrated Eisenstein in Freudian theory would be more than justification for such an approach, I would emphasise that psychoanalysis may be seen as relevant to this enquiry for three principal reasons, which are perhaps rather more pertinent to our methodology. First, as refined and honed through rigorous critical debates since at least the late 1960s, this branch of critical theory has quite simply offered the most satisfactory, and the most sustained, accounts of the construction and representation of gender in cinema from a range of perspectives: not only at the level of characterisation and the role of the spectator, but most specifically for this study, in terms of the films themselves as gendered discourse. Although psychoanalytic theory has been both attacked and rigorously defended for its perceived

shortcomings regarding the 'feminine',[23] it nonetheless speaks volumes about modern western masculinity (Easthope's 'masculine myth'), both directly – in the accounts of case histories – and, perhaps more importantly, indirectly – in the ways in which psychoanalytic theory is constructed and applied as organised by its own inherent patriarchal assumptions.

The second argument in favour of a psychoanalytic approach to these films concerns perhaps their best known aspect, which is the fact that they were submitted to a ferocious and all-pervasive mechanism of censorship. The issue of repression, and what cannot be formulated within existing discursive frameworks, is obviously of primary concern to a study of Soviet cinema under the 'Kremlin censor'. But psychoanalytic theory also points towards ways in which the repressed will always return from the unconscious to find expression in one or other form, however distorted. In fact, for psychoanalysis, the existence of this expression is no more important than the nature of such a distortion: we can listen to the unconscious through its effects, in order to build up a picture of the uncertainties and anxieties bubbling beneath the surface veneer of a happy, well ordered society; we can also learn a great deal about the organisation and functioning of such a society through an examination of the passage from one to the other. Before proceeding along this line, however, we should perhaps introduce one or two psychoanalytic concepts, and examine the ways in which they might impact on this enquiry.

The psychoanalytic perspective underpinning this work rests on the basic principle that – as in human subjectivity – the enunciating text is always in excess of the text enunciated: a single word or text is never adequate to the ideal of self-expression (if it were, a work of interpretation such as this one would be rendered redundant). As well as the major issues and minutiæ detailed within the texts themselves, then, I shall also focus on the unspoken assumptions underpinning their production within a culture that was striving towards a model of one fixed meaning for each word of the language. Foregrounding the tension between the questions that are examined by my selection of films and the ways in which such examinations were undertaken – and in particular the almost deafening silences of these films on certain key issues – I hope to open up for wider discussion a subject area that has itself remained a basic assumption on the part of scholarly literature, that the Soviet Union of the Stalin era was steeped in patriarchal dogma.

This study begins, then, with psychoanalytic theory, which in turn always rests upon Freud's discovery of the unconscious.[24] Whilst the existence of such an agency – the wilful and

unpredictable id – is still the subject of some heated debate, for the purposes of this study, I must insist upon it myself. It is certainly true that the idea of an unconscious mind may be difficult to grasp – and of course it is, by its very nature, radically unknowable. Furthermore, as Juliet Mitchell points out, even Freud had his doubts to begin with: 'In one sense, Freud found the unconscious because nothing else would explain what he observed – and he certainly tried everything anyone could think of first.'[25] However, we need only think of the merry dances we are led by both urgent memories and seemingly instant forgetfulness – not to mention the fact that 'slips of the tongue' have become the commonplace 'Freudian slips' – to recognise that the message has hit home more widely than we might at first think, even if the medium has proved less palatable to some than to others.

I am stressing the centrality of the unconscious because it is precisely that which lies at the heart of the 'return to Freud' led by the French psychoanalyst Jacques Lacan, and Lacan's work is, in turn, central to this study in more than one way. First and foremost, the figure of Lacan has dominated film theory in the past few decades – and most particularly so in the field of gender-based analyses of film texts.[26] Furthermore, just as Lacan – never himself a film theorist – has been co-opted into the academic analysis of cinema, so has his work been brought to bear in the fields of ideology and historiography.[27]

If we are to accept Lacan's 'return to Freud', we must first establish that Freud's final model of the mind posited not only the unconscious id, but also two more psychic agencies, the ego and the super-ego. The ego is seen as performing a mediating function between the irrational impulses of the id and the exigencies of social interaction. Its work as a kind of psychic public relations department is overseen at all times by the authoritarian super-ego – that is, for Freud, the internalised laws of the castrating father – in order that unconscious impulses will find only socially-acceptable meaningful expression in everyday life, often in distorted form, or displaced onto another object that is not immediately recognisable as related to the unconscious object. For psychoanalysis, a symptom always represents both an unconscious wish and its prohibition. As in Freud's study of parapraxis and dreamwork, however, of greater interest to this study are the ways in which unconscious wishes find their expression in society: the operations of censorship, and the imposition, in Lacanian terminology, of an organising 'symbolic order' on the chaotic 'real'.

The 'real', for Lacan, lies right at the heart of human existence, and yet it is experienced, only dimly, as a lack. Robert Lapsley and

Michael Westlake have formulated rather succinctly Lacan's account of the human subject's relationship to this lack:

The child is born into the experience of lack, what Lacan terms the *manque à être* (the 'want to be'); and the subject's subsequent history consists of a series of attempts to figure and overcome this lack, a project that is doomed to failure ... In retrospect – and for Lacan this history, like all histories of the subject, his own theory included, can only be retrospective – the child interprets the prior union with the mother as anterior to lack, a condition where it was everything and lacked nothing. Throughout its life the child will attempt to recapture this imagined entirety in a search for that which will overcome the lack, the missing component Lacan terms *l'objet petit a* and whose most obvious prototype is the breast. This stands as a representation, no more than that, of what is ultimately unrepresentable, in that the object that could overcome the lack is non-existent. As compensation for the continual failure to re-establish unity, the child will console itself with imaginary solutions, notably in idealised images of itself as complete.[28]

Although this is a long quotation, it does encapsulate rather well a number of key points of reference for this study. Most importantly, the *objet petit a* as both originary cause *and* object of desire may never be attained – for every 'found' object is found lacking, and as soon as lack is discovered in one *objet petit a*, the subject's desire is projected towards the promise of fulfilment held out by a new one. Ultimately, the best the child can do is to seek comfort in a misrecognition of itself as unified. Such a misrecognition plays an important role in the formation of the ego, as we shall see later on in this study; it also has its archetype in Lacan's account of the 'mirror stage', which is emblematic of his third order of existence, the 'imaginary'.[29]

Put briefly, Lacan's 'Mirror Stage' describes the moment at which the infant, still without speech and entirely dependent upon the care of the mother, identifies with its reflected image as an entire and complete individual. Lacan, as we have seen, rather pessimistically sees the assumption of this apparent, though ultimately fictional, unity as the beginning of a lifelong search for an imagined completeness. Such a completeness is 'imagined' because it belongs only in the realm of the imaginary, and yet it is compromised by the child's projection into the symbolic order, characteristically figured by the look of an Other, which affirms that the reflection is in fact a true representation of the infant.

Although the misrecognition of the 'Mirror Stage' has certain benefits – Lapsley and Westlake point out most notably an awareness of boundaries which paves the way for co-ordinated physical activity, a sense of identity, and the beginnings of social

interaction[30] – it also entails, precisely inasmuch as it is a *mis*-recognition, both alienation and division of the subject. The Lacanian ego, then, quite apart from its role as mediator between the id and the outside world, is entrusted with the extra task of concealing the glaring disparity between the child's sense of its own body, and the idealised unified *mirage*, which it does in ways that, I hope, will become apparent in the course of this study.

The final point I will make here on Lacanian theory is tied up with the act of signification itself. Words are first and foremost used as substitutes for their absent referents, and as such themselves attempt to cover over the *manque à être* central to human subjectivity. As I have already suggested, and as Lapsley and Westlake point out: 'Like Hegel, Lacan conceived of the word as murderer of the thing: no representation is ever adequate to what it claims to represent [...] this is crucially the case with the subject's self-representation.'[31] The adoption of the subjective 'I' is only ever a compromise with the symbolic order – and the subject must struggle to represent the self as best he or she can, always aware of two crushingly limiting factors. The first of these resides in the fact that any enunciation is immediately open to subjective interpretation on the part of the Other: the relevance of this point to Bakhtinian theories on the history of language will be discussed in the next chapter. Secondly, therefore, we may see how the accession to language involves the child's entry into a kind of pact, figured best by Lacan's own '*vel* of alienation' and his accompanying commentary on the choice the subject has to make between *being* (in the 'real') and *meaning* (the opportunity to signify in the symbolic order): 'If we choose being, the subject disappears, it eludes us, it falls into non-meaning. If we choose meaning, the meaning survives only deprived of that part of non-meaning that is, strictly speaking, that which constitutes in the realization of the subject, the unconscious.'[32] The crux of this formulation is a reiteration of the point that the enunciating subject is always in excess of the subject of the enunciation. Moreover, the ruthless repression of any number of dissonant voices that begins with speech, spills over into the act of writing, and, perhaps most particularly for our study (as I have already indicated), into the act of writing history.

Traditional, liberal humanist historiography – the writing of (capitalised) History – is of especial interest to us here, particularly in the ways in which it strives to protect its claims to truth and the uncovering of historical 'facts'. Of course, such claims cannot be held up too closely to inspection, but, as Michel de Certeau notes: 'The operation in question is rather sly: the discourse [of History] gives itself credibility in the name of the reality which it is

supposed to represent, but this authorised appearance of the 'real' serves precisely to camouflage the practice which in fact determines it. Representation thus disguises the praxis that organises it.'[33]

The lending of credibility to historical discourse has also been discussed by Roland Barthes, who sees the 'reality effect' as produced by a submerging of the signified of History into its referent, thereby again camouflaging the purely linguistic basis of 'fact' 'as if this linguistic existence were merely a pure and simple "copy" of *another* existence, situated in an extra-structural field, the "real."'[34] We shall discuss a more accurate definition of the signified of History below, but for now we should remind ourselves that the 'linguistic' expression of 'fact' is still very closely related to attempts at self-representation, which similarly refuses to lay bare its organising praxis. Despite the best efforts of the historiographer to pretend otherwise, however, history can never simply 'tell itself' in a pure, unmediated way.

Writing with a characteristically postmodern mistrust of meta-narratives, Keith Jenkins has demonstrated that both epistemology and methodology are always organised around the careful exclusion of an undifferentiated mass of voices from the past, within a discursive formation that is circumscribed by ideology.[35] This echoes de Certeau's observation that 'historians begin from present determinations. Current events are their real beginning'.[36] In this case, it is perhaps more pertinent to enquire not so much what 'History' is, as for whom it is written. By ideological sleight of hand, however, 'History' is displaced from the domain of the political to the 'common sense' realms of dominant ideology – which attempts to enshrine historical 'truth' beyond even self-analysis. We have already noted that the apparent reluctance on the part of men to speak about masculinity performs a similar conjuring trick: the universal 'human' of liberal humanism is in fact revealed to be a very specific western European male, exulting in his perceived mastery of bourgeois Renaissance space.

The real signified of History, then, far from being a 'discovered' moment from the past, fully analysed, categorised and understood, is in fact a re-affirmation of the hegemony of the structures of power that licensed its production, as de Certeau points out: 'In the final analysis, what always accredits the discourse is power because power functions as a guarantee of the "real" in the manner in which gold bullion validates bank notes and paper money.'[37] Such a re-affirmation is often brought about, as Hayden White suggests, by the imposition of an ordering narrativity on the chaotic and disparate realm of 'the past', and narrativity demands a certain final resolution: 'The demand for closure in the historical story is a

demand, I suggest, for moral meaning, a demand that sequences of real events be assessed as to their significance as elements of a *moral* drama.'[38]

Aside from liberal humanist historiography, another institution that attempts to safeguard and, to an extent, to guarantee, bourgeois morality is the modern western nuclear family, and the role of the family in the complex processes of socialisation will crop up with reference to the fairy tale musical comedies under discussion in chapters 3 and 4. Whereas I am not unaware that the traditional Russian family unit was a much more extended affair than that of western European households – or indeed that it is precisely Russia's ambivalent location (both geographically and culturally) between East and West that has acted as the mainspring for centuries' worth of Russian and Soviet culture – we should note that the nuclear family unit was re-established in official Soviet discourse, not only as the root cell of society, but as a model for that society as a whole, at around the same time that Stalin was consolidating his hold on power.[39] This must have been a crushing blow for the hopes for gender reconstruction of old-school Bolshevik feminists such as Inessa Armand, who had stated rather bluntly: 'The age-old structure of the family is pretty much the last stronghold of the old system, the old slavery. This fortress must be destroyed.'[40]

On the other hand, this re-establishment does point towards the final reason why a psychoanalytic approach to the films of the era might be appropriate. If psychoanalysis may lay claim to the status of any kind of science, then it must be that of a science of the family: just as Freud uncovered a devastating complex of murderous drives and lustful desires beneath the veneer of 'happy families' in his native Vienna, one of the central projects of this book is to test the applicability of his theories of 'family romance' to the happy, smiling Soviet families portrayed on screen throughout the Stalin era in the USSR. Whether or not Freud ended up merely describing or in fact sustaining father power, the extreme patriarchal structure of the 'Great Soviet Family', with Stalin as 'father of fathers', should also prove a useful cultural location for the separating off of patriarchy and masculinity, which should in turn provide a fruitful and more subtly nuanced account of gender structures in Stalin's Soviet Union.

There are, as I have already stated, many objections to psychoanalytic theory, but perhaps the most relevant of these to our context is that it makes universalising claims to being a science of the subject untouched by history. The world of Freud's Vienna, or Lacan's Paris – not to mention the Hollywood scenarios that so

inspired the groundbreaking work of Laura Mulvey on psycho-analysis and cinema[41]– do appear, at first glance, to be far removed from the bleak terrain of Stalin's terror. So how am I to defend the importing of a theory that seems to have little or nothing to do with the actual conditions of life and cinematic production in Stalin's Soviet Union?

One answer to this question, quite apart from the issue of family values mentioned above, might be the apparent absence of anything better. We have already discussed the shortcomings of attempts to apply what Clark terms 'Western "highbrow" literary criteria' – in general poorly defined and alien notions of what constitutes 'great art' – to a form of discourse to which they have absolutely no relevance; moreover, native Soviet film theory, as elaborated in the writings of Eisenstein, Vsevolod Pudovkin, the documentary film maker Dziga Vertov *et al.*, had never really attempted to theorise gender, and had been explicitly and repeatedly rejected by the early 1930s in their native Soviet Union as bourgeois (to an extent, Eisenstein's popularity in the 'bourgeois' West was testament to this). A second answer to this question would adduce (as I intend to do in the next chapter) the high-level decision to emulate the American cinematic paradigm in a genuine attempt to engage Soviet audiences, as well as Soiuzkino chief Boris Shumiatskii's project to establish a 'Soviet Hollywood' in the Crimea, to argue that similarities between Hollywood and Soviet cinema ran rather deeper than might at first appear to be the case. In this context, it is worth noting again Clark's comparison of the Soviet novel to 'other varieties of popular formulaic literature, such as detective stories and serial novels.'[42] It is surely not unfeasible, with certain necessary adjustments, to map the tropes and codes specific to such literature onto the cinematic conventions analysed by Mulvey: again this book, to an extent, intends to test out this proposition, and to investigate what such necessary adjustments might entail.

Such a project would, of course, be hamstrung by the whole-sale transplanting of a single body of theory lock, stock and barrel, without reference, once again, to the discursive context of the films to be analysed. For this reason, my readings of these films is anchored within the specific discursive framework of Stalinist culture by the second methodological strand of this study, which in turn rests largely upon the writings of two Soviet thinkers who will come under detailed discussion in the next chapter. Both Abram Terts (pseudonym of the Soviet dissident Andrei Siniavskii) and Mikhail Bakhtin represent distinctive voices within, but not necessarily *of*, socialist realist discourse; similarly, both are concerned, in different ways and towards differing ends, with the question of

what can be said, and perhaps more importantly, with the ways in which it could be said.

Terts was one of very few Soviet writers to engage directly and critically with the discourse through which he was expected to express himself, although his famous polemical essay 'What is Socialist Realism' – written in the immediate aftermath of Khrushchev's partial denunciation of Stalin – could only be published abroad,[43] and led to Siniavskii's showcase trial in 1966, where the author was sentenced to seven years hard labour. In a sense, this is hardly surprising: the tone is forthright and self-consciously provocative, more in keeping with the impassioned treatises of the 'radical firebrand' Russian critics of the nineteenth century such as Dobroliubov and Belinskii than his more cautiously conservative contemporaries; with the dismissal of Khrushchev from his post as General Secretary, the series of 'thaws' that had punctuated his rule came to an end, and such writings – barely tolerable even in the most relaxed moments of the Khrushchev era – were once again anathematised.

Bakhtin, on the other hand, had been on the scene for a significantly longer period of time, but had also suffered numerous persecutions and frustrations. Writing less directly about socialist realism per se, Bakhtin's discourse theories have enjoyed something of a renaissance in the West since the 1980s, and his writings – especially on the history of languages – are deeply imbricated in the precise issue of the policing of 'meaning' and the limits of the utterable, as well as the strategies adopted by the ruling discourse to hierarchise the speech of others as somehow inferior. As such, they are of direct relevance not only to his own life and times, but also to the areas addressed by this book.

To conclude on the subject of my own position in this field, it should be clear by now that I am very aware of my own status as a non-participant observer, but I also hope to have demonstrated some sensitivity to the fact that Stalinist cinema represents a shifting nexus of culturally-, sociologically- and politically-specific discourses (although attempts were made, as we shall see in the next chapter, to merge culture, society and politics into a single, unified discourse). My aim, therefore, is by no means to re-write the past, but rather to keep the debate on this terrible period of Russian history open by maintaining within view the fact that, contrary to certain preceding accounts, there remained a certain degree of flexibility within this discourse to accommodate the changing demands not just of the Stalinist State, but of the Soviet Union as a whole – an enormous and largely unpredictable societal experiment.

Outline of the book

This brings us back, then, to the subject of contextualisation: if we accept that the films under discussion here articulated a utopian vision in an attempt to secure the active consent of Soviet citizens to the Stalinist regime, then it follows that the parameters of this utopian vision – if it was indeed to exercise a broad appeal across a range of expectations and aspirations over the vast 'sixth of the world' under Stalin's aegis – could not be the same at all times and in all places. For this reason, the book is organised along a geo-graphical – as well as a more loosely chronological – principle. In the next chapter, therefore, I offer a thematic discussion of the debates surrounding the Soviet film industry during the years of Cultural Revolution up to and including the introduction of socialist realism as the 'single method' for all art and criticism. This discussion is largely structured around the open polemics between the old guard of radical directors of the 1920s, who championed the Formalist dream of developing a 'film language', and the more commercially-minded proletarian school and critics, who dismissed the work of their forebears as 'unintelligible'. Drawing on the discourse theory of Bakhtin, my argument fits a number of key decisions regarding the future of Soviet cinema squarely into a marked tendency of con-temporary Soviet culture and society, towards a radical centralisa-tion and masculinisation of Stalinist discourse.

Socialist realism was introduced as a means to transcend the apparent dichotomy between commerce and ideology, but Zhdanov's notorious combination of 'what is' and 'what *should be*' also performed a number of other elisions: between epic and nov-elistic forms (which has led to Katerina Clark's diagnosis of social-ist realist art's 'modal schizophrenia');[44] between the individual and society; and, perhaps most importantly, between subjectivity and objectivity. The resulting positive hero emerges as a distinctly two-dimensional character – as much a descendent of the iconos-tasis as the inheritor of the revolutionary mantle of nineteenth-century radical literature – and it is precisely this lack of 'psychologising' that enables him to move, largely unaltered, from one formulaic plot to another. To close the chapter, a paradigmatic 'New Soviet Man' is presented through an analysis of the 1941 aviation blockbuster *Valerii Chkalov*. Chkalov, as one of the 'fledg-ling children of Stalin', is portrayed as a modern-day saint, and a focus on the pseudo-religious nature of Stalinist discourse – with its ultimate goal of promoting the Soviet Union as an earthly par-adise – directs the reader toward the extreme utopian sensibilities of socialist realism.

This utopianism was not only ordained from on high and enshrined in the 1936 Constitution, but even found its way into people's hearts through the twin media of folklore and collective song – the realm of the era's privileged cinematic genre, the musical. The book moves on, therefore, to assess the life and Moscow-centric works of the Soviet king of the musical genre Grigorii Aleksandrov, whose 1936 film *Circus* has been hailed as a near-perfect fusion of ideology and entertainment, and remains a staple of contemporary studies of Soviet culture.

Aleksandrov had already gained international acclaim for his extensive input into all of Eisenstein's silent classics. With the introduction of socialist realism at home, however, and Eisenstein distinctly out of favour following the pair's sojourn in America, Aleksandrov rose alone to become a key player in the powerful domestic neo-folklorist movement. Within a limited variety, all Aleksandrov's musicals are of a general type in regard to their fairy tale structure and content: this remains true for the 'amoral' Leonid Utesov in 1934's *The Happy Guys*, whilst *Volga-Volga* of 1938 may even be read as a burlesque parody of the contemporary national mania for folklore itself. The first part of this chapter engages with modern interpretations of the symbolic – and social – values and functions of the mass-mediated fairy tale.

Next, a close formal and textual analysis is of Aleksandrov's four most important musicals explores similarities to their Hollywood counterparts in terms of structure, themes, and the star system, as well as highlighting significant differences in their informing value systems. This comparative approach demonstrates that – unlike the more light-heartedly escapist RKO fantasies of, for example, Fred Astaire – Aleksandrov's musicals were in fact deeply imbricated in the political, social and cultural debates of their times, and that the repressed pluralistic discourses of 1920s Soviet art were barely contained by their extreme centripetality. Nonetheless, these movies make explicit their claims to represent the dreams of millions of members of the 'Great Soviet Family'. An investigation into the latent content of these dreams – that is to say, a journey down the Freudian 'royal road' to what the State imagined to be the Soviet collective unconscious – in fact yields startling evidence as to exactly what Stalin, in his role as patriarch, expected of his 'model sons'.

Having established and discussed the omnipresence of Freudian conflict and 'family romance' beneath the veneer of 'pure' entertainment in Aleksandrov's utopian musicals, the spotlight is turned onto the more controversial figure of Ivan Pyr'ev. Recognised as Aleksandrov's rival 'country cousin', Pyr'ev is also reviled as the most notorious of all Soviet directors: attempting to deny the harsh

realities of collective farm existence, and presenting instead to the world the kind of stereotyped image one would expect to find on a lacquered box, Pyr'ev's comedies – in particular his triumphalist 1949 extravaganza *Cossacks of the Kuban* – were even the object of a thinly-disguised attack at the heart of Khrushchev's so-called 'secret speech'.

Fine examples of unabashed propaganda, these movies were made, quite explicitly, to celebrate the much-trumpeted (if, in reality, somewhat hollow) successes of the government's collectivisation policy. A brief discussion of the somewhat more harsh conditions prevailing in the Soviet countryside off-screen leads into an exploration of both how Pyr'ev wished to portray the 'Motherland', and possible reasons why he should have chosen this particularly distinctive style. Removed from the ideological tug of Moscow, Pyr'ev's heroes suggest very clearly that the idealised masculinising project of Soviet culture was only performing, if at all, on a very superficial level in the traditionally female domain of the country.

In their portrayal of a properly 'party-minded' positive hero, who instinctively acts for the good of the State, the films of both Aleksandrov and Pyr'ev implicitly raise the question of the twin narratives of masculinity and statehood. But what happens to such a masculinity when the State itself is under attack? Drawing together the twin methodological strands of this book – psychoanalytical film theory and Bakhtinian discourse theory – and analysing the 'New Soviet Man' in his most hegemonic guise – as the soldier hero enlisted to protect the fragile unity of the nation – the final chapter addresses vital questions concerning contemporary readings of the gendered narratives of war.

The standard for comparison here must be the eponymous Civil War hero of the Vasil'ev Brothers' *Chapaev*, whose studied resolve and political commitment act as guarantors of the shining future that is to come about under socialism. Films made during the Second World War, however, present us with a hero of rather a different stripe: calling into question the assumed cast-iron certainties of the likes of Chapaev, my argument contends that the unleashing of discursive forces during the 'Great Patriotic War' – as it was rather tellingly christened – opened up issues of male identity and sexuality at the very heart of the Stalinist culture industry. The high watermark of this tendency remains Eisenstein's masterpiece *Ivan the Terrible*, although this remarkable testament to the dangers inherent in socialist realism's denial of split subjectivity is still too often locked in a rather limited debate over authorial intent. My argument highlights the cultural significance of Eisenstein's portrayal of a truly three-dimensional hero, without losing sight of the political

implications of casting this hero in the guise of a troubled megalomaniac despot. Finally, an analysis of a soldier hero in a Khrushchev-era war film is offered in an attempt to gauge the extent of the changes engendered in Soviet cinema by the new leader's denunciation of his predecessor.

Notes

1 Antony Easthope, *What A Man's Gotta Do: The Masculine Myth in Popular Culture* (London: Routledge, 1992), p. 170.

2 Lynne Attwood, *Creating the New Soviet Woman: Women's Magazines as Engineers of Female Identity, 1922–53* (Basingstoke: Macmillan Press, 1999), p. 1. Attwood also explores shifting Soviet attitudes to the nature/nurture debate in *The New Soviet Man and Woman: Sex-Role Socialisation in the USSR* (Basingstoke: Macmillan Press, 1990), pp. 32–66.

3 The issue of 'propaganda' as such is not one of the main themes of this study. In the immediate context of the Soviet Union, the subject is discussed at some length, and from different perspectives, by Richard Taylor in *Film Propaganda: Soviet Russia and Nazi Germany*, rev. edn (London and New York: I. B. Tauris, 1998), and Peter Kenez in *The Birth of the Propaganda State: Soviet Methods of Mass Mobilization, 1917–1929* (Cambridge: Cambridge University Press, 1985) and *Cinema and Soviet Society from the Revolution to the Death of Stalin*, 2nd edn (London and New York: I. B. Tauris, 2001).

4 Kenez, *Cinema and Soviet Society*, pp. 68–113.

5 Grigorii Mar'iamov, *Kremlevskii tsenzor: Stalin smotrit kino* (Moscow: 'Kinotsentr', 1992).

6 Kenez, *Cinema and Soviet Society*, p. 131.

7 Kenez, *Cinema and Soviet Society*, p. 145.

8 *Ibid.*

9 Katerina Clark, *The Soviet Novel: History as Ritual*, 3rd edn (Bloomington and Indianapolis: Indiana University Press, 2000), pp. xi–xii.

10 See Clark's *Appendix A*, 'The Master Plot as Exemplified in the Production Novel and Other Basic Types of Novel of the Stalin Era', *Soviet Novel*, pp. 255–60.

11 Clark, *Soviet Novel*, pp. 27–45.

12 Clark, *Soviet Novel*, p. 5.

13 V. N. Voloshinov, 'Slovo v zhizni i slovo v poezii', *Zvezda*, 6, 1926; I shall be quoting from John Richmond's translation, 'Discourse in life and discourse in poetry: questions of sociological poetics', in Ann Shukman (ed.), *Bakhtin School Papers*, Russian poetics in trans.lation, vol. 10 (Oxford: RPT Publications, 1983), pp. 5–30.

14 Voloshinov, 'Discourse in life', p. 17.

15 Kenez, *Cinema and Soviet Society*, p. 162.

16 Frank Ellis, 'The media as social engineer', in Catriona Kelly and David Shepherd (eds), *Russian Cultural Studies: An Introduction*

(Oxford: Oxford University Press, 1998), pp. 192–222 (p. 197); the authoritative account of pre-revolutionary literacy in Russia is Jeffrey Brooks' *When Russia Learned to Read: Literacy and Popular Culture, 1861–1917* (Princeton: Princeton University Press, 1985).

17 Quoted in Richard Taylor and Ian Christie (eds), *The Film Factory: Russian and Soviet Cinema in Documents, 1896–1939* (London: Routledge, 1994), p. 197.

18 See the paradigmatic lyrics to the popular song *Life's Getting Better* by Vasilii Lebedev-Kumach, who penned the lyrics for many of the centrepiece songs of the Stalinist musical comedies, in James von Geldern and Richard Stites (eds), *Russian Popular Culture: Tales, Poems, Songs, Movies, Plays and Folklore, 1917–1953* (Bloomington and Indianapolis: Indiana University Press, 1995), pp. 237–8; another foundation myth for the new Soviet society, that of the 'Great Family' of the Soviet state, is also of central importance to this study.

19 Quoted in Taylor and Christie (eds), *Film Factory*, p. 365.

20 Jonathan Rutherford, 'Who's That Man?', in Rowena Chapman and Jonathan Rutherford (eds), *Male Order: Unwrapping Masculinity* (London: Lawrence and Wishart, 1988), pp. 21–67; see also Easthope, *What A Man's Gotta Do*; R. W. Connell, *Masculinities* (Cambridge: Polity Press, 1995); the fact that masculinities are predominantly defined relationally, as what is not 'feminine', is just one reason why I am paying particular attention to the female leads in the musical comedies of Aleksandrov and Pyr'ev in chapters 3 and 4.

21 Teresa de Lauretis, *Alice Doesn't: Feminism, Semiotics, Cinema* (Bloomington: Indiana University Press, 1984), pp. 38–9 (my italics).

22 A point also made by Lynne Segal, who attacks the myth that men do not speak or write about themselves: 'In reality [...] both men and women have written volumes on the male sex. When men write about themselves, however, they have done so as though presenting the universal truths of humanity, rather than the partial truths of half of it.' Lynne Segal, *Slow Motion: Changing Masculinities, Changing Men*, rev. edn (London: Virago, 1997), p. xxxiii.

23 See, most famously, Kate Millett, *Sexual Politics* (New York: Doubleday, 1970), and the response of Juliet Mitchell in *Psychoanalysis and Feminism* (Harmondsworth: Penguin, 1974).

24 For a brilliantly concise and accessible introduction to the precepts of early Freudian psychoanalysis, see Sigmund Freud, 'Five Lectures on Psycho-Analysis', in *Two Short Accounts of Psycho-Analysis*, trans. and ed. James Strachey (Harmondsworth: Penguin, 1991), pp. 29–87; for an overview of Freud's later map of the conscious and unconscious mind, see *The Ego and the Id* (1923) in Anna Freud (ed.), *The Essentials of Psychoanalysis: The Definitive collection of Sigmund Freud's Writing*, trans. James Strachey (Harmondsworth: Pelican Books, 1986), pp. 439–83.

25 Mitchell, *Psychoanalysis and Feminism*, p. 6.

26 See, for example, the British journal *Screen*, which has for many years pioneered the application of structuralist and psychoanalytic theories of language to cinema, very often in conjunction with feminist film analysis. Of more immediate relevance to our study is Judith Mayne, *Kino and the Woman Question: Feminism and Soviet Silent Film* (Columbus: Ohio State University Press, 1989), a rare attempt to bring theory to a field dominated by film history.

27 See in particular Slavoj Zizek, *The Sublime Object of Ideology* (London and New York: Verso, 1989); Michel de Certeau, *The Writing of History*, trans. Tom Conley (New York: Columbia University Press, 1988).

28 Robert Lapsley and Michael Westlake, *Film Theory: An Introduction* (Manchester: Manchester University Press, 1988), pp. 67–8. I have chosen Lapsley and Westlake's reading of Lacan for a number of reasons, not least that of all the conflicting accounts and interpretations of Lacan, it is in theirs that I see most clearly elucidated my own understanding of him. Furthermore, I am also introducing this pair now for reasons of consistency, as I shall be relying on another work of theirs later on in this study.

29 See Jacques Lacan, 'The Mirror Stage as Formative of the Function of the I as Revealed in Psychoanalytic Experience', in *Ecrits: A Selection*, trans. Alan Sheridan (London: Tavistock, 1977), pp. 1–7.

30 Lapsley and Westlake, *Film Theory*, p. 68.

31 Lapsley and Westlake, *Film Theory*, p. 70.

32 Jacques Lacan, *The Four Fundamental Concepts of Psycho-analysis*, trans. Alan Sheridan, ed. Jacques-Alain Miller (London: Vintage, 1998), p. 211 (including illustration).

33 Michel de Certeau, 'History: Science and Fiction', in *Heterologies: Discourse on the Other*, trans. Brian Massumi (Manchester: Manchester University Press, 1986), pp. 199–221 (p. 203). References to the 'real' in this and the subsequent passages on historiography are not concerned with the Lacanian 'real'.

34 Roland Barthes, 'The Discourse of History', in *The Rustle of Language*, trans. Richard Howard (Oxford: Basil Blackwell, 1986), pp. 127–40 (p. 138, his italics).

35 Keith Jenkins, *Re-thinking History* (London: Routledge, 1991), pp. 10–18.

36 De Certeau, *The Writing of History*, p. 11.

37 De Certeau, 'History: Science and Fiction', p. 213.

38 Hayden White, 'The Value of Narrativity in the Representation of Reality', *Critical Inquiry*, 1980–81, 5–27 (p. 24) (his italics).

39 See, for example, Clark, *Soviet Novel*, pp. 114–35; Hans Günther, 'Wise Father Stalin and his Family in Soviet Cinema', in Thomas Lahusen and Evgeny Dobrenko (eds), *Socialist Realism Without Shores* (Durham and London: Duke University Press, 1997), pp. 178–90.

40 Cited in William M. Mandel, *Soviet Women* (New York: Anchor Books, 1975), p. 61.

41 The best recognised starting point for Mulvey's work is her article 'Visual Pleasure and Narrative Cinema', *Screen*, 16:3 (1975), 6–18; reprinted in John Caughie, Annette Kuhn, and Mandy Merck (eds), *The Sexual Subject: A Screen Reader in Sexuality* (London: Routledge, 1992), pp. 22–34.

42 Clark, *Soviet Novel*, pp. xi–xii.

43 Abram Terts, 'Chto takoe sotsialisticheskii realizm?', in *Fantasticheskii mir Abrama Tertsa* (New York: Inter-Language Literary Associates, 1967), pp. 401–46.

44 Clark, *Soviet Novel*, pp. 36–45.

2 Cultural revolution, or the masculinisation of culture

[I]t is not sufficient to demonstrate how, over time, official values have been imposed on literature, since these official values have themselves been culturally determined. (Katerina Clark)[1]

There has never been much doubt that the Soviet Union of the Stalin era fostered a particularly virulent strain of patriarchy. By the end of the 1920s, the so-called 'woman question' had been declared 'solved' – i.e. no longer on the agenda for debate: all hopes for socialised childcare and the concomitant releasing of the nation's women from what would become known as the 'double burden' of professional and house work (should such widespread employment for women ever actually materialise) had been dashed. Perhaps most significantly for our study of masculinity, with characteristic enthusiasm and arrogance, Stalin himself assumed the rather ominous title 'Father of the People'.

From the start of this chapter I shall be taking as read the idea that hopes of the 1920s for gender restructuring in the USSR not only came unfounded, but were in fact *ab initio* fundamentally flawed, falling foul of the same deep-seated patriarchal assumptions which had underpinned Russian culture since at least the times of Peter and Catherine, and which were enshrined in the *Domostroi* – the Russian guidebook to family life.[2] What I do hope to cover here is the acknowledged 'period of transition' in Soviet cinematography,[3] bracketed rather neatly between the first Party Conference on Cinema in March 1928 – convened very shortly after the defeat of the United Opposition, and the expulsion of Trotsky and his supporters from the Party – and the 1935 All-Union Creative Conference of Workers in Soviet Cinema, which took place with the cult of Stalin already well-established, and on the eve of the years of the 'terror'.

Within this period, I shall be exploring the re-emergence of overt patriarchal values as the dominant mode of Soviet culture accompanying Stalin's consolidation of power. With particular reference to the State's monopoly on the medium of film, I will argue that the so-called 'Cultural Revolution' – counterpart to the economic reforms of the first Five Year Plan – can be seen to amount to a remasculinisation of culture after the relative liberalism of the first decade of Soviet power. I shall also examine in some depth the emergence and maintenance of the 'single method' of socialist realism in all art; discuss the pressures that such a pervasively masculine cultural model exerted on the psyche of the New Soviet Man; and attempt to locate the position of cinema within this framework.

I hope to demonstrate how cinema fits into this dominant mode of Soviet culture both during and after the plan years, in terms of the downgrading of the role of the collective, and the conferring of sole responsibility for the success or otherwise of a film on the scenarist; the substitution of a single world-view for the apparent pluralism of the 1920s; and the newly-emerged primacy of the scripted word over the visual image in cinema – a notion that goes against all received western notions of film as art. Furthermore, I will be exploring the relation of this re-fashioning of discursive forces – towards a monologising centripetal model – to both the covert and overt patriarchal values of socialist realism under Stalin, and examining their maintenance by structures of censorship, and the privileged position reaccorded to the family unit in both society and art.

As the following two chapters will be dealing specifically with musical comedies – a genre that very particularly foregrounds the heroine and female as star – I shall be appending an analysis of Mikhail Kalatozov's 1941 aviation adventure classic *Valerii Chkalov*. In the light of our more general conclusions about socialist realist cinema – its re-casting of patriarchal values and its apparent fascination with, for example, the theme of overcoming nature – Kalatozov's film provides an invaluable opportunity to explore the heroic male paradigm emerging from the years of Cultural Revolution.

1928: a conference for the millions

From the very first days of the October Revolution, the Bolsheviks had embraced the cinema as what appeared to be the perfect proletarian art form. A genuinely collective industry that, as Lynne Attwood has pointed out, seemed free of the bourgeois stigma still attached to the theatre,[4] cinema was recognised as a form of visibly technological progress that was able to convey political messages to

a population estimated at 80 per cent illiterate in areas where support for the new government was shaky. With truly revolutionary zeal, the Bolsheviks appropriated a centuries-old tradition of iconography, and imbued it with a novelty value that quite literally had people fainting into the aisles of the *agit* trains that were sent – armed with a formidable array of propaganda materials – speeding off into the vast Russian countryside.

Given the near-perfection of this ideological tool, it may be pertinent to ask why the Bolsheviks – usually so careful to plan and organise all the fine details of the enlightenment of the masses – took over ten years to set up a conference on cinema. Whilst it is quite possible that the cultural hegemony of film in the 1920s allowed it to set its own agenda, by 1928 the Party was expressing regular dissatisfaction with both the form and content of Soviet-made features. It was finding particularly irksome the scant ideological content of commercial cinema, not to mention the apparent preference of the mass audience for imported American films. Coupled with contemporary plans for 'revolution from above', and a retreat from NEP values in culture as well as economics, the necessity of establishing a more rigid Party line on cinematic production throughout the USSR became more and more apparent.

The debates and resolutions of the 1928 conference are well-enough documented elsewhere. Richard Taylor, for example, has summed up the proceedings as follows: 'The resolutions passed by the conference called for greater ideological vigilance, more efficient production methods and a greater identification between the films produced and the audiences for which they were intended.'[5] Quite apart from the tensions implicit in the calls for both vigilance *and* increased productivity, the third issue – at the bottom line one of popularity, not to mention accessibility – was to be easily solved, as the opposition between commerce and ideology – hitherto largely accepted as problematical – was declared 'incorrect'.[6] Such a declaration was disingenuous, to say the least, particularly in the light of the fact that it was precisely this apparently spurious opposition that, as we have seen, acted as a prime motive for the existence of the conference in the first place.

Throughout the 1920s, in fact, cinema had become perhaps the most highly-charged ideological battleground of Soviet culture. Initially conceived of as a brave new world for experimentation, and the concrete testing-ground for the application of all manner of abstract theories – not least among them genuine literary Formalism[7] – cinema could not, however, realistically lay claim to such a complete rupture with the pre-revolutionary past that its

principal exponents espoused. For example, Eisenstein's theories on montage-cinema forcing the viewer into a qualitative leap in consciousness clearly owe a certain debt to the symbolists, in particular Andrei Bely's writings on the possibility of glimpsing neo-Platonic ideals by a process of disestablishing the form of the world, and then re-assembling it into a higher cohesion.

Moreover, and quite apart from montage theory, interests were declared in the uses and abuses of *typage* – the use of non-actors for their particular *look*, which was to embody an idea, or even an entire social class; and Pavlovian reflexology – the conditioning of the audience to respond to certain image combinations in a way that the director, it was hoped, could predetermine. Most importantly for our study, however, were the debates over the possibility of creating a 'film language', which focused on attempts to manipulate the visual image as distinct and free from the constraints of the written or spoken word, and had attracted the particular attention of, among others, the formalist Viktor Shklovskii. The development of film as a visual text became something of an obsession for the great directors of the 1920s, and the fate of their attempts to wrest the image from the chains of the word will be one of the key points of this chapter on the Cultural Revolution and socialist realism. As we shall see, the tensions between directors and scenarists grew up alongside our other major concern: the question of the reconciliation of commerce and ideology.

For all the sloganeering and polemical banner-waving of the 1920s regarding 'proletarian' art, the political enlightenment of the workers, and the much-trumpeted centrality of the masses to Soviet film-making, it would appear that these same masses did not enjoy watching their portrayal on the silver screen. The plain fact of the matter was that the acknowledged 'classics' of Soviet cinema of the day were quite simply, and rather ironically, always appreciated much more in the bourgeois West than on home soil, where audiences voted overwhelmingly with their feet in favour of American imports and commercial NEP films harking back to pre-revolutionary themes. Amongst others, Richard Stites has pointed out how 'old-style yarns of romance and adventure, cleansed only of counter-revolution and blatant sex, became again the mainstay of movie audiences through the 1920s'.[8]

Although international acclaim went a long way towards securing the domestic and foreign reputations of both Soviet cinema and the likes of Eisenstein,[9] ultimately, as Richard Taylor notes: 'The problem in practice was that audiences did not share Eisenstein's cultural breadth and depth and could not comprehend even many of his relatively straightforward references ... like so many other

Soviet artistic experiments of the 1920s it went too far too fast.'[10] Taylor is in fact being much more kind to Eisenstein here than many of the director's contemporaries. As the 1928 conference approached, the pace of the various polemics really began to pick up, debates became more and more heated, and increasing levels of abuse were heaped upon not only the 'leftist' avant-garde, but also the 'rightist tendency' – that is, the directors and organisations who had been making and importing commercially viable, if ideologically disappointing, films.

Of particular interest to us in this context is the figure of Commissar for Enlightenment Anatolii Lunacharskii, who – evidently aware of the storm about to break over his head – began shoring up his defence in January 1928, with a speech to Soviet film workers. Beginning with a legitimation of his 'commercialist' position by an appeal to the authority of Stalin, and in particular to the dictator's desire for films to replace vodka not only in the hearts and minds of the peasants and workers of the Soviet Union, but also as the prime source of income for the State, Lunacharskii went on to reject the search for 'scapegoats', and stated bluntly: 'it is well known that boring agitation is counter-agitation'.[11] As Peter Kenez has pointed out, however, Lunacharskii was still the prime candidate for whipping boy at the March conference, alongside the Sovkino organisation, which since 1924 had been organising the production, importation and distribution of films throughout the Soviet Union:

That the conference took place at all was a political defeat for the leadership of Sovkino ... Foreseeing that the conference would give a platform to their critics, the leaders of Sovkino had tried to prevent it. Predictably, they were once again mercilessly attacked for ideological errors made in films and for being commercially minded.[12]

As we have seen, the apparent conflict between ideology and profitability was denounced as 'incorrect' time and time again at the conference. It was declared that the masses actually did want to see ideologically-valuable films, and so the films of the future were to be not only politically correct, but, perhaps more importantly, 'intelligible to the millions'.

This phrase soon caught on as the new legitimising metaphor for cinema of the Cultural Revolution. If, in the past, film-makers had justified their various positions by reference to Lenin's apocryphal and yet ubiquitous dictum that 'of all the arts, for us the cinema is the most important', the 1928 conference unleashed a flood of campaigns and articles – including ones by Eisenstein, his collaborator Grigorii Aleksandrov and the 'eccentric' Leonid Trauberg[13] – each

appropriating the notion of 'intelligibility' to defend their own particular approach to film-making.

Predictably enough, the spirit of the slogan was also taken up by Soviet critics. For the 1928 conference had not completely closed down debate on cinema in quite the way that the introduction of socialist realism was to do, and in fact to a large extent the Party – more aware of what they did not want than any essential characteristics of 'good' cinema – had left room for the critics to argue amongst themselves over the coming shape of Soviet film. One element was, however, crystal clear: there was to be no return to 'formalism' (which by now could be interpreted fairly generally as ideological deviation) in any field of art, as this would almost certainly jeopardise the desired fusion of entertainment and ideology demanded by the conference resolutions. A characteristically extreme viewpoint in what became a ferociously heated debate was expressed in an article by Pavel Petrov-Bytov, published in *Zhizn' iskusstva* in April 1929:

When people talk about Soviet cinema they brandish a banner on which is written: *The Strike, The Battleship Potemkin, October, The Mother, The End of St Petersburg* and they add the recent *New Babylon, Zvenigora* and *The Arsenal. Do 120 million workers and peasants march beneath this banner? I quite categorically state that they do not.* And never have done.[14]

Although Petrov-Bytov was himself attacked for this position, by the time he was writing this diatribe it had already become something of a truism to say that creative experimentalism alienated the masses, and that the ultimate responsibility for that particular 'mistake' lay with the directors who were stubbornly insisting on this approach to film-making. The solution to this problem, then, lay in the training of new scriptwriters, along with the guarantee that there would be no directorial deviation from the written screenplay. This solution, however, was not without its own problems, the most immediate of which was another issue hotly debated at the 1928 conference: that of the 'script hunger'.

Film language or written language?

The lack of workable screenplays – or, more accurately, the difficulty of getting a script accepted for production – had, even as early as 1928, become enough of a problem in the Soviet Union to warrant special attention in the conference resolutions. A full twelve months earlier, in fact, the self-proclaimed 'poet of the Revolution', Vladimir Mayakovsky, had published a particularly embittered article in *Novyi Lef* concerning a script he had written. This script had been rapturously received by, among others, Lev Kuleshov and Viktor

Shklovskii, but then critically panned and rejected by the Sovkino leadership, with the secretary declaring it – of course – 'unintelligible to the masses!'[15]

In his article, Mayakovsky goes on to lament the passivity of the directors who – 'like ... the fish who covers his mouth so that you cannot hear that he is singing' – accept such outrageous decisions, and asks two very pertinent questions: 'Does the phrase "We must pay our way" mean that scripts must be written by cashiers?'; and (well worth quoting at length): 'If this (general) system is safeguarding us against pulp literature, why are the scripts of the films that are shown so wretched, why is scriptwriting confined to making use of corpses and why does every investigation of every film organisation reveal the staleness of the worthless scripts that are accepted?'[16] Quite clearly, the roots of the director/scenarist opposition lie very close to the commerce/ideology dichotomy explored above, and it is this theme that I would like to explore next in relation to the advent of sound cinema in the USSR, the site described by Richard Taylor as containing 'the essential conflict between the aesthetic and the political ... in filmic terms'.[17]

It is vital to note that, in his *Novyi Lef* article, Mayakovsky is *not* referring to a scripted dialogue, but to a scenario for a silent picture. The arrival of 'talkies' was a shock to the Soviet film industry, which had neither anticipated it in their 1928 conference, nor budgeted for it in the economic reforms of the Five Year Plan. However, in the same article, Mayakovsky seems to predict the way in which the Soviet Union would soon be rushing to catch up with her American rivals when he asks: 'what are we going to do about new inventions in cinema? How much will you pay in the end to other countries for this inventiveness?'

The actual debate on sound cinema kicked off in earnest with the famous 'Statement' of Eisenstein, Pudovkin and Aleksandrov, published in *Zhizn' iskusstva* in August of 1928. The writers, whilst foreseeing the realisation of a cherished dream in the advent of sound, argue for a cautious approach to the new possibilities opening up before them. Principal among their arguments is the idea that synchronised sound – the 'certain "illusion" of people talking, objects making a noise, etc.' – is:

a double-edged invention and its most probable application will be along the line of least resistance, i.e. in the field of the *satisfaction of simple curiosity* [...] Sound used in this way will destroy the culture of montage, because every mere *addition* of sound to montage fragments increases their inertia as such and their independent significance; this is undoubtedly detrimental to montage which operates above all not with fragments but through the *juxtaposition* of fragments.[18]

This typically extreme – not to mention slightly panicky – point of view was rebutted in the same journal only a month later by Vladimir Messman, who (however sympathetically) accused the *Statement*'s authors of certain 'misconceptions', especially in their calls for a 'contrapuntal method' in sound cinema.[19]

However, the principal points – in particular the danger of cinema becoming merely 'filmed theatre' – were unapologetically reiterated by Pudovkin the following summer. More blunt than ever (perhaps a function of his impending isolation, with Eisenstein and Aleksandrov preparing to depart for western Europe and the USA) Pudovkin states that '*the talking film has no future* [...] For us sound-bearing, shouting and talking images on the screen have only relative value'. He repeats his rather stern warnings that 'the appearance of sound is once again pushing us along the line of least resistance towards being a substitute for theatre'; and that synchronised sound 'will have no influence whatsoever on the development and deepening of cinema language'; before concluding that 'We have no need for the synchronisation of sound and visual material'.[20]

The leading directors of the Soviet film industry were in fact much better-organised than their apparent collapse in the early 1930s might indicate, and they clearly recognised the need for action, as well as words. A group of eight of them, including Eisenstein, Aleksandrov, Pudovkin, and the 'eccentrics' Kozintsev and Trauberg, had issued another joint statement to the 1928 conference acknowledging the need for closer links to the Party, 'above all a political and cultural organ that is directly linked to the Central Committee'. The point behind this move would be to 'involve as many directors as possible as the cultural force on which the actual realisation of these plans [for political cinema] has depended in the past, does depend and will continue to depend in future'.[21] This is not just a gesture of submission to Party control, then, but also an attempt to retain the hitherto-supreme directorial control over Soviet film production. This question of control over the finished film will be examined in more depth below.

Ultimately, however, and while not denying the centrality of montage to Soviet cinema's world-wide reputation, the Party could not allow such a position to be maintained by the old school of Soviet directors. First and foremost, the type of cinema suggested was to be experimental, Formalist (in the correct sense of the word), and quite frankly 'unintelligible to the millions'. The leadership of Sovkino evidently had little faith in the idea that the same viewers who had even fallen asleep during Eisenstein's *October* [*Oktiabr'*, 1928],[22] or were to shake their heads in bewilderment at Dziga Vertov's *Man*

With a Movie Camera [*Chelovek s kinoapparatom*, 1929], would be packing out houses to catch the avant-garde's newest offerings of a ' "hammer and tongs" approach' to '*the contrapuntal use* of sound ... *a sharp discord with the visual images.*'[23]

The high road to socialism, then, was to follow the 'path of least resistance', and the victory of synchronised sound laid another foundation for the antipathy of the early 1930s between directors and scriptwriters. In essence, 'film language' was to play second fiddle to the constraints of the scripted word, and in one fell swoop, it seemed, all the achievements of 'revolutionary' cinema were to be consigned to the dustbin of history. In spite of the 'Faustian pact' made between directors and the State, which Ian Christie believes paved the way for Stalin's regular forays into the cutting room,[24] the Party was expending much more time and energy on the work of the scriptwriter, and the scripts would be plain, straightforward, ideologically-approved, and of course 'intelligible'.

All of this was, naturally, a major blow to the directors, who came up against criticisms not only of the primacy of montage, but also, as Kenez has pointed out, of 'not taking the scripts seriously enough'.[25] We have already discussed the antagonism between the avant garde film-makers and the up-and-coming scenarists, but we still need to question why the apparent lack of reverence for the written word on the part of the directors was considered such anathema to the future advancement of Soviet cinema.

On the surface, the answer seems clear enough: directors who deviated from scripts had tended to do so in the direction of aesthetic symbolism and a necessary degree of abstraction and ambiguity. We have already seen how, in an age that was calling for a clear ideological message to be conveyed to the masses, the masses themselves did not appear to have much time for the practice of piecing the message together for themselves (a central tenet of montage theory), and of course there were also fears that any ambiguity not only diluted but even muddied the clarity of that message.

However, there is also a deeper level to the debate, which accounts for the triumph not only of the script, but also of synchronised sound. The synchronised-sound, fully-scripted screenplay provided a vital opportunity for the *politici* to exercise a much more complete form of control over the old directors, as the demarcation line between following and deviating from a script became rigidly fixed. In addition to this, the strictly-followed word was to be used to fix meaning on a broader level, in a fashion that was entirely unambiguous. In order to study this closing-down of meaning more fully, our discussion will be diverted towards the work of the Russian theorist Mikhail Bakhtin on discursive forces in language, and the ways

in which they can be seen to reflect on the type of society that produces them in a given historico-political context.

For Bakhtin – and I am particularly indebted here to Tony Crowley's essay 'Bakhtin and the History of the Language'[26] – the production of culture is underpinned by the conflict between monologism and dialogism. Dialogism is the form that Bakhtin himself privileges, as the provisional and relativised state of a language that always takes up a position in relation to the response of another, equally dialogic position in a culture. As such, meaning is allowed to multiply, and language is always in some sense undermined by the conflict between the intended meaning of an utterance, or cultural product, and that understood by the interlocutor.

Words can therefore be deconstructed, as in the Derridean analysis of the tensions inherent in discourse's ability to undermine itself, and also manipulated for future use, as can be seen in the 're-appropriation' of pejorative labels such as 'queer', to stand for a legitimate and healthy subject position. The signifier, allowed the free rein of what Bakhtin calls 'centrifugal' forces in discourse, is permitted non-central viewpoints, the use of dialects, and above all the freedom to open up questions of meaning and the nature of distinct, yet relative, subject positions.

On the other hand – and perhaps more importantly in our chosen cultural context – monologism is the rigid condition of the language of a single world-view.[27] In this instance, conflict between meanings is considered unnecessary, as 'centripetal' forces operate to close down the multiaccentuality of words – attempting to fix a given meaning for each one – as in a dictionary definition. Dictionaries are in fact rather good sites to explore the work of centripetal forces, as they operate to dictate accepted forms of a given language, and by extension to banish forms considered unacceptable or, more often, subversive, by the dominant cultural group of a particular time.

Bakhtin sees the conflict between centrifugal and centripetal forces as an ongoing battle, with the side that is on top at any given time dictating the cultural forms produced. We should by now be able to see more clearly not only how the intervention of the Soviet government operated to champion the synchronised sound film as a far less ambiguous form than that proposed in the 'Statement' of Eisenstein and his cohorts, but also *why* the cultural form of the carefully-scripted (and rigidly followed) screenplay predominated from the early 1930s, as monoglossia always privileges the written word of a (supposedly) standardised language.

We should also be able to recognise, and begin to understand, the genuinely revolutionary nature of the Soviet Cultural Revolution, during a period when, as Peter Kenez has pointed out, as far as the

Party was concerned, all criticism was to be in terms of political use-fulness, rather than aesthetic categories.[28] Moreover, these monolo-gising centripetal forces, at work on the closing-down of ambiguities and excesses of meaning in the films themselves, had their counter-part in the cinema as institution: in 1930, the board was swept clear of all competing film factions with the establishment of Soiuzkino as the sole centralised State film organisation.

The years of the Cultural Revolution can be seen very clearly as an era of centralisation, not only of cultural production, but also of discursive forms themselves. What is of further interest to our par-ticular study, however, is first of all the way in which, as Crowley points out, centralising, authoritative monoglossia ensures a cer-tain narrowness of choice of subject positions in society, and thus plays its part in the workings of hegemony,[29] and secondly that nei-ther monologism nor dialogism can ever fully win out. This being the case, as Crowley argues, the 'victory' of monoglossia can never be entirely exclusive: in fact, rather than excluding or silencing other forms of the language (or culture), it works to hierarchise them, distinguishing itself 'as the form which could not be used by certain speakers, whilst at the same time damning their own speech as inferior'.[30]

Language used in this way, as a legitimiser of certain power rela-tions, can then be seen to allow access to a privileged symbolic order to a select few – and then only if they agree to buy into that order.[31] The nature of the Stalinist patriarchal order is already well-known to us, but Crowley bears out our argument by noting that, 'if the conflict which characterises social life is resolved one way then monoglossic and monologic forms dominate, the word of the father is the last word, and authoritative discourse appears to be the only form permitted'.[32] *The word of the father is the last word*: the pre-emi-nence granted by Crowley to the word of the father (almost as an afterthought) provides us with a key to unlock the manner in which the centripetal forces at work during the Cultural Revolution can be seen as specifically masculinising forces. Although no victory of either monoglossia or heteroglossia can ever be complete, the cen-tralising discursive forces at large in the Soviet Union of the early 1930s were working towards the establishment of a language that would not only pay due respect to the law of the father Stalin, but would also in fact fix the meanings of the people's words in a very rigid relationship to that law.

By this stage, a more concrete example is perhaps in order, and a very obvious one for us to take is that of the male hero in cinema produced by the newly centralised Soviet film industry. This exam-ple not only allows us to examine the establishment of a specific type

of male subjectivity in cultural productions of the plan years, but also to chart the progression of the New Soviet Man to the status of fully-fledged, Soviet socialist realist positive hero.

Socialist realism and the making of the New Soviet Man

Let us begin by setting the positive hero – that much-maligned figure at the heart of socialist realist texts – in his proper context. Socialist realism is usually dated from Zhdanov's speech to the first All-Union Congress of Soviet Writers in April 1934, during which he not only reminded writers of their duty to the State – to be 'engineers of human souls', as Stalin had put it – but called for a new type of literature involving 'a combination of the most austere, matter-of-fact work with the greatest heroic spirit and grandiose perspectives'.[33]

This apparent contradiction in terms – generally summed up in the critical literature as a combination of 'what is' and 'what ought to be' – became the corner stone for an immense body of creative work, applying as it did across the board from literature to the fine and plastic arts. It also provides the key, according to Katerina Clark, for an understanding of the 'modal schizophrenia' of the Soviet novel.[34] Drawing again on Bakhtin, Clark demonstrates how the structure of the socialist realist text was to elide the differences between the closed, perfected 'great time' of the epic – which may be seen as inherently monological – and the complex points of view (more precisely, the heteroglossia) of the novel. The ways in which this elision was to be brought about are rather significant for us:

What sets the Soviet novel apart from most other serious modern novels is the absence in it of those features that can be seen as an exploration or celebration of the objective/subjective split: parody, irony, literary self-consciousness, and creative or complex use of point of view. If the Soviet novel lacks this multiplanar dimension, it is not, in Bakhtin's view, a true novel. Or, to put it another way, though it may have a questing hero, it lacks a 'questing form'.[35]

It would appear that the Soviet novel was to be genuinely dialectical: in its depiction of 'reality in its revolutionary development',[36] it was to provide a synthesis not only of epic and novelistic forms, but also of rhetoric and literature, the individual and society, and of course the so-called 'consciousness/spontaneity dialectic', viewed by Clark as one of the master categories organising both pre- and post-revolutionary culture ('one of the key binary oppositions in Russian culture ... particularly well adapted to the ritual needs of the entire country').[37] We shall be returning to the resolution, or otherwise, of this dialectic later in this study.

Meanwhile, and although the Soviet novel is characterised by the modal split between epic and novelistic form, it is vital to note that, as Clark points out, it was the monological epic form that was privileged. The sudden transplantation of the positive hero to a time outside of reality always accompanied his moments of (political) enlightenment, giving them the weight of knowledge handed down from on high about the essential mysteries of our regular lives on earth. At such moments, then, the New Soviet Man is allowed access to a neo-Platonic realm, where he sees things as they truly are – the world of 'Soviet reality' which is juxtaposed, in a generally unrecognised adaptation of montage theory, with the more humdrum depictions of the Soviet Union as it struggles towards this utopian ideal. The 'questing hero' (with or without his 'questing form') was therefore educated in an enclosed, monoglot culture and, as we discussed in the last chapter, the lack of alternative narratives open to him was to parallel a similar lack presented to the consumers of his heroic deeds.

As such, the actual depiction of the positive hero also reflects an inculcation of such values. In the days of the hegemony of the proletarian writers' association, RAPP, which was at its height in the years of Cultural Revolution, the two principal slogans of art reflected the type of hero sought in both the literature and cinema of the era. First of all, following the tendency of the 1920s to portray 'character ... submerged in events' (as Soiuzkino's chief, Boris Shumiatskii, was to put it in 1935),[38] there were calls for a 'tearing off of the masks', and these were accompanied by demands for the depiction of 'a living hero'.[39] The first of these campaigns, as Rufus Mathewson points out, was related to a Tolstoyan ethic concerned with the removal of external trappings to reveal the essential truths of nature, but we shall be following the fate of the 'living man'.

The end of the first Five Year Plan, however, was marked by a shift in Soviet culture. As Clark has noted, literature of the plan years had made great use of the metaphor of the machine.[40] Such a usage was not only highly appropriate for a society that was in the throes of a frantic plan of industrialisation, but also appealed to the remnants of 1920s 'massism': since no single part of the machine was counted as self-valuable, all Soviet citizens could be portrayed as working in synchronised harmony, as a team, with no more than the customary lip-service paid to the Party as the 'driving axle'. However, a number of factors had combined by 1934 to stimulate the search for a hero of a much more specifically *heroic* nature.

First of all, the cult of the machine was being supplanted by a much more sinister cult of the leader, and obviously the egalitarian massism of the 1920s was unable to accommodate this. In addition,

the exhortations of dry statistics were evidently proving as stimulating to the workers as the abstruse symbolism of such directors as Eisenstein and Pudovkin. There was a clear need, then, for exemplary heroic figures performing almost superhuman feats, as Clark points out:

In mid-thirties rhetoric, an entire series of 'remarkable people' was singled out as official harbingers of a revolution in human anthropology soon to affect every Soviet man. These men were not merely 'bigger' than that earlier paradigm, the 'little man'; they were the 'biggest': they represented an order of humanity unlike that of the Ivans. The fantastic age had begun.[41]

In keeping with this paradigm shift towards heroes and Stakhanovites, there was also a Stalinist re-alignment of the official interpretation of Marxist social theory, which moved it away from the 'determinist' strains favoured by disciples of Plekhanov – to some extent still current even in the 1920s, after the Revolution had 'proved' Lenin's thesis on the 'vanguard of the proletariat'[42] – for good. Such a treatment of the masses as passively conditioned by an environment which had been in the sole charge of the Bolsheviks for well over a decade, was beginning to be something of an embarrassment to the leadership, and not least in terms of the 'solving' of the 'woman question'. Consequently, the Leninist approach to the *individual* as the active agent of historical change was vigorously re-asserted.[43] Similarly re-asserted was the traditional binary of active masculinity and passive femininity, and within this conceptual framework we can see that not only language, but society itself, was to become masculinised.[44]

Subjectivity and society

By now we have seen how Soviet society and culture were being manipulated towards the re-establishment of a rigid patriarchal order. We have seen in particular the ways in which, formally, structurally *and* linguistically, discursive forces were operating to remasculinise the cultural productions of the Soviet Union, which were in turn informed by extreme patriarchal assumptions.

But what of the positive hero? What had happened to the 'living man' trumpeted by RAPP? The positive hero that emerged from the 1934 congress was in fact a man of a very different stripe. Right from the start, Zhdanov had made clear the rejection of passive determinism by announcing that 'the principal literary heroes of our country are the *active builders of a new life*'.[45] Furthermore, their role as builders was to be a dedicated and optimistic one, with little room for worrying about the complexities of everyday life. The

enthusiasm displayed by RAPP for questions of realistic portrayals, motivation, and in particular, 'psychologising', had by this time fallen from favour, and were even seen as superfluous to the requirements of Soviet culture, as Mathewson remarks: 'Preoccupation with 'the living men' had led writers to concentrate entirely too much on the psychological problems of isolated men, and, it was pointed out scornfully, to set 'eternal problems' above the far more important matters of socialist construction.'[46] The Soviet dissident Andrei Siniavskii, writing as Abram Terts, comments in his essay 'What is Socialist Realism?' on the rejection of the nineteenth-century literary tradition of the 'superfluous man' under socialist realism: as a figure standing wholly outside the positive/negative hero binary, the superfluous man is therefore more dangerous to the monoglot world-view of socialist realism than the negative hero, who, contained by that binary, merely hinders progress towards the goal of the shining future.[47] The superfluous man, like the 'living man', is characterised by excessive psychologising, and Terts jumps back another hundred years to see the roots of the Soviet positive hero in the neo-classicism of the eighteenth century.

We shall be returning to neo-classicism below, but we should first note that Katerina Clark has also pointed out various literary predecessors of the positive hero, in a tradition that stretches back through Russian Orthodox hagiography, and nineteenth-century radical tracts and fiction. Whilst being careful not to posit a genealogy between Christian and Bolshevik iconologies, she does point out that the level of depersonalisation involved in the depiction of the positive hero makes him a close relative of the virtuous figures, both sacred and secular, of the old Russian written and oral tradition. One advantage of this type of hero, as Clark mentions, is that 'he was, in fact, so deindividualised that he could be transplanted wholesale from book to book, regardless of the subject matter'.[48]

This level of impersonality was effected through the use of certain stock epithets to describe the hero, such as 'stern', 'determined', 'shiny-eyed', 'brave', 'proud' and 'calm', to name but a few.[49] Most interesting for our study, however, is the fact that these epithets are all very *visual* – 'word icons', as Clark refers to them – so it should come as no surprise that the Bolsheviks, with their keen sense of the tradition of iconography, should appropriate these forms as well. Later in this study we shall be exploring in more detail the ways in which Soviet positive heroes were expected to live the lives of saints, but for the moment we shall confine ourselves to noting that the positive hero's visual aspect is *always* radiant, and above all calm. Clark sees this calm as reflecting the transcendence of a turbulent inner self[50] – the resolute serenity that should accompany the working-out of the

consciousness/spontaneity dialectic. The harmony of inner and outer self is just one of the elements of the positive hero's appearance and personality that implies the effacement of contradiction – and perhaps therefore the somatic assumption of monoglossia. Just as socialist realism refuses to work with anything exploring or celebrating the split between subjectivity and objectivity, the positive hero was in no way to be seen as a split subject.

In many ways, the idea of the split subject can be seen to represent a major threat to the operations of monologising centripetal discourse. As subjects, we are both constituted and divided by language, but the condition of monoglossia, with its inflexible ideal of one fixed meaning for each word, attempts to deny such a possibility. In this context, we can understand more clearly the opposition of Soviet cultural organs to what was sneeringly referred to as 'psychologising': not only was Freudian theory, as perhaps the most extensive and challenging body of thought produced in the twentieth century, a rival to socialist realism as a world-view, but it was also a theory that, although open to accusations of universalising individual experience, nonetheless championed that experience, and socialist realism was much more keen on a homogeneous society than a heteroglot chorus of individuals.

In fact, the monologising discourse of socialist realism not only sought to bridge the gaps between rhetoric and literature, epic and novelistic forms, but its centripetal forces also operated to efface the distance between the subjective and the objective, that is, between the individual and society. As Mathewson makes clear: 'This, finally, is the point: the revelation of human complexity is politically harmful.'[51]

Furthermore, the apparent effacement of these binaries can also be seen as something of a feint: just as the novelistic form was subordinated to the epic, thus rendering literature a form of rhetoric, so the subjective individual was to be subsumed into her or his society, which, as we have seen, was striving towards monoglossia. This particular application of socialist realism was not confined to the positive hero on the page, canvas, stage or screen, however, as the artists themselves were to become positive heroes as well: Ian Christie has pointed out the idealised Stalinist image of artists submerging their individuality beneath their social role as truly *Soviet* artists, to join battle with the dark forces of old-fashioned notions of art or language;[52] similarly, Slavoj Zizek, citing the case of Nikolai Bukharin, has demonstrated that even the highest ranking Party members were expected to follow suit: 'In such a universe, of course, there is no place for even the most formal and empty right of subjectivity, on which Bukharin continues to insist'.[53]

By a rather strange paradox, then, just as socialist realism was ushering-in a fantastic era of heroic feats, it was also eroding individuality. Just as artists were encouraged to study 'life', it was also becoming clear that this meant life 'in its revolutionary development' – 'Soviet reality' – and that this development was to be mediated through heroic, but thoroughly depersonalised, individuals. The price to pay for any kind of subjectivity was that of having it merged with the objective processes of socialist construction, and this point lies perhaps at the heart of Leonid Trauberg's comments at the 1935 All-Union Creative Conference of Workers in Soviet Cinema, as he looked back over the previous five years of cinema production: 'The characteristics of a man, a hero in one of the films from our first period have nothing in common with the characteristics of a hero from the contemporary period [...] in these five years we got away from the accursed legacy of "fractured consciousness"'.[54] The key concept in doing away with 'fractured consciousness', in both the production of Soviet films and their positive heroes, in the erosion of the boundary between subjectivity and objectivity, and most especially in the politically harmful revelation of human complexity, lay in the new spirit of *partiinost'*, which was to infuse all layers of Soviet society and culture.

This concept, with its legitimating origins in Lenin's 1905 article 'Party Organisation and Party Literature' involved the willing and active participation of members of the public, not only in submitting to the will of the Party (which, of course, knew how best to direct their day-to-day affairs), but also in the construction of the new socialist Utopia to which it pointed. As Mathewson remarks:

The final measure of truth, the final touchstone of value, the final determinant of behaviour were all declared to reside in Lenin's single, all-embracing term, *partiinost* ... minutely intimate, and unlike other, similar codes of allegiance, it solicits not obedience, or reverence, or acquiescence, but the conscious, whole-hearted collaboration of every individual.[55]

As such, the notion of *partiinost'* – as a key to the workings of Soviet hegemony, the attempts of the party to secure the active consent of the public – is clearly the focal point not only of the majority of Soviet public statements on culture, but also (more familiarly in the West) of George Orwell's attack on totalitarianism in 'Nineteen Eighty-Four': a lack of this spirit was a distinct shortcoming, and one meriting severe re-education. 'Party-mindedness', as Katerina Clark's own somewhat Orwellian translation has it, was to bind the people as one to the interests of the Party, which in turn were represented as the best possible interests of the people themselves. The promised new socialist dawn could only break if the entire nation

pulled together with the Party, and if you were not for the Party then you were against it. The one crime shared by all the defendants of the show trials, the traitors, spies, wreckers and saboteurs, all real and perceived enemies of the people, was simply that of not being 'Party-minded'.

On the other hand, as we have said, the concept of *partiinost'* also held the key to the 'shining future', to which all works of socialist realist culture looked forward. Even tragic deaths at the end of novels and films were to be rendered optimistic – as is most famously (in the West, at least) the case with Pudovkin's film of Gorky's classic novel 'The Mother'. As she dies, trampled to death by a regiment of Cossack horsemen, the eponymous heroine clutches a red banner, which is ultimately transposed to a red flag flying over the Kremlin: the martyrdom is seen as paving the way to a brighter future. More importantly for our study, this shining future was always to be depicted as within reach.[56]

Onward Stalinist soldiers

The nature of *partiinost'* as a sort of faith is one of the focal points of Terts' essay 'What is Socialist Realism?'. In fact, the element of quasi-religious conviction plays a major role in the formation of the positive hero in both literature and cinema. Within the teleological structures of socialist realism posited by Terts, the positive hero – with his innate knowledge of the final purpose of human life in Communism – draws strength from his own awareness of, and proximity to, this ultimate goal.[57] Unlike Christianity, however, the religion underpinned by socialist realism has at the heart of its teleological purpose a goal that, theoretically at least, is in fact accessible *in this life*: the rewards allotted to the heroes of the era – Stakhanovites and artists alike – were a mere foretaste of the joys promised for the socialist paradise on earth. The All-Union Exhibition of Agriculture in Moscow, which plays a catalytic role in many of the musical comedies we shall be discussing later, provides a striking example of the Soviet media's provision of what Sheila Fitzpatrick refers to as 'a preview of the coming attractions of socialism'.[58]

As we mentioned above, the fervent, quasi-religious conviction of the ultimate accessibility of such attractions harks back to the neoclassicism of the eighteenth century, with all its rigid certainties, not to mention its implicit patriarchal assumptions. Positive heroes such as Maksim, from the trilogy of films by former 'eccentrics' Grigorii Kozintsev and Leonid Trauberg, share in that era's certain knowledge that God is with them: the only difference, of course, is that God

now reigns on earth, from his offices in the Kremlin. The convinced faithful of socialist realism, as Terts argues, do actually have their God: this knowledge is reflected in the features of the positive hero, who 'overcomes his enemy not with cunning, nor intelligence, and not with physical strength, but solely by his proud look'.[59] This characteristically masculine look is one that commands absolute knowledge of time and space, and is in turn reflected by the 'masculine' style of socialist realism: clarity, mastery, knowledge and conviction are all discursively constituted in modern western societies as classic 'male' modes, and are utilised by Stalinist art to advance the Leninist line on the resolution of the spontaneity/consciousness dialectic. We may recall the harmonious depiction of the positive hero as a man who has overcome a turbulent inner self, and this accords with Lenin's belief in the rational taming of the elemental side of human nature to the point at which all decisions taken by the hero are also for the good of society as a whole.

Just as Stalinist musical comedies offer a portrayal of a harmonious earthly paradise, then, it can also be argued that a prime motive behind Stalinist art as a whole was to impose a specific type of symbolic order on the chaotic reality of Russian life – a life that was still in large part seen as 'backward', with its residual worship of the *rodina-mat'* (Motherland) and the figure of the *Bogomater'*, the mother of Christ, around whom the Orthodox faith is largely structured. We have already seen in our discussion of historiography how such an imposition – of a narrative framework on a chaotic flux of events – tends towards a moralising discourse: in the case of socialist realism, with its rigidly monoglot and authoritarian mode, this moral was articulated through the final word of the father of fathers, Stalin himself. The dissident Terts, who, with his implicit Slavophile positioning, is bound to resist what he regards as an imposition of western value systems, complains that 'the river of art is covered over by the ice of classicism', and argues instead for a new phantasmagoric art: an art which, we should note, would allow free rein to centrifugal forces in discourse.[60]

The cutting-room floor: censorship and state intervention

As we have seen, however, the Party could not tolerate centrifugal discursive forces any more than socialist realism could coexist with any other world-view in the arts. Crowley suggests that the privileging of monoglot discourse is safeguarded by 'national yet centralised forms of authority in institutions such as the police force, bureaucratic government and elementary education'.[61] In the Soviet Union the task of policing the production of meaning in the

cinema fell to the centralised censorship authorities, whose powers were significantly increased with the appointment of Boris Shumiatskii as head of Soiuzkino. Furthermore, as Kenez points out:

Unfortunately, the word 'censorship' is something of a misnomer. One should not imagine that the problem of the Soviet artist was that he had to submit his completed work for examination by a censor or a body of censors. The representatives of the Party, those responsible for ideological purity, were in fact cowriters and codirectors, who participated in every stage of the production of the film from the first glimmer of an idea to the last cut.[62]

What we are dealing with here goes far beyond the conventional understanding of censorship, to a point at which censorship mechanisms are intimately involved at all stages, and all levels of film production. Nobody, it seemed, was safe: after the fiasco of *Bezhin Meadow* [*Bezhin Lug*, 1936], even an acknowledged great such as Eisenstein was plagued throughout the filming of his historical biopic *Aleksandr Nevskii* of 1938 by, as Marie Seton puts it, 'new collaborators whose task it was to see to it that he did not lose his way again.'[63]

The cinema, above all the other arts, was particularly prone to monologising forms of censorship of meaning, a situation which stems in part from its privileged position as Stalin's personal favourite medium, as well as its acknowledged supremacy as a tool of enlightenment. In addition to these factors, however, the cinema was by far the easiest of the arts to submit to watertight control: writers and artists could always produce work 'for the drawer' – to be kept secret, awaiting a relaxation of control – and paintings, novels and poetry at least stood a chance of underground publication either at home or having been smuggled abroad (such was the case, in fact, with the Terts' essay 'What is Socialist Realism?'). The centralisation of the film industry, however, included not only the studios, but also the cameras, film stock, and lighting and editing equipment: it was impossible to make a film in the Soviet Union of the 1930s without some official knowing exactly what you were up to.

Furthermore, there was no guarantee, even for those films that did reach completion, of any screening or distribution: an enormous number of completed films of the time were shelved, and many others ordered burnt. The final acid test of a movie's suitability for reproduction and distribution was very often a private screening of the finished version for Stalin himself – the 'Kremlin Censor', as Mar'iamov puts it.[64] In fact, Stalin was notorious for the personal interest he so loved to take in the cinema which, in combination with

his specific designs for the medium – often reduced in the critical literature to an apparently complete lack of comprehension of film art – managed to bring film production in the Soviet Union almost to a standstill.[65] The unpredictable nature of policy on ideological content engendered a cautious approach to the approval of films: even the censors themselves were far from immune to arrest and imprisonment, should they be seen to allow an ideological reject through the net. As a result of this extreme conservatism, approximately one third of completed films were never screened.[66]

As should be evident from our earlier discussion of the nature of socialist realism, the principal targets for the censors were such elements as irony, ambiguity, and experimentalism – in fact anything which permitted more than one interpretation. We have covered irony and ambiguity, and of course experimentalism had been out of favour on the overt grounds of its real or perceived lack of 'intelligibility' since 1928. There is perhaps also a deeper level to this issue, however, which ties in with the indiscriminate application of the term 'formalism', as we have mentioned, to any piece of artistic work that did not fall into line with the constraints of the 'single method'. Not only was genuine literary Formalism one of the strongest of the home-grown theoretical movements of the 1920s, but at its heart lay both the requirement that the text be experimental, as well as the sacred autonomy of the work of art. This autonomy was necessarily anathema to socialist realism, which demanded the spirit of *partiinost'* from art, and especially so because it also entailed the (idealised, in the case of cinema) ability of the artist to create great works in isolation – that is, without the Party being able to take any credit for it – and to leave her or his own individual stamp on such works.[67]

In fact, and perhaps rather surprisingly, it was not the directors themselves who suffered the most under the censors. This is quite possibly a result of an acknowledgement on the part of the authorities that, although the 'script crisis' was far from resolved, there were even fewer directors to spare, and indeed a number of directors were engaged to teach their art to up and coming film students at VGIK, the All-Union State Institute of Cinematography in Moscow. On the other hand, the downgrading of the visual image in Soviet cinema – whilst undoubtedly denying directors the conditions within which to develop a 'film art' along similar lines to those with which we are more familiar in the West – also operated on a more practical level to the advantage of those same directors, as the privileging of the written word led to a focus on the *content* of the screenplays. Under these conditions, for a while, scriptwriting became a more dangerous occupation than directing.

Meanwhile, one of the principal criticisms that the censors and critics levelled at film-makers and scenarists alike, was that of not portraying 'Soviet reality'. Some films did indeed attempt to portray the very real problems of everyday life in the Soviet Union, but the point is that everyday life, as we have seen, was being effaced in art by the portrayal of a great heroic age of fantastic feats. Just as the 'living man' championed by RAPP had been criticised for dwelling too much on humdrum problems, the Soviet reality that was to be portrayed was, of course, reality 'in its revolutionary development'.

Back to basics: family values in society and art

The operations of socialist realism in safeguarding the single world-view of what was attempting to become a monoglot culture are by now well-known to us: the masculinisation of language, form, and content became standardised, and sought to pre-empt any challenge to the deeply patriarchal assumptions embedded in Soviet discourse. The Stalinist organisation of language around patriarchal assumptions discussed above also had its counterpart in the everyday lives of the citizens of the Soviet State, with the shift in dominant cultural metaphors at the end of the first Five-Year Plan. Most importantly, the family, which had been described by Russian feminist Inessa Armand as 'pretty much the last stronghold of the old system, the old slavery',[68] was re-established as the basic cell of Soviet society; moreover, this family's kinship axis was now hierarchised rather than egalitarian, and vertical, as opposed to the horizontal ('sibling') axis of the plan years. The importance to our study of appeals to this specific type of kinship is made clear by Clark: 'The vertical axis marked the lines of authority and descent and was *patrilineal*: the wife always moved into her husband's family on marriage, and the line of male descent running through her husband's family was considered more powerful and authoritative than her own.'[69] Any problems or anxieties this creeping return of patriarchal values may have caused the likes of Armand, however, were swept aside, as the Great Soviet Family was just as idealised, just as enclosed within the monoglot world-view, as the rest of 'Soviet reality'. We shall be coming across more than one extreme example of this idealised, harmonious family in the musical comedies of the next two chapters, but first we need to make a few basic points about its structure. Above all, as we have seen, the family cell – like so much else in Stalinist culture – represented a return to pre-revolutionary values: just as ranks and medals crept back into the Red Army, so the family became rigidly hierarchised, with clearly assigned roles for the men, women, parents and offspring inscribed into the very fabric of Soviet culture.

Although the re-establishment of the family solved more than one problem for the Stalinist regime – not least the issue of socialised childcare – it also posed another, equally pressing, problem in terms of kinship and loyalty. Allegiance to the State was paramount, but how could this be reconciled with the promotion of good old-fashioned family values? Clark devotes an entire chapter to the subject,[70] but, since family structures will occupy much of our discussion of Stalinist musicals in chapters 3 and 4, for now we shall confine ourselves to noting the ways in which the State was to act as a traditional extended family, with the vertical kinship axis as a legitimising metaphor for the newly-hierarchised society, as well as the apparent generational succession – from Marx to Lenin, and finally of course to Stalin himself – of spiritual father-figures for Soviet society.

Just as the individual was to be submerged in her or his social role, then, so the blood family was not to be in opposition to the State, but was in fact to act as its microcosmic auxiliary. The authority of the father in the blood family, however, was never to challenge that of the ultimate father Stalin – the 'father of the people'. If there is still any doubt as to Stalin's claims on the fatherhood of the entire nation, we need look no further than documentarist Dziga Vertov's somewhat disappointing 1937 feature *Lullaby* [*Kolybel'naia*], in which we are presented with a plethora of images of contented Soviet mothers and infants, at work and at play. Attwood points out that 'These are no ordinary mothers, however. Vertov wanted to convey with these images "not just a mother, but The Mother."'[71] The only immediately apparent structuring absence in this happy Soviet family – that of a father figure – is ultimately filled by the appearance of Stalin, as he gathers the children of the nation into his arms in the final sequence.

Under such circumstances, then, it is hardly surprising that the censors had difficulty in accepting Margarita Barskaia's *Father and Son* [*Otets i syn*, 1937] for distribution. The story tells of a child neglected by his father, who is too busy attending to his duties as a factory director to spend any 'quality time' with his son; the child subsequently joins a group of bandits, only to repent just in time to stop them committing a robbery at a new school. In spite of the fact that both protagonists recognised their 'mistakes', and are reconciled in a happy ending, the idea of a father neglecting his son was obviously a little too close to the bone for the authorities, who refused the film a release, criticising it, tellingly, as a 'Slander against Soviet reality'.[72]

In fact, the only apparent exception to this rule was, paradoxically, also the best publicised: the story of Pavlik Morozov – the child

hero murdered by his bloodthirsty relatives after denouncing his father to the authorities for harbouring kulaks – became something of a morality tale concerned with the primacy of loyalty to the state over blood ties; it was also only able to circumvent its implications of father-son tension by extreme figural excesses in the portrayal of Pavlik – resplendent in his red Pioneer neckerchief beneath a portrait of Lenin, as he made his denunciation to the local Party committee – and its almost hysterical repetition, which made Morozov's possibly the fastest transition from citizen to folk-hero status, even during the fantastic era of Stalinist socialist realism. Furthermore, alongside the ban on *Father and Son*, Eisenstein's ill-fated adaptation of this legend for the screen was also an indicator of the State's cautious approach to issues of intra-necine feuding. Possibly wary of the impact such a representation may have on the 'family values' rhetoric underwriting so much of Stalinist culture, the tale was kept on a purely mythical, rather than realistic, footing.

Patriarchal structures in society, then, were to combine with those in art to legitimise the phallocentrism – the organisation of the signifying economy around the privileged signifier of patriarchal domination – inherent in Stalinist discourse. Even the 'terror' was to be seen as in some way 'for the best' – in the same way as children are expected not to question the authority of their father's decisions. And with one of the major functions of the master plot of socialist realism as a model for social development, the progress of the positive hero was clearly to be seen as a rite of passage – a kind of 'coming of age' in the great family of the Stalinist State. We shall be saying more about the actions expected of the children of this State in the forthcoming chapters, but for now all we need to take with us is the notion that, in common with the big happy families of pre-revolutionary Russia, these children were brought up on a staple diet of hagiography and folk tales.

Valerii Chkalov: socialist realist flights of fancy

One useful example of such a blend of hagiography and folk-heroics is provided, as we have already suggested, by Mikhail Kalatozov's 1941 aviation blockbuster *Valerii Chkalov*, which portrays key moments in the life and political development of its eponymous hero. Chkalov was in fact a real-life aviation hero – perhaps most famous for flying his plane, *against orders*, beneath Leningrad's Troitskii Bridge – who became the darling of Moscow society for his daredevil feats, including record-breaking flights both to the far eastern outpost of Kamchatka, and over the North Pole to America.

As early as 1937, however, Chkalov had already been the subject of a brief fictionalised biographical tale in *Pravda*, in which the author, B. Galin, is quick to point out that the daring pilot also had an especial admirer in the Kremlin.[73] The story portrays Stalin, as we might expect, as a stern but loving father-figure, who responds to his pilot's impatience to fly over the North Pole with an indulgent smile and a hearty laugh. In this folk epic – as in much of socialist realism – it is the 'father of the people' who fulfils the role, as Vladimir Propp puts it, of 'donor', setting the hero on the path to a happy ending.[74] Permission is therefore granted to extend the 'Stalin Route', although only – and not insignificantly for this study – after Chkalov points out: 'We've abandoned our wives since February ... We live by ourselves, Comrade Stalin, and think of only one thing.'[75]

Such a pseudo-monastic withdrawal from worldly affairs in the story already hints at the hagiographic style of Kalatozov's film, which reflects the quasi-religious elements of socialist realism discussed above. Kalatozov in fact introduces us to Chkalov as he sits, evidently bored and awaiting orders to fly, in a room that bears an uncanny resemblance to a cell. Not only does this device point up the injustice of chaining a 'natural' flyer to the earth, but the image of Chkalov in a cell, awaiting his calling, is also reminiscent of some kind of Orthodox monk – although it is made clear that Chkalov's is a very secular calling.

Nonetheless, religious imagery pervades the film, perhaps most obviously when, grounded by his mentor Aleshin, Chkalov retreats to the Volga basin. It is made very clear that this period of his life amounts to his own Christ-like 'forty days and forty nights in the wilderness' – a point reinforced as he is called by a *fisherman* to 'lend a hand', just as he catches sight of an aeroplane gliding across the sky 'like a bird'. The fisherman comments on the joys of 'flying like a bird', and with no apparent thought – as though seized by a fervent and *unmediated* impulse – Chkalov dives straight into the river, and from this point onwards displays all the outward characteristics of the classic resolute Soviet positive hero: outwardly stern and proud, but with flashing bright eyes and a fixed smile.

Of course, the motif of flying in itself contains a certain religious dimension. Proximity to heaven in physical terms has traditionally connoted spirituality – witness church towers soaring into the skies, or even the symbolism of the eagle (as the bird presumed to fly higher than any other) which represents John as the most mystical of the evangelists, and has led to some churches appropriating the form for their sculpted lecterns. Elsewhere, Chinese graveyards are customarily built on hillsides – and the plots towards the top always

cost more than those below. Finally, although this concentration on, quite literally, 'higher things' was not strictly a male preserve – Richard Stites mentions the celebrity of a number of female fliers in the context of their mobilisation to recruit more women to the Air Force during the Great Patriotic War[76] – Chkalov agrees to marry his sweetheart, Olga, only once she has promised never to meddle in his love of, and participation in, flying.

Within the framework of the film, then, the traditional male/female binary is enlisted to bolster up the division of sacred and secular, and yet at the same time the division is never entirely final. Chkalov does participate in the raising of his family in a fairly token way, but becomes much more impassioned when called upon to argue for the absolute necessity of designing and constructing new planes – a necessity that would be on quite a few minds by 1941. Whilst it is entirely possible that this passion derived from his love of flying and adventure, however, the film is careful to point up the purely *useful* and *practical* nature of Chkalov's work alongside its more dazzlingly heroic aspects. Galin's *Pravda* article had done the same, although much more bluntly (and quite possibly with a greater degree of success), when it stated rather baldly: 'It was difficult work, full of risk and *value for the country*.'[77] If Chkalov's spiritual concerns and physical confines are reminiscent of Dostoevsky's Elder Zossima, then, it is clear that his path is to follow more that of Alesha Karamazov.

In common with the broader tenets of socialist realism, which as we have seen promote the idea that the socialist Utopia will be constructed in this life (as opposed to the Christian dogma which states that heaven will only be attained in the next) Chkalov's religious fervour – whilst taking him close to heaven – is nonetheless firmly rooted on earth. In this way, the film manages to fuse the genre's twin aspects of realism and revolutionary romanticism, which we have already encountered in Zhdanov's 'combination of the most austere, matter-of-fact work with the greatest heroic spirit and grandiose perspectives'. *Valerii Chkalov* goes further, however, to effect this notoriously difficult coupling at the level of *form* as well as that of content: the regular shot-reverse shot dialogue that accompanies the thrashing-out of practical issues is complemented by what Stites refers to as 'Kalatozov's mastery ... in the low-angle shots and heroic composition of frames.'[78]

Such mastery, of course, really comes into its own with the portrayal of Chkalov's death-defying aerobatics, and ultimately his historic flight over the North Pole, as befits a Soviet superhero. Stites also points out the centrality of men like Chkalov to the construction of the Stalinist heroic age:

Pilots and aviators played a special role in the mythology of the 1930s – and not only in the USSR. They embodied the leading edge of applied science and technology, the frontier spirit, bravery and adventure in distant and forbidding locales, and spirited youth tempered by fatherly mentors.[79]

We have already mentioned the theme of youths and 'fatherly mentors', and we shall return to it later on. For the moment, however, it is worth considering in more depth the theme of the 'frontier spirit', especially as I believe it impacts not only upon Stalinist myth-making, but also, and perhaps more importantly for our study, upon the construction of broader cultural paradigms of masculinity.

By the middle of the 1930s, at the time Chkalov was breaking aviation records, the Soviet wilderness was considered, in Stalinist discourse at least, to be effectively 'tamed'. During the Cultural Revolution, films, plays, novels and songs had all been filled with young Komsomol brigades going out into the wilds and imposing order on the chaos they found there. This frenetic constructivism even went so far as to build entire new towns, 'socialist islands', as von Geldern puts it, 'immersed in a sea of hostile influences – the open spaces'.[80] With the consolidation of socialist realist hegemony, however, the Soviet Union – like the New Soviet Man – was represented as a unified whole, the same all the way through, and von Geldern points out that, at this stage, 'heroism lay not so much in subjugating the hinterland as in discovering and exploiting its riches'.[81]

This is true, up to a point. However, as in American culture of the time, with the conquest of the land seen as complete, a new frontier was sought-out and established – this time in the skies. The logical conclusion of this shift was of course the 'space race' – as encapsulated by Captain Kirk's weekly encounters with 'space – the final frontier', on that flagship of American Cold-War cultural imperialism, *Star Trek*'s 'USS Enterprise'. Susan Faludi has commented on the hollow nature of America's victory in the space race – at least as far as modern masculinity is concerned – in terms of, first of all, the astronauts' status as male objects of a gaze that they could not disavow by engaging in 'masculine' activity (since they in fact had little to do on board Apollo 11, except chat and wave to camera); secondly, there was also the impossibility of sharing their experience with their fellow men, since so few of them would ever be able to follow:

They [at home] had no way of participating in such a drama except from their sofas. Some male spectators would begin to suspect that they, too, had landed on a lunar surface of sorts ... where the important things were not made but filmed, where control was exerted from afar.[82]

The point of this discussion of men in space lies in the fact that, just as the space race was the logical conclusion of the search for new frontiers, so Faludi sees it as epitomising, in a very extreme way, a conflict between two paradigms of modern masculinity that began on the original American frontier of the mid-West. We shall be examining the origins of this conflict later on in this study, but at this point it is perhaps more apposite to discuss Faludi's observations on American aviation heroes of the Second World War, and to see how they may be mapped onto our analysis of Soviet airmen.

Faludi introduces her readers to the figure of Ernie Pyle, a journalist from the last World War whose *Washington Daily News* diary column followed the 'little men' – the undifferentiated mass of mud-spattered infantrymen whose quiet acts of extreme bravery and collective sense of fraternity did more to secure victory than even they themselves would dare to admit. For a time, 'GI Joe' was even endorsed by the 'big men': 'By Eisenhower's voice and Pyle's typewriter, the foot soldier was elevated into a masculine emblem – a man who proved his virility not by individual feats of showy heroism but by being quietly *useful* in conducting a war and supporting the welfare of his unit.'[83]

The relevance of this prototype to the 'living man' championed throughout the Soviet Cultural Revolution by RAPP should be readily apparent: the 'brothers' who waged war on the wilderness, constructing new outposts *of and for* a better society were certainly the largely unsung heroes of the Plan years. Furthermore, it should come as no surprise to discover that the polar opposite to Pyle's foot soldiers – or 'grunts', as he referred to them – was based in the glamorous Air Corps, and led the flashy daredevil life of the 'flyboy'. Needless to say, as the 'few glamorous men who understood intuitively that in the coming media and entertainment age the team of men at work would be replaced by the individual man on display',[84] it was not long before the flyboys, with their specifically *ornamental* masculinity, would eclipse the utilitarian, but ultimately earthbound, infantrymen. As Faludi puts it: 'The man of the future was to be the flyboy, not the grunt. Ernie Pyle's model of manhood would not hold past the Eisenhower presidency [...] By 1980, the new president would be Ronald Reagan, a man who only went to war in the movies.'[85]

Once again, the implications for this study should be clear, but there are a couple of issues that need to be clarified if this model is to be transposed to our study of *Valerii Chkalov*, and both of them relate to the problems we mentioned earlier with reference to the Apollo 11 astronauts. First of all, there is the question of the ornamental male hero on display being an object of the gaze, which of

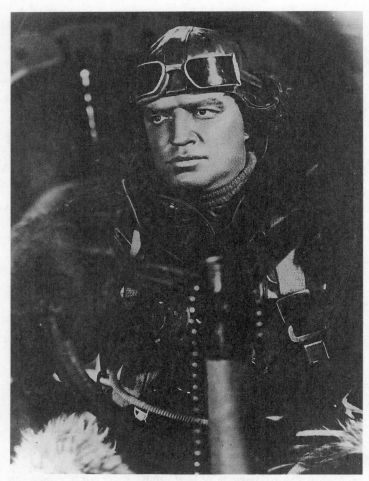

1 Sheer party-mindedness: Vladimir Belokurov as
the eponymous *Valerii Chkalov* [1941]. Not a flight from
the earthly, but a flight into the future

course threatens to place him in the uncomfortable 'female' position of what Laura Mulvey refers to as '*to-be-looked-at-ness*'.[86] In this respect, it is certainly worth noting Richard Stites' characterisation of *Valerii Chkalov* as 'enhanced by shots of leather-clad airmen',[87] but we should also enquire as to how this problem is circumvented by the film, if at all.

Help is at hand in the form of an essay by Richard Dyer – also first published in *Screen* – on the male pin-up model.[88] Dyer posits two general tactics to protect the male model from the gender confusion

threatened by his position in front of the lens, both of which are hap-
pily endorsed by our hero Chkalov. First of all, there is the tactic of
disavowing the threatening gaze either by staring straight back
through the viewer, or, more commonly, barely acknowledging the
viewer by directing his own gaze elsewhere – often upwards and out
of shot. Chkalov's role as a hero pilot licences him to do just that –
most particularly at the moments when he is most on display.
Interestingly, for Dyer, 'this *always suggests a spirituality*: he might be
there for his face and body to be gazed at, but *his mind is on higher
things*'.[89]

At this point, it appears that Chkalov is one step ahead of the
game, and he is certainly a text-book example of Dyer's second tactic
of disavowal – that of negating any status with which he may be
invested as passive object through engaging in an almost frenzied
excess of 'masculine' activity. Just as Dyer points out that 'images of
men are often images of men doing something [...] time and again
the image of the man is one caught in the middle of an action, or
associated, through images in the pictures, with activity',[90] Chkalov
rarely seems to rest. Even as he sits in his 'cell' at the beginning of
the movie, we are painfully aware of his restlessness – he is poised to
strike as soon as he receives his mission, and it is quite possible that
his evident discomfort derives in large part precisely from his appar-
ent inactivity. Like a stone in an overstretched catapult, Chkalov is
held by an almost unbearable tension in a state of passivity that lasts
only until the order to fire: once released, however, he does not, will
not – indeed, seemingly, *cannot* – stop until the end of the film. The
fact that a positive hero like Chkalov conforms so rigidly to the dic-
tates of the bourgeois, western 'myth of masculinity' raises the
question of just how 'new' the New Soviet Man really was. This is a
point that will recur later on in this study.

Meanwhile, we may recall that the second issue raised by the
Apollo 11 astronauts involved their inability to communicate their
experience, to pass it on or share it with others. In the same way, the
dazzling feats performed by such Soviet heroes as the Arctic fliers
would appear – like the victory of the Battle of Britain – to be the sole
preserve of the privileged 'few'. Of what relevance to the day-to-day
life of the average Soviet citizen are the exploits of the nation's
superheroes? Doesn't a film such as *Valerii Chkalov* lay itself open to
the charge so often levelled at Soviet cinema, that it was not por-
traying issues that were of genuine concern to the masses? There is
clearly a grain of truth in this, but, if we think back to Zhdanov's
notorious combination of 'what is' with 'what *should be*', and bear
in mind the explicitly *political* function of socialist realist cinema, we
can begin to see how, in theory, the films produced in Stalin's Soviet

Union were in fact intended to grapple with precisely the issues that the leadership believed *should be* of concern to the moviegoing public. As I have already indicated in the last chapter, the articulation on screen of such a programmatic vision of *and for* the nation, far from rendering these films uninteresting, actually makes them all the more worth watching (from, at the very least, a historical point of view) precisely for what they have to tell us about the state's plan for both the country as a whole and, in our context, about the state's plan for the shaping of the New Soviet Man.

There remains, however, the problem of just how to convince the masses that such issues *should be* of concern to them; that is, how to represent the experiences of Stalin's 'model sons' in such a way as to engage not only the attention, but also the emotions of cinema audiences who, given the very real problems facing the country, must have felt far removed from such experiences. At this point, classic Hollywood film *theory* must take second place to analysis of socialist realist cinema as a *practice*, which, alongside its encompassing context of mobilised rhetoric,[91] also had its own specific textual mechanisms to combat this seemingly elitist dilemma. Von Geldern points out: 'The introduction of hierarchical centralism might have weakened the social position of the average citizen. But closer inspection of the mass media suggests that the new values offered something to all levels of the population'. He then goes on to produce a convincing argument of the *inclusive* nature of Stalinist culture of the 1930s, in which '[e]levating Moscow elevated the entire Soviet Union'.[92] Not only was the entire population invited to bask in the reflected glory of 'our' Chkalov, however: the apparent dichotomy between portrayals of an 'equal' society, and those of one-off dazzling feats of almost lunatic daring was constantly elided in the socialist realist text, which insists unceasingly that *anybody* could become a hero. We shall be returning to this point towards the end of this study, but for now we may draw one or two preliminary conclusions from it, with which to end this chapter.

First of all, in *Valerii Chkalov* – as in almost any other socialist realist text – we may recognise a heavy emphasis on the humble origins of the positive hero. We should note that Pavel Vlasov and his eponymous *Mother* in Pudovkin's 1926 classic [*Mat'*] – arguably as much a prototype for the socialist realist genre as the Gorky novel from which it is adapted – are clearly products of a deprived background (proletarian upbringing, exploitation in the capitalist sweatshop factories, drunken and abusive father and so forth). In the same way, the positive hero was to be an illustration of Lenin's dictum that 'every cook could learn to govern', or, in the slogan culled from the 'Internationale': 'We have been naught, we shall be all.'[93] In this

respect, the specific privileging of the orphan in socialist realism fulfils rather a neat double function: not only does it act, as we have seen, to promote the notion of the Great Soviet Family as more stable and permanent than blood ties; the orphan also epitomises a particular type of downtrodden figure – and one for whom it is fairly easy to win sympathy – who is able, through courage, conviction, and sheer party-mindedness, to rise through the social hierarchy and, ultimately, to reach that pinnacle of achievement, the cathartic meeting with the Great Father, Stalin himself.

The aviation heroes, in fact, seemed to be forever attending meetings and receptions in the Kremlin – the very heart of the new centralised social hierarchy. In spite of the fact that, as Clark points out, 'they did not play a political role of national significance', they were nonetheless privileged as the 'fledgling children of Stalin' who duly took it upon himself to impose a greater degree of 'consciousness' upon their wilful natures:

It was Stalin who most often performed the ritual role of 'father' or 'teacher' and taught the fliers greater self-control ... He proved himself worthy of those titles by exuding 'fatherly warmth' whenever he met pilots. It was even suggested that Stalin's 'warmth' was so powerful that it could protect his fliers from the Arctic cold ... Whenever a prominent airman fell ill, Stalin would intervene to supervise his medical treatment. If he was killed in some disaster, Stalin would act as pallbearer at his funeral.[94]

The point is that, although the aviation heroes may appear to be a special case, Stalin's 'fatherhood' was offered to all. City orphan or rural farmhand, the 'path to life' was generally a path to the Kremlin – a rags to riches grand fairy tale narrative that is epitomised in particular by the musical comedy genre film, to which we shall shortly turn our attention.

Before we do so, however, we might make a note of the degree of excess in such a quasi-hysterical portrayal of the harmonious relationship between Stalin and his 'model sons' in both the rhetoric and the cultural productions of the era which, to an extent, as I have argued in this chapter, were merged into the same 'objective processes'. Such hysteria, as is so often the case, is accompanied by a ruthless degree of repression effected by an all-pervasive censorship. In his discussion of that censorship, Kenez cites three films that fell foul of the authorities: one of them, Aleksandr Stolper's *Law of Life* [*Zakon zhizni*, 1940], actually made a brief appearance in cinemas, but was slated in *Pravda* the following week for its less than wholesome portrayal of a Komsomol leader (whom one might expect to behave as a 'model son'); the film was withdrawn the next day.[95]

Whilst there is no doubt that such a swift act of censorship may be taken as an index of the paranoia of the Soviet cinematic institution, it is perhaps more instructive to examine the motivation behind the foreclosure of certain representations on the Soviet screen. We shall discuss the specific taboos of the musical comedy in the next two chapters, but for the moment we might do well to recall that in Kenez's two other examples, Eisenstein's *Bezhin Meadow* and Barskaia's *Father and Son*, the offensive subject matter was, as we have already mentioned, precisely a tension between father and son. Unlike Stolper's *Law of Life*, neither of these films – one abandoned unfinished, the other shelved upon completion – even made it as far as the screen. We should therefore question why such appropriations of a myth dating back at least as far as Sophocles, and which we might expect to find in any rites of passage drama, made Stalin and his authorities so uncomfortable as to repress them utterly.

Barskaia's film, as we have mentioned, was declared a 'slander against Soviet reality', and in light of our examination of what constitutes this specific form of 'reality', it would perhaps be appropriate to examine such questions in the specific context of the films that not only allow this 'Soviet reality' almost wholly to displace everyday reality, but which also numbered among the personal favourites of the Great Father himself.

Notes

1 Katerina Clark, *The Soviet Novel: History as Ritual*, 3rd edn (Bloomington and Indianapolis: Indiana University Press, 2000), p. xiii.

2 This problem – and the necessity of distinguishing between the 'women's movement' (the efforts of women to be recognised in the public sphere) and the 'woman question' as a male discourse involving male agency, is rather neatly summed up by Linda Edmondson's perceptive comment on post-revolutionary histories of women's passage toward an illusory 'liberation': 'the historians who studied the pre-revolutionary woman question were working to an agenda drawn up by the victors of the October revolution who claimed to have "solved" it'. Linda Edmondson, 'Women's Emancipation and Theories of Sexual Difference in Russia, 1850–1917', in Marianne Liljestrom, Eila Mantysaari and Arja Rosenholm (eds), *Gender Restructuring in Russian Studies: Conference Papers – Helsinki, August 1992* (Tampere: University of Tampere, 1993), pp. 39–52 (p. 39).

3 In doing so, I must apologise to Leonid Trauberg, who told the 1935 conference: 'It seems to me, comrades, that a division into periods is always rather tentative.' See Richard Taylor and Ian Christie (eds), *The Film Factory: Russian and Soviet Cinema in Documents, 1896–1939* (London: Routledge, 1994), p. 349.

4 Lynne Attwood (ed.), *Red Women on the Silver Screen: Soviet Women and Cinema from the Beginning to the End of the Communist Era* (London: Pandora Press, 1993), p. 9.

5 Richard Taylor, 'Ideology and Popular Culture in Soviet Cinema: *The Kiss of Mary Pickford*', in Anna Lawton (ed.), *The Red Screen: Politics, Society, Art in Soviet Cinema* (London: Routledge, 1992), pp. 42–65 (p. 58).

6 Taylor and Christie (eds), *Film Factory*, p. 215.

7 The Russian Formalists – of whom the best-known remain Viktor Shklovskii, Boris Eikhenbaum and Roman Jakobson – argued that the 'literariness' of a text as an object of scientific study resided in, amongst other things, its inherent usage of devices of estrangement and complication of form. Their dictum that 'form precedes content' paved the way for such notions (now commonplaces of literary theory) as intertextuality and the 'death of the author'. As we shall see, by the time Shklovskii published a recantation of his theory in 1930, 'formalism' was a blanket term of abuse for any non-conforming cultural product. See Ann Jefferson, 'Russian Formalism', in Ann Jefferson and David Robey (eds), *Modern Literary Theory: A Comparative Introduction*, 2nd edn (London: Batsford, 1986), pp. 24–45.

8 Richard Stites, *Russian Popular Culture: Entertainment and Society since 1900* (Cambridge: Cambridge University Press, 1992), p. 56.

9 For an interesting discussion of this question, see Ian Christie, 'Canons and Careers: The Director in Soviet Cinema', in Richard Taylor and Derek Spring (eds), *Stalinism and Soviet Cinema* (London: Routledge, 1993), pp. 142–70.

10 Taylor, 'Ideology and Popular Culture', p. 51.

11 Taylor and Christie (eds), *Film Factory*, p. 197.

12 Peter Kenez, *Cinema and Soviet Society from the Revolution to the Death of Stalin*, 2nd edn (London and New York: I. B. Tauris, 2001), p. 94.

13 Trauberg was a member of the Factory of the Eccentric Actor (FEKS) – a Petrograd-based film-making group which drew on the traditions of circus and music-hall, and had made its rejection of high art fairly explicit in its 1922 manifesto, which stated bluntly: '*We prefer Charlie's arse to Eleonora Duse's hands! [...] We prefer a Pinkerton cover to the concoctions of Picasso!!!*' Quoted in Taylor and Christie (eds), *Film Factory*, pp. 59, 63 (their italics).

14 Pavel Petrov-Bytov, 'We Have No Soviet Cinema', translated in Taylor and Christie (eds), *Film Factory*, p. 259 (Petrov-Bytov's italics).

15 Vladimir Mayakovsky, 'Help!', translated in Taylor and Christie (eds), *Film Factory*, pp. 160–1.

16 *Ibid.*

17 Taylor, 'Ideology and Popular Culture', p. 60.

18 Sergei Eisenstein, Vsevolod Pudovkin, Grigorii Aleksandrov, 'Statement on Sound', translated in Taylor and Christie (eds), *Film Factory*, pp. 234–5 (their italics).

19 Vladimir Messman, 'Sound Film', translated in Taylor and Christie (eds), *Film Factory*, pp. 235–7 (p. 236).

20 Vsevolod Pudovkin, 'On the Principle of Sound in Film', translated in Taylor and Christie (eds), *Film Factory*, pp. 264–7 (his italics).

21 The statement, dated 16 March 1928, is also translated in Taylor and Christie (eds), *Film Factory*, pp. 205–6 (p. 206).

22 See T. Rokotov's *Zhizn' iskusstva* article 'Why is *October* Difficult?', translated in Taylor and Christie (eds), *Film Factory*, pp. 219–20 (p. 219).

23 Sergei Eisenstein, Vsevolod Pudovkin, Grigorii Aleksandrov, 'Statement', pp. 234–5 (their italics).

24 Christie, 'Canons and Careers', p. 151.

25 Kenez, *Cinema and Soviet Society*, p. 100.

26 Tony Crowley, 'Bakhtin and the History of the Language', in Ken Hirschkop and David Shepherd (eds), *Bakhtin and Cultural Theory* (Manchester: Manchester University Press, 1989), pp. 68–90.

27 See Kenez's point that 'For socialist realist art to carry out its assigned social function, it had to enjoy complete monopoly [...] the consumer of art must get the impression that there is no other way to look at the world than the one that is presented to him'. Kenez, *Cinema and Soviet Society*, p. 145.

28 Kenez, *Cinema and Soviet Society*, p. 97.

29 Crowley, 'Bakhtin and the History of the Language', p. 80.

30 Crowley, 'Bakhtin and the History of the Language', p. 81.

31 The issue of access to the symbolic order – in the more strictly Lacanian sense – will be discussed at greater length towards the end of this study.

32 Crowley, 'Bakhtin and the History of the Language', p. 82.

33 'Rech' sekretaria TsK VKP(b) A. A. Zhdanova', in *Pervyi vsesoiuznyi s"ezd sovetskikh pisatelei 1934: stenograficheskii otchet* (Moscow: Sovetskii pisatel', 1990), pp. 2–5 (p. 4).

34 Clark, *Soviet Novel*, pp. 36–45.

35 Clark, *Soviet Novel*, p. 39.

36 Zhdanov, 'Rech' sekretaria', p. 4.

37 Clark, *Soviet Novel*, pp. 15–24 (p. 20).

38 In one of the extracts from his *A Cinema for the Millions* translated in Taylor and Christie (eds), *Film Factory*, pp. 358–69 (p. 361).

39 Rufus W. Mathewson, Jr., *The Positive Hero in Russian Literature* (Stanford: Stanford University Press, 1975), p. 212. Needless to say, this 'hero' was more than likely to be male. Although there were a number of attempts to portray 'living heroines' at the time, as we shall see, women generally continued to be used as ciphers, acting out the symbolic roles allotted them by History.

40 Clark, *Soviet Novel*, p. 117.

41 Clark, *Soviet Novel*, p. 119.

42 See Clark, *Soviet Novel*, especially pp. 17–19.

43 Mathewson, *Positive Hero*, p. 215.

44 This fixed, binary usage of the terms 'masculinity' and 'femininity' is reflected, not unselfconsciously, in this book.

45 Zhdanov, 'Rech' sekretaria', p. 4 (my italics).

46 Mathewson, *Positive Hero*, p. 217.

47 Abram Terts, 'Chto takoe sotsialisticheskii realizm?', in *Fantasticheskii mir Abrama Tertsa* (New York: Inter-Language Literary Associates, 1967), pp. 401–46 (pp. 428–31).

48 Clark, *Soviet Novel*, p. 47.

49 See Clark, *Soviet Novel*, pp. 58–63.

50 Clark, *Soviet Novel*, p. 63.

51 Mathewson, *Positive Hero*, p. 217.

52 Christie, 'Canons and Careers', p. 160.

53 Slavoj Zizek, 'When the Party Commits Suicide', *New Left Review*, 238 (November/December 1999), 26–47 (p. 31).

54 Speeches to the All-Union Creative Conference of Workers in Soviet Cinema, translated in Taylor and Christie (eds), *Film Factory*, pp. 348–55 (pp. 352, 353).

55 Mathewson, *Positive Hero*, p. 216.

56 See Terts, 'Chto takoe', p. 415: his example of an 'optimistic tragedy' is actually from a play by Vishnevskii, although the martyr is once again a woman.

57 Terts, 'Chto takoe', p. 421.

58 Sheila Fitzpatrick, *Stalin's Peasants: Resistance and Survival in the Russian Village After Collectivization* (New York and Oxford: Oxford University Press, 1994), p. 262. The Utopian role of Stalinist musical comedies as portraying an earthly paradise will constitute a major theme of the next two chapters. I am also indebted on this point to Richard Taylor's chapter 'But Eastward, Look, The Land Is Brighter: Towards a Topography of Utopia in the Stalinist Musical', in Diana Holmes and Alison Smith (eds), *100 Years of European Cinema: Entertainment or Ideology?* (Manchester: Manchester University press, 2000), pp. 11–26.

59 Terts, 'Chto takoe', p. 422.

60 Terts, 'Chto takoe', pp. 438, 446.

61 Crowley, 'Bakhtin and the History of the Language', p. 80.

62 Kenez, *Cinema and Soviet Society*, p. 127; Kenez's chapter on Censorship is recommended reading for anyone interested in the complexities of this system.

63 Marie Seton, *Sergei M. Eisenstein: A Biography*, rev. edn (London: Dennis Dobson, 1978), p. 379.

64 G. Mar'iamov, *Kremlevskii tsenzor: Stalin smotrit kino* (Moscow: 'Kinotsentr', 1992).

65 The number of films produced in the Soviet Union declined fairly rapidly from 1933, through the post-war years of 'film hunger' (only nine films produced in 1951!) until the death of Stalin. See in particular Maya Turovskaya, 'The 1930s and 1940s: Cinema in Context', in Taylor and Spring (eds), *Stalinism and Soviet Cinema*, pp. 34–53 (p. 44).

66 See Kenez, *Cinema and Soviet Society*, p. 130.

67 Having said this, of course, Aleksandrov – and particularly Pyr'ev – are strong candidates for an *auteur* approach which unfortunately falls beyond the scope of this study.

68 Quoted in William M. Mandel, *Soviet Women* (New York: Anchor Books, 1975), p. 61.

69 Clark, *Soviet Novel*, p. 116 (her italics).

70 'The Stalinist Myth of the "Great Family"', in Clark, *Soviet Novel*, pp. 114–35; see also Hans Günther, 'Wise father Stalin and his family in Soviet cinema', in Thomas Lahusen and Evgeny Dobrenko (eds), *Socialist Realism Without Shores* (Durham and London: Duke University Press, 1997), pp. 178–90.

71 Quoted in Attwood (ed.), *Red Women*, p. 57. Citation referenced back to N. P. Abramov, *Dziga Vertov* (Moscow: Academy of Sciences, 1962), p. 146.

72 Kenez, *Cinema and Soviet Society*, p. 139. Citation referenced back to L. Zamkovoi, 'Kleveta na sovetskuiu deistvitel'nost'', *Iskusstvo kino* 7 (1937), 30–1.

73 B. Galin, 'Valerii Chkalov', *Pravda*, 21 June 1937, p. 3; translated in James von Geldern and Richard Stites (eds), *Mass Culture in Soviet Russia: Tales, Poems, Songs, Movies, Plays and Folklore, 1917–1953* (Bloomington and Indianapolis: Indiana University Press, 1995), pp. 260–6.

74 Vladimir Propp, *Morphology of the Folktale*, 2nd edn, trans. Lawrence Scott, rev. by Louis A. Wagner (Austin and London: University of Texas Press, 1968), p. 39.

75 Galin, 'Valerii Chkalov', p. 260.

76 Richard Stites, *Russian Popular Culture*, p. 70; heroine pilots are the subject of Karen Petrone's 'Gender and Heroes: The Exploits of Soviet Pilots and Arctic Explorers in the 1930s', in Sue Bridger (ed.), *Women and Political Change: Perspectives from East-Central Europe. Selected Papers from the Fifth World Congress of Central and East European Studies, Warsaw, 1995* (Basingstoke: Macmillan, 1999), pp. 7–26; interestingly for our discussion of Chkalov's masculinity, Lynne Attwood also discusses the exploits of Valentina Grizobudova *et al.* in the broader context of gender confusion in the Stalin era: Attwood, *Creating the New Soviet Woman: Women's Magazines as Engineers of Female Identity, 1922–53* (Basingstoke: Macmillan Press, 1999), pp. 126–35.

77 Galin, 'Valerii Chkalov', p. 262 (my italics).

78 Stites, *Russian Popular Culture*, p. 88.

79 Stites, *Russian Popular Culture*, p. 69.

80 James von Geldern, 'The Centre and the Periphery: Cultural and Social Geography in the Mass Culture of the 1930s', in Stephen White (ed.), *New Directions in Soviet History* (Cambridge: Cambridge University Press, 1992), pp. 62–80 (p. 65).

81 Von Geldern, 'The Centre and the Periphery', p. 66.

82 Susan Faludi, *Stiffed: The Betrayal of the Modern Man* (London: Chatto and Windus, 1999), pp. 452–68 (p. 468).

83 Faludi, *Stiffed*, p. 17.

84 Faludi, *Stiffed*, p. 33.

85 Faludi, *Stiffed*, p. 39.

86 Laura Mulvey, 'Visual Pleasure and Narrative Cinema', *Screen*, 16:3 (1975), 6–18 (p. 11); reprinted in John Caughie, Annette Kuhn, and

Mandy Merck (eds), *The Sexual Subject: A Screen Reader in Sexuality* (London: Routledge, 1992), pp. 22–34 (p. 27).

87 Stites, *Russian Popular Culture*, p. 87.

88 Richard Dyer, 'Don't Look Now: The Male Pin-Up', in Caughie, Kuhn and Merck, *The Sexual Subject*, pp. 265–76.

89 Dyer, 'Don't Look Now', p. 267 (my italics).

90 Dyer, 'Don't Look Now', p. 270.

91 Cf. the *Pravda* editorial, 'The Whole Country Will Watch *Chapaev*', discussed in chapter 5.

92 Von Geldern, 'The Centre and the Periphery', pp. 67–8.

93 For a discussion of power-reversals in Stalinist cinema and culture, including this example, see in particular Maria Enzensberger, '"We Were Born to Turn a Fairy Tale into Reality": Grigori Alexandrov's *The Radiant Path*', in Taylor and Spring (eds), *Stalinism and Soviet Cinema* , pp. 97–108 (p. 103).

94 Clark, *Soviet Novel*, pp. 126–7. In one scene – subsequently 'de-stalinised' – of *Valerii Chkalov*, Stalin greets our hero warmly after a flying display that had nearly ended in disaster. Stalin gently reprimands Chkalov for not bailing out of the plane as it span out of control: 'People are more important to us than planes', he reminds him.

95 Kenez, *Cinema and Soviet Society*, pp. 134–40 (p. 139).

3 Urban myths: the musical comedies of Grigorii Aleksandrov

The victorious class wants to laugh with joy. That is its right, and Soviet cinema must provide the audience with this joyful Soviet laughter.

(Boris Shumiatskii).[1]

In spite of the original notoriety of socialist realist musical comedies of the Stalin era, and the resulting antipathy towards them on the part of western scholars who saw no apparent value in such apparently frivolous and 'unrealistic' works of art, a lot of very fruitful attention has been paid in the past few years to the musicals of both Grigorii Aleksandrov and Ivan Pyr'ev. Most of this has taken as its starting point the idea that such films were never intended to portray 'reality' at all, but do in fact function rather well as modern fairy tales – an approach that is able to circumvent puritanical anxieties about the so-called 'varnishing' of reality achieved by these films (a problem that, I imagine, would never arise had the films not been made under what is seen as a dogmatic totalitarian order), while at the same time accounting for their abiding popularity.[2]

I shall begin this chapter by taking a look at the similarities between many of the aspects of socialist realism detailed in the last chapter, and the folk tale genre as a whole. I hope to demonstrate that the two genres had a great deal in common, not only in terms of their shared themes, but also in their practical applications for Soviet society of the 1930s: this may account for the privileging of the fairy tale form most clearly represented in cinema by the musical genre. In the rest of the chapter I shall offer analyses of Aleksandrov's city-based musical comedies not only as fairy tales, but also as buttresses for the political and discursive centralisation discussed in the previous chapter, and by comparison with the conventions of inter-war Hollywood musicals, which have attracted

critical attention not only for their utopian topography, but also their sexual politics.[3]

In the last chapter we discussed the privileging of the epic over the novelistic in socialist realism, as well as the idealised self-image of the nation as a realm of superheroes performing legendary and fantastical feats. Both of these elements were very well suited to a wholesale revival of Russia's ancient folk tradition, and this tradition was brought up to date to provide structuring myths for the whole of Soviet society in the 1930s and 1940s. In fact, as Richard Stites has remarked:

It is hardly an exaggeration to say that after 1936 virtually all of Soviet mass culture became 'folklorised' under the impact of literary models ... Its themes of optimism, affirmation of life, healthy work and construction, collective ambition and success, hot-blooded heroism yoked to cool-headed wisdom made their way into song lyrics, circus acts, and movies.[4]

Furthermore, the folk genre was able to flourish within the broad framework of socialist realism for a number of other reasons besides thematic ones – most notably the fact that, as Vladimir Propp points out, '*all fairy tales are of one type in regard to their structure*'.[5] The formulaic nature of the tales – the fact that 'components of one tale can, without any alteration whatsoever, be transferred to another',[6] coupled with the physical, rather than psychological nature of the action[7] – meant that other, less rigidly structured genres were quite simply unable to compete under the narrowly prescriptive single method, more often than not defined *exclusively* by what was *not* acceptable rather than what *could* be published.

The folk formula, then, was quite clearly a winning one. On a purely practical level it was able to outstrip any competition in terms of satisfying the demand for increased film production: the straightforward linear narratives, with the lack of psychological complexity inherent to polarised portrayals of 'good' or 'bad' types, were recycled time and again without any danger of political disfavour; the repeated use of these narratives not only provided a way of circumventing the 'script crisis', then, but was also able to hit the rather narrow ideological target every time. This target, in essence, was not only the requirement to portray an enclosed 'epic' world, but also to convey to the Soviet public the sheer boundlessness of opportunity available to all, in a country whose new constitution took as its starting point the achievement of the first stages of socialism.

One of the founding principles of socialist realism, as we have seen, is its looking forward to an ideal world *in this lifetime*, and, as Jack Zipes has pointed out, 'fairy tales have always spread word through their fantastic images about the feasibility of utopian

alternatives'.[8] This evangelising function was not lost on those who recognised that, in order to keep step with the times, such a 'feasibility' was in fact to be read as a historical necessity. But it is also possible to account for the privileging of the folk genre through its transparent 'intelligibility', and of course its abiding popularity. Most interestingly for our study, Zipes sees the continuing popularity of fairy tales as stemming precisely from social upheavals:

A group of people may still think in terms of a previous time or behave according to thought patterns and traditions of a past society while living in the present. This is often the case when the social development does not fully work out the contradictions of the past society while moving forward and leaves groups and classes of people dissatisfied, uprooted, confused etc.[9]

After a revolution, years of civil war, retreats to and from NEP, and an intense programme of rapid industrialisation – all of which did little to resolve the deeply entrenched divisions in Russian/Soviet society – the mobilisation of neo-folklorism was clearly intended to rally support for the construction of socialism, by speaking to the Soviet public in a language that they could understand, about the realisation of their shared utopian dreams in the here and now. We have already touched upon Katerina Clark's argument that the structuring 'master plot' of socialist realism functions at least in part to justify the Leninist line on historical progression, and therefore to some extent to excuse 'the state's resistance to its scheduled "withering away"'.[10] If this is the case, then a major function of the fairy tale films produced by Aleksandrov and Pyr'ev was clearly to portray for the people the abundant plenitude of the world to come, the Utopia they were constructing – a world which was often represented as only a song away.

Just such a song was written in 1936, with lyrics by one of the most successful songwriters of the Stalin era, Vasilii Lebedev-Kumach. Taking its title from Stalin's ubiquitous dictum, *Life's Getting Better* [*Zhit' stalo luchshe*] offered up a rousingly life-affirming message of optimism at the very dawn of the 'terror', and at the same time provided a template for many of the song lyrics Lebedev-Kumach was to pen for Aleksandrov's musical comedies. Beginning with joyful musings on the people of the Soviet Union, united in smiles and song, the final verses pledge allegiance to military chief Marshall Voroshilov in defending the Soviet borders, before thanking Stalin for this happy state of affairs, and wishing him a long and healthy life.[11]

At this point it may be worth noting the explicit references to the borders of the Soviet Union in songs, films and literature of the Stalin era, as a theme that will recur throughout this study. With the

rise of Nazism in Germany, the external enemies so often warned of in Bolshevik rhetoric finally appeared, and in the clash of ideologies, the threat to the borders was figured as a threat to both the Soviet family and its way of life. Not only were the border guards suddenly exalted to the ranks of Soviet heroes, but strong kinship attachments were appealed to even here: Katerina Clark has found two examples in just one issue of the journal *Bolshevik* (March 1936) of a border guard being killed, and subsequently replaced by his *biological* brother.[12] Soviet culture of the time, then, managed to avoid the potential tension between a rigidly enclosed world-view and its claims of boundless opportunity, simply by representing this boundlessness as a mythologised, 'natural' facet of life *within* the Soviet family, which would nonetheless come under serious threat should the borders not hold firm.

One way to ensure the social cohesion necessary to counteract this threat was, of course, education (in its broadest possible definition) and the inculcation of morally virtuous behaviour in the Soviet public; and here once again the fairy tale genre was able to play its part. In his later study of the development of the fairy tale film, Zipes has shown how, since the late eighteenth century, such tales have played a leading role in the socialisation of children;[13] furthermore, Bruno Bettelheim has elaborated the specifically moral uses of the genre, that a demonstration of the advantages of virtuous behaviour is always, for Bettelheim at least, more effective than a simple laying-down of rules.[14] Perhaps most importantly from a psychoanalytic point of view, Bettelheim also remarks how the stories 'give conscious credence and body to id pressures and show ways to satisfy these that are in line with ego and superego requirements.'[15]

We may overlay Bettelheim's comments, to a degree, with Clark's view of the socialist realist text as a 'politicized variant of the *Bildungsroman*, in which the hero achieves greater harmony both within himself and in relation to his society';[16] similarly Zipes, in his discussion of Disney's *Pinocchio* as a paradigmatic fairy tale film, recognises the opportunity it presents for a simple peasant boy to assume a responsible role in society.[17] However, the idea of the fairy tale as a parable of social development is a knife that cuts either way. Zipes, writing from a Marxist perspective, also laments the case of Pinocchio, as 'a tale in which a puppet without strings has strings of social constraint attached so that he will not go his own way but will respond to the pull of superior forces'.[18]

If the fairy tale still performs a 'useful' function in societies experiencing the throes of modernisation, then, the question must be raised as to whose purpose is served best. The institutionalisation of

what began as a collective cultural form involving face-to-face clarification of phenomena, and the establishment of meaningful social relations, has led to a condition in which, as Zipes claims elsewhere,

the narrative perspective of a mass-mediated fairy tale has endeavoured to endow reality with a total meaning, except that the totality has assumed totalitarian shapes and hues because the narrative voice is no longer responsive to an active audience but manipulates it according to the vested interests of the state ... the inevitable outcome of most mass-mediated fairy tales is a happy reaffirmation of the system which produces them.[19]

Furthermore, it should come as no surprise to us that, with the disembodiment of the storyteller, and the downgrading of the dialogical function of the fairy tale, the now-unidentifiable narrative voice has 'assumed a paternal role'.[20] As in the case of the triumph of monoglossia in discourse, the final word belongs to the father – and as we already know, in the Soviet Union of the 1930s, the symbolic father of the entire nation was Stalin himself.[21] However, just as the triumph of monoglossia can never be complete, the liberating aspects of the folk genre – which often raises explicit questions of gender, power and subjectivity – still enable more than one single, 'preferred' reading. This point can be best illustrated by turning to the musical comedies of Aleksandrov.

All that jazz: the trouble with Utesov

In the new Stalinist atmosphere of superstars and record-breakers, not to mention the trappings of material inducements and rewards for success, the undisputed stars of the Soviet screen were the husband and wife team of Grigorii Aleksandrov and Liubov' Orlova. Loved by the Soviet public, and despised in roughly equal measure by western critics,[22] the pair reigned supreme throughout the Stalin era, most famously for their musical comedies *The Happy Guys* [a.k.a. *Jazz Comedy*, *Veselye rebiata*, 1934], *Circus* [*Tsirk*, 1936], *Volga-Volga* [1938], and *The Radiant Path* [*Svetlyi put'*, 1941]. The films, along with their stars, scriptwriters, and crew, were decorated repeatedly, and Orlova firmly established her reputation as the 'prima donna' of Soviet cinema.

Aleksandrov himself, however, was far from a new face on the scene. By the time he made *The Happy Guys*, he had already served a lengthy apprenticeship as Eisenstein's assistant, and had thus made a major contribution to the world-wide fame of Soviet film art underwritten by such films as *The Strike* [*Stachka*, 1924], *The Battleship Potemkin* [*Bronenosets 'Potemkin'*, 1926], *October* [*Oktiabr'*, 1928], and *The Old and the New* [*Staroe i novoe*, 1929]. He had also

accompanied Eisenstein on his ill-fated trip to the USA, but whilst the internationally acclaimed director had run into seemingly endless trouble with both his hosts abroad, and his bosses back home, it appears that his assistant had been studying American film production techniques rather seriously. All of which was to stand Aleksandrov in good stead on his return to the USSR, to a climate that was by this time wholeheartedly encouraging the production of movies as mass entertainment. Not only were films now to be 'intelligible to the millions', *and* provide a major source of revenue for the government, but the head of Soiuzkino Boris Shumiatskii himself was developing plans to establish a 'Soviet Hollywood', based on the American model, in the Los Angeles-like climes of Crimea.[23]

The new requirements for Soviet films, as we have seen, fitted the mould of neo-folklorism very well, and Aleksandrov set about making his directorial debut proper as a bona fide rags-to-riches story of a musically-gifted shepherd finding fame and fortune at the Bolshoi Theatre. *The Happy Guys*, however, represents something of an aberration in the canon of Soviet musical comedies for a number of reasons: it seems likely that, as both Aleksandrov's first solo feature, and the founding movie of the socialist realist comedy genre, it encountered problems with both form and content, which were to be ironed out in later productions, but are of immediate interest for our study.

First of all, although the film depicts the route to success of a simple-hearted shepherd from a collective farm background, it is by no means the conventional route one might expect of a fairy tale, particularly in the light of our discussion of the moralising nature of such tales. In fact, the story fits rather more neatly into a subcategory of the fairy tale – that of the *amoral* type: 'Such tales', according to Bettelheim, 'build character not by promoting choices between good and bad, but by giving the child the hope that even the meekest can succeed in life [...] Morality is not the issue in these tales, but rather, assurance that one can succeed'.[24] Rather than the moulding of the subject into a neatly ordered social system, then, fairy tales of this type entail a certain degree of anarchy. This is well reflected in the plot structure of *The Happy Guys*, which, as 'a loose chain of *estrada* numbers performed by Leonid Utesov and his band in zany situations',[25] is a far cry from the straightforward linear plotline demanded by the constraints of socialist realism. Moreover, the utilisation of slapstick humour, irony and satire (particularly of classical forms, in an era of neo-classicism), the jazzy flavour of the music, and the echoes of Eisensteinian *Strike*-era montage (including a scene in which farm animals gorge themselves on a banquet prepared for a bourgeois reception) all

combined to render the finished picture somewhat problematic for contemporary critics.

The problem was that, although the film represented a testament to the boundless opportunity to recreate both the world and the self in the Soviet Union, *The Happy Guys* lacked moral fibre. Nonetheless, accusations of frivolity, escapism, and in particular the film's 'lemonade ideology' were rebutted by the seemingly irrepressible Shumiatskii, who argued famously: 'Neither the Revolution nor the defence of our socialist fatherland are a tragedy for the proletariat. We have always gone into battle, and we shall go into battle again in the future singing and, at times, laughing.'[26]

Furthermore, the film's staggering popularity bore out not only the notion that 'the victorious class wants to laugh with joy', but also the sentiment expressed by Aleksandrov, and incorporated into the 1978 restoration of the film as a kind of epigraph: 'This film is very dear to my heart. It was made at a time when the cinemagoer expected films that were fresh, happy, and lively. *The Happy Guys* was the first response to this demand of the era.' Aleksandrov is quite right to contextualise the film as very much of its day, and not only because, as Stites remarks, it 'coincided with the onset of the short-lived jazz age' of the early 1930s.[27] Optimism abounds, with Utesov's rags-to-riches storyline paralleled by Liubov' Orlova's rise from humble housemaid to centre-stage at the Bolshoi – a clear hint at the new potential for social mobility available to all under Stalinism, although more often than not this is depicted as merely making the most of what resources are available; furthermore, Aleksandrov displays flashes of amusing technical wizardry with animated segues that may well have been inspired by his visit to the Disney studios in Hollywood.

Ultimately, however, the film is most notable for its songs. The collective singing of the music of Isaak Dunaevskii and the lyrics of Lebedev-Kumach played such a central role in the mythicisation of Stalinist culture that, as Clark points out, their songs have become a kind of metaphor for the entire Stalin era in several recent films, alongside 'such visual bric-a-brac as posters with slogans, portraits or busts of Stalin and Lenin, and even the telltale cornices of the Stalinist apartment block'.[28] Furthermore, as Svetlana Boym remarks, the function of songs of the era was purely life-affirming: 'The song was not made to be read but only to be memorized and repeated *as an incantation of fairy tale magic*. This is a key issue in the creation of the utopian commonplace of the Stalinist era.'[29]

Such songs are nowadays seen to represent the ultimately hollow promises of the socialist Utopia, and they are perhaps best-qualified to do so: along with the more obvious representational signs – Clark's

'visual bric-a-brac' – as Richard Dyer notes, the often-overlooked *non-representational* signs of the musical also ignite its utopian spark.[30] These non-representational signs include music itself, as appealing to an emotional response, and therefore an *affective* involvement with the action visible on the screen, just as Dyer sees the utopianism of 'pure entertainment' as 'contained in the feelings it embodies. It presents, head-on as it were, what Utopia would feel like rather than how it would be organized.'[31]

Collective singing is also an important element in the musical insofar it provides possibly the best opportunity to develop a genuine sense of *community* – and not just between the characters on screen, but also between these characters and the audience as a community in itself: whereas all cinemagoers share a visual perception of a film, the darkness of the auditorium also generally entails a certain sense of isolation – it is only in the case of the musical (and possibly the sports film) that specific attention is drawn to spectatorship, and the extradiegetic audience can sing along with (or at least tap their feet to) the diegetic audience, who are in turn singing along with the performers on stage. Jim Collins makes a similar point, when he describes the 'escapism' (i.e. the utopianism) of the 1930s RKO musicals of Fred Astaire and Ginger Rogers as depending upon 'an entire textual apparatus that insures its own success by "musicalizing" the world'. It would appear that – whether in Stalin's Soviet Union or in the America of the Depression – 'The musical creates not only the possibility for involvement of the spectator, but also the desire for that involvement through its own self-glorification.'[32]

The question of the *desire* of the audience to collude in the utopian conceits of the musical typifies the Althusserian concept of *interpellation* – the process by which a consumer of a text is made to feel that there is a subject position ready-made for her or him within the world of the diegesis. Such a 'calling' is most often effected in the musical by the explicit acknowledgement and addressing of the extradiegetic audience, through such devices as the use of I/you pronouns in songs. Aleksandrov's musicals show no qualms when it comes to 'breaking the fourth wall' – the extradiegetic audience is repeatedly acknowledged and invited into the world of the movie, more often than not by Liubov' Orlova's trademark looking directly to camera, occasionally topped off with a cheeky knowing wink.[33]

Furthermore, once beckoned into the action, the spectator can experience as though at first hand the plenitude of the numbers, those explosions of creative energy that Martin Sutton sees as freezing the narrative, and to an extent both frustrating and releasing the spectator. In an analysis that could easily be concerned with the

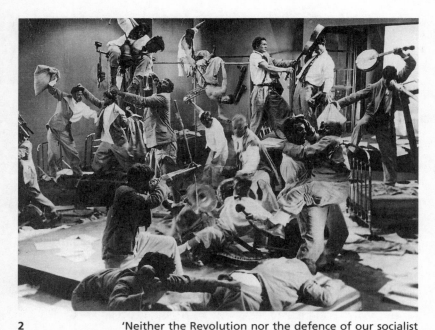

'Neither the Revolution nor the defence of our socialist fatherland are a tragedy for the proletariat. We have always gone into battle, and we shall go into battle again in the future singing and, at times, laughing' (Shumiatskii): Leonid Utesov's jazz troupe wreake carnivalesque mayhem in *The Happy Guys* [*Veselye rebiata*, 1934]

tensions of socialist realism (between the linear chronological plot-line and the 'spectacle/fantasy number'), Sutton points out the regulatory function of the narrative as taking 'the part of "super-ego" to the unruly "id" of the number'[34] – citing the appearance of a policeman during Gene Kelly's *Singin' in the Rain* routine. This notion recalls Bettelheim's idea of the fairy tale as giving body to id pressures, and subsequently resolving them in line with the requirements of the super-ego, the internalised voice and interdictions of the father, just as Sutton suggests that the musical 'finally turns its wayward dreamers into conformists'.[35]

The problem with *The Happy Guys*, however, is that the explosive energy of the numbers and set pieces is, as we have seen, largely untamed by considerations of plot, and although Utesov is squeezed into a tuxedo for his performance at the Bolshoi, he still insists on mugging frantically to camera both during and between numbers, and continually rebuts the traditional moralising narratives of folk – when he cannot afford to pay for a lift to the theatre, for example, he simply floors the driver with a well-aimed punch. Ultimately, the

episodic, fragmentary nature of the narrative threatens to desta-
bilise the 'paternal' role of the narrator, and in fact the film is in
many ways much more problematic for patriarchal ideology than it
is for the hegemony of socialist realism.

For the trouble with Utesov, as far as socialist realism is con-
cerned, was quite clearly his lack of morality/ideology, not to men-
tion his seemingly ebullient celebration of this lack: however much
the film satirises the bourgeois ladies at Utesov's home resort, or the
stuffy classical musicians encountered along the path to success,
Utesov always seems to destroy more than he constructs – exposing
the crumbling facade of residual bourgeois tendencies, but (at first
glance at least) appearing to offer nothing in its place except inter-
mittent explosions of wildly anarchic energy. I would argue that the
trouble with Utesov as regards *patriarchal order*, then, is rather more
significant.

First of all, it is worth noting that *The Happy Guys* is unique
among the four Aleksandrov comedies under discussion here, in
that it is the only one featuring a roughly equal male/female pro-
tagonist pairing. It is therefore also the only one that takes the bold
step of propelling a male body into the limelight as a constant object
of spectacle, and thus of the active male gaze.[36] Steven Cohan com-
ments on a similar problem with the portrayal of Fred Astaire, fit-
ting him into a canon of song-and-dance men – including Bing
Crosby and Danny Kaye – none of whom 'were likely candidates
either for pin-ups or action heroes'.[37] The threat to the traditional
active male/passive female binary is disavowed not only by the
rather plain look of the star – and with all due respect to Utesov, he
is not exactly 'pin-up material' any more than his Hollywood coun-
terparts – but also by the privileging of Astaire's 'spectacular' talent
over action and narrative.

This re-imagining of the masculine in spectacular terms fore-
grounds virtuosity and versatility, and Utesov – in many ways the
embodiment of the jazz ethic – has plenty of both. His phenomenal
skill at improvisation not only throws the rule books of music theory
out of the window, but even goes so far as to bypass traditional
notions of what constitutes a musical instrument in the first place.
The transcendence of adversity by both the re-interpretation of
space, and the attachment of new significance to props noted by
Sutton in the case of the Hollywood musical,[38] is taken to an
extreme level by our unlikely hero. In many ways, in fact, Utesov
exemplifies the strategies of reappropriation – of consumption as a
form of cultural production – privileged by Michel de Certeau in *The
Practice of Everyday Life*. In de Certeau's eyes such 'poetic ways of
"making do" (*bricolage*)' are actively subversive challenges to

authority – acts of affirmation of the self under systems of power (well-documented by Michel Foucault) which are experienced as attempts to homogenise individuals into a 'mass'.[39]

Obviously, none of this was quite what the cultural authorities in Stalin's USSR had in mind when they were calling for individual heroes to rise up from the masses, but we should also note that the carnivalesque mayhem wrought by Utesov's *bricolage* is once again damaging to the patriarchal order on which that culture rested. In one particularly farcical scene – just as the genuine maestro has appeared on stage to confront Utesov's impostor – our hero himself shrugs into camera, announces with resignation that yet another chase is about to begin, and promptly loses his trousers, causing a nearby woman to faint.

Mark Simpson has pointed out how, on the other side of the globe, Stan Laurel and Oliver Hardy were also producing spectacles of men who were apparently unable to function in a classically masculine way – whilst at the same time quite literally exposing the artificial foundations of male power – with particular reference to the orgies of debagging in the duo's 1928 silent *You're Darn Tootin*: 'The gag is simple but universal in its effectiveness, relying on one basic assumption: men and the way they take themselves so seriously are actually the biggest joke going – just pull their trousers down and you'll see why [...] "Pants" also symbolise the civilisation and refinement of the "nether regions"; *their loss stands for disorder*.'[40] In a similar way, Utesov's buffoonery destabilises the patriarchal order of socialist realism, and typifies the possibility for the sheer energy of a performance – and especially the explosions of energy ('id pressures') of a musical number – to transcend the dominant ideology that, as Robin Wood argues, 'may determine [...] the forms in which the drives find embodiment', but nonetheless, 'can't account for the drives themselves'.[41]

Circus: the politicisation of the personal

If this is the case, then the dominant ideology was clearly anxious not to make the same mistake twice: Aleksandrov's next musical comedy, *Circus*, is much more strictly ordered than its predecessor, with a linear narrative that (for the most part) relies on more conventional chains of cause and effect rather than the episodic structure of *The Happy Guys*. This strengthening of the film's 'super ego' results in a much more traditional type of fairy tale, complete with clear-cut moral conclusions.[42]

As Ratchford points out, in fact, Aleksandrov performed a spectacular u-turn between the two films: having 'depoliticised' *The*

Happy Guys to produce a slapstick comedy with little overt ideology, the director 'took the original work of Kataev, Ilf, and Petrov, and imparted such a strong ideological slant to it that the authors withdrew their names from the film credits in protest'.[43] This almost remarkable turnaround in attitude may be explained with reference both to contemporary debates within the Soviet film industry – including, of course, the establishment of a social purpose to all genres of cinema – and perhaps also to Aleksandrov's own instinct for self-preservation following the slating of his former associate Eisenstein at the 1935 cinema conference.[44] Such behaviour may have guaranteed success for Aleksandrov at home, but his wholehearted embracing of socialist realism quite possibly did little for his reputation abroad, where intellectual circles looked upon the beleaguered Eisenstein with some sympathy.

The idea of *Circus* as an explicitly political film is signalled right from the opening shot: a poster for the film is pasted over an older one advertising *The Happy Guys*. Richard Taylor quite rightly points out that Aleksandrov is here underlining a certain continuity between the two films,[45] but there is also a deeper level at which this opening shot can be seen to operate. Not only does the use of such an overt ideologically-charged form as the poster immediately establish the blend of propaganda and entertainment for which the film is so famous, but the carnivalesque aspects of circus itself are also circumscribed within an 'official' space and specific times, all within an institutionalised framework that is, as Stites remarks, 'deeply conservative … enmeshed by family acts and dynasties'.[46] The political is not only the personal, but also bound up with the type of vertical kinship appealed to in all rhetoric surrounding the great Soviet family.

In common with the majority of musical comedies, the romantic plot is set in motion by the arrival of an interloper into this microcosmic Soviet family: the American circus performer Marion Dixon (played of course by Liubov' Orlova) is driven out of redneck Kansas by a lynch mob, enraged at her giving birth to a black baby, and she is brought to Moscow by her evil Svengali, the sinister von Kneishitz. Taylor points out the ways in which this German figure is depicted to represent the twin evils of Fascism and the aristocracy: the moustache and slick black hair are surely reminders of Hitler, and his clipped accent and the 'von' prefix connote upper-class pretensions. The similarity between the German 'von' and the Russian '*von*' ('stink') probably do not need commenting upon, but in a musical that has not entirely rejected the conventions of slapstick humour, it may yet retain some small significance.

The arrival of Dixon, however, and more particularly the manner of her flight from America, also link this seemingly light romantic

comedy directly to the new Soviet constitution of 1936. This constitution not only declared the initial stage of socialism achieved, but also guaranteed the equal and democratic rights of all nationalities in the Soviet Union – and there are implicit allusions to this throughout the movie. Perhaps most importantly, however, the constitution represented the Soviet Union as more than half way to the condition of just the type of Utopia looked forward to in both fairy tales and Soviet socialist realism, as Ratchford explains:

> It created the impression that life had indeed become happier and more prosperous under Stalin and that there was truly no other country where people enjoyed such freedom and collective wealth. Stalin encouraged a xenophobic sense of security by contrasting this socialist 'Garden of Eden' with the projected misery and terror of fascist and bourgeois countries.[47]

Not only does Dixon's predicament at the start of the film offer a graphic demonstration of the terrifying world outside of this Soviet Utopia, but the idealism of the richness and freedom of that country is made explicit in lines from the centrepiece *Song of the Motherland*: 'I don't know of any other country/Where man can breathe a freer air!'[48] In fact, it can be argued that the 'preferred reading' of Dixon's love for the Soviet artiste Martynov – which develops and is frustrated until almost the very end of *Circus* – is in fact a growing love for the Soviet Union itself, where, as *Song of the Motherland* goes on to point out, 'There are no longer black or coloured races'.

Predictably enough, in fact, Dixon's declaration of love for Martynov coincides with her choice of the Soviet Union as home. Furthermore, this choice is underwritten by the attitude of the audience inside the big top towards her hitherto guilty secret: the various nationalities present refuse to react with the horror that von Kneishitz had anticipated toward her black baby, and instead pass him lovingly from one to another, singing a lullaby composed of several different languages as they do so.

This 'unmasking' of von Kneishitz's *psychological* make-up parallels an earlier scene, in which his *physical* attributes are exposed as a sham: the German, in an attempt to compete with the physical prowess of Martynov, dons an inflatable 'muscle suit', which subsequently bursts. As on so many other occasions in the film, the amusing episode contains a heavily didactic message: it is as though the splendid physique of the Soviet artiste (not to mention his phallic posturing) is 'natural', and at the same time the Nazi cult of fitness and the body is satirised as wholly artificial (and easily deflated). The double unmasking of the villainous enemy not only confirms the film's position within the folklore genre – as Propp makes clear, 'the

folktale canon requires that false heroes be put to shame and the real hero exalted'[49] – but also, as Ratchford points out, implicitly looks forward to those other, rather more chilling, spectacles of the 1930s, the show trials.[50]

Circus, then, clearly has much more of a moral backbone than *The Happy Guys*, and this particular rags-to-riches story is worked through purely in terms of the theme of enlightenment. Taylor points out how Aleksandrov illustrates Dixon's enlightenment through language by his use of colour: as her blonde hair begins to show from under her dark wig, she grows both in confidence and in Russian linguistic competence.[51] The centrepiece of this theme is a conversation between Dixon and Raika (a minor character from a parallel love intrigue) in which the concept of understanding is explicitly bound up with questions of personal fulfilment. At first sight, it appears quite possible that this is indeed a case of female solidarity conquering language barriers, as Taylor suggests, but does *Circus* really represent the coming to political consciousness of Soviet womanhood?

To explore this issue further, we may adduce the themes of confinement and liberation brought up by the film, which ostensibly charts Marion's progress from captivity to equality under the law as a Soviet citizen. The liberation on offer is indeed explicitly a question of language, but once again we may see how Stalinist discourse operates to a male agenda: given that the boundless 'possibility' of socialist realism only becomes an available 'reality' when the subject has learned to speak correctly, it should come as no surprise to find out that it is the leading man, Martynov, who takes on the task of educating Dixon. Furthermore, any concessions made to other Soviet languages in the singing of the lullaby clearly do not hold good outside the big top, for as the scene shifts to the grand finale on Red Square, we see the restoration of Moscow-centric patriarchy: it is the blond, male Russian Martynov who heads the group's section of the parade to honour the spiritual father of the country, Stalin – who appears only as an icon!

Any lingering doubts about the centrality of patriarchy to the movie can be allayed by reference to the Soviet artiste's 'flight to the stratosphere': not only is this hyper-masculine stunt intended to outdo Marion's 'flight to the moon' showstopper, but Martynov's flight around the big top – as Ratchford notes, complete with a 'Flash Gordon'-style costume befitting the age of the Soviet superhero – is closely followed by a Busby Berkeleyesque extravaganza of sequin-bedecked women in a formation dance set.[52] Any ground lost by patriarchy in the film, therefore, is wholeheartedly recuperated by this demonstration of not only Soviet, but also male, superiority, and

the subsequent repositioning of women in complete submission to the male gaze.

Are we to infer from all this, then, that the opportunity for boundless possibility ostensibly celebrated by the film really existed – and was available specifically to men? We may examine this issue once again within the context of the 'flight to the stratosphere'. Martynov's flight around the edge of the big top – accompanied not only by a joyfully garish costume, but also the barely controlled roar of his motorcycle cohort – certainly appears to represent an explosion of centrifugal forces, and yet it is quite possible to see how this particular show-stopping spectacle – like those of Dixon *and* the heteroglot chorus of *Song of the Motherland* – remains circumscribed by the dominant order. First and foremost, Martynov's stunt is kept strictly *within* the big top, which now represents not only the Soviet Union, but the *entire world* (including the encircling atmosphere): we have already discussed the idea that the self-contained nature of the socialist realist world-view is fundamentally incompatible with any glimpses of its workings from the outside – for such a glimpse from outside threatens to destabilise its delicately-balanced internal logical consistency. At this point in *Circus*, however, this 'outside' is simply disavowed, *in spite of* the opening scene set in the USA, creating a rather creepy impression of 'no escape' for Marion, whilst apparently demonstrating that the world is Martynov's oyster. On the other hand, it does not require too much insight into the workings of circus trickery to recognise that Martynov is flying on wires: like his wooden American counterpart, Disney's Pinocchio, Martynov too remains very much attached to strings of social constraint which hold him, like Marion, within the discursive parameters of Soviet socialist realism. Once again, there is a tension in *Circus* that is not only characteristic of socialist realism, but also comparable to the Hollywood musical, between the fantastical, anything-goes id, and the moralising constraints of the narrative super-ego: in the case of Martynov, although the Freudian dream-symbolism of flying as the sexual act is appealed to, this is brought strictly into line with the internal logical consistencies of socialist realist discourse – the same logical consistencies that characterise psychosis. I hope both to develop the theme of the sexuality of the New Soviet Man, and to touch on the notion of his potentially psychotic tendencies, later on in this study.

Meanwhile, as though to strengthen the comparison between Martynov and Pinocchio, Ratchford complains that our hero 'comes off as a very wooden and one-sided character, resembling one of the many faceless workers on billboards throughout the Soviet Union'.[53] This holds true, but again only as far as the limit point of

Martynov's centrepiece daredevil stunt. As with the aviation hero Chkalov, audiences are invited to thrill at the death-defying antics of the screen hero, who takes centre-stage as the object of the camera's gaze. Whereas Chkalov makes every effort to disavow this 'feminine' position, however, in the case of Martynov it appears to be his *masculinity* that is hysterically disavowed through a combination of a thinly veiled *passivity* (it seems to take little in the way of butch, masculine prowess to be swung around a big top on wires) and a very overtly over-the-top spangled outfit, topped off with a liberal application of panstick and glittering make-up. We have already argued that masculinity is not a fixed essential quality, but a broad range of subject positions defined largely in opposition to that which is discursively constituted as Other (most obviously, the 'feminine'). During the 'flight to the stratosphere', however, audiences both within the film and in the cinemas at which it is shown are presented with a hero who seems to exemplify a type of masculinity that – characterised as it is by a figural excess that borders on the grotesque – quite simply was *not on offer* at the time in the Soviet Union. Indeed, question marks are still raised over the validity of such a masculine mode even in sections of today's liberal-democratic United Kingdom – the same country that spawned a generation of sexually ambiguous 'glam rock' stars in the early–mid-1970s!

How are we to account, then, for this apparently bizarre representation of masculinity in a movie which otherwise attempts a return to the traditional gender roles of woman as spectacle, and the phallic posturing of the male hero? Perhaps some preliminary clarification may be gleaned from an examination of the function performed within the film's plot by the episode which frames this representation. We can recall that the show-stopping star turns of Aleksandrov's musicals – most often a joyfully spontaneous outburst of collective singing and dancing – are events that *freeze* the forward motion of the linear plotline, and present us with a direct, *affective* involvement in how the socialist utopia-on-earth would feel. On this level, they may be read as a permutation of the more standard socialist realist plot device of removing the hero from contemporary (novelistic) space and time – the here-and-now of Zhdanov's 'austere, matter-of-fact work' – to an (epic) self-enclosed time and world of 'the greatest heroic spirit and grandiose perspectives', in which he receives his most important social and political education. This is where the positive hero, the New Soviet Man, sees things not only as they *ought to be*, but even – fully submerged as he is in monoglot Stalinist discourse – as they *really are*. This 'grandiose perspective' affords a glimpse of 'reality in its revolutionary development' – that is, *Soviet reality* (the 'slandering' of which earned so

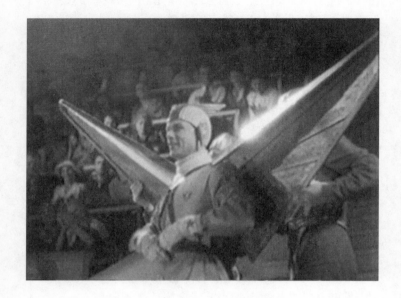

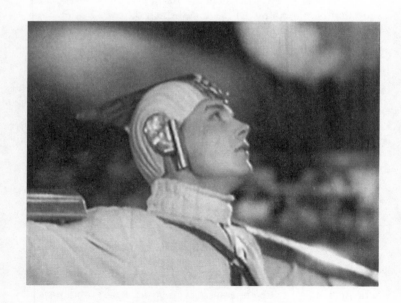

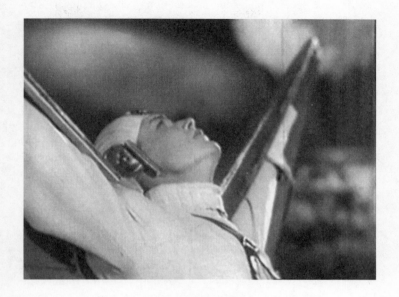

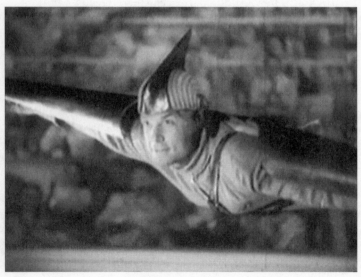

3 (a–d) Taking the stage on a wing and a prayer: Sergei Stoliarov as Soviet Superman Martynov in *Circus* [*Tsirk*, 1936]

many projected films their consignment to the shelf – or the dustbin of history). In the musical comedy, explicitly didactic lessons to heroes take second place to the emotional engagement of the diegetic and extradiegetic audiences, but a scene such as Martynov's 'flight to the stratosphere' – in which the big top encloses the entire world, suddenly rendered *epic* – nonetheless presents audiences with *Soviet reality*, the way things *really* are.

A risky operation, to say the least – and one which we have already seen as failing in the case of *The Happy Guys*, where chaos reigns supreme not only during the numbers, but even in the loosely-structured plot which is supposed to keep them in order. One reason for the success of *Circus*, then, must be that it has a linear plot strong enough to contain the explosive energy of the numbers, but Aleksandrov even goes a step further: although perhaps still unable to account for the drives that make up performance, the dominant ideology, from *Circus* onwards, was in fact very clearly dictating the *embodiment* of these drives, and this applies even as far as the actual bodies involved. At the very moment when Martynov puts his masculinity on proudest display, when he takes the opportunity literally to 'rise above' the crowd, that crowd (and the cinema audiences) *see him as he really is*, and his body is heavily marked with reminders of his 'real' position not as autonomous masculine subject, but feminised, *objectified* as part of the processes of socialist construction feted in the 1936 constitution. Henceforth, all credit for the fantastical feats performed by either men or women is very explicitly – in both song lyrics and framing devices – shared between the miracle-workers themselves and the society that created them, not to mention the correct social conditions which enable such feats to be performed.

Although this is a very telling moment, however, within the body of *Circus* it is also an isolated one: after the characteristically individual features of Utesov, Aleksandrov presents his audiences with men who, like the Martynov we see throughout most of the movie, are indeed barely distinguishable from countless other, equally depersonalised, New Soviet Men on billboards and in literature of the Stalin era, characterised by little other than abstract concepts such as optimistic determination and stern resolve. After the rather dangerous positioning of Utesov – and, in a more controlled way, Martynov – as male spectacle, Aleksandrov made sure he confined himself for the rest of his comedies to a female lead. This is not, however, any reason not to analyse the heroines of *Volga-Volga* and *The Radiant Path* – like all masculine portrayals of femininity, these representations can tell us a great deal about contemporaneous constructions of masculinity as defined *against* such portrayals.

Meanwhile, the hysterical excess in the figuration of the 'real' Martynov is an indicator of a certain tension just below the surface of the New Soviet Man – the perceived threat of gender confusion that marks a split subjectivity – and the easiest way to dispel this threat is simply to efface it, thus apparently absolving it from (self-) analysis.

Whilst it would be very easy to take Aleksandrov to task for this apparent retreat, we must not forget that he was working in an age, and under a system, that both celebrated opportunity and at the same time denied it. Similarly, criticisms of his political affiliations should not detract from the fact that, in *Circus*, he created possibly the finest example of the ideology/entertainment fusion ever seen in the Soviet Union. The film, like many of the songs of the day, has achieved the status of a cultural marker of the Stalin era, as mentioned above – a status that reflects its enormous and abiding popularity and significance, and is not always portrayed as such a bad thing. Although the insidious power of Dixon's signature tune is commented on in Elim Klimov's harrowing 1979 war film *Come and See* [*Idi i smotri*], as the first stirrings of the child hero's consciousness following an air raid, there is another side to Aleksandrov's comedy, which resides precisely in its value *as a comedy*. This is portrayed to great effect in Evgenii Tsymbal's 1988 short feature *Defence Counsel Sedov* [*Zashchitnik Sedov*] – a bleak black and white portrayal of the era of terror, persecution mania, and show trials, in which the one brief moment of respite for the eponymous hero is figured by a trip to the cinema, where *Circus* is playing. Whilst the inclusion of the film within the diegesis of *Sedov* immediately identifies it with the grim world portrayed outside the cinema, it is nonetheless portrayed as a joyful release from the almost electric tension that fills that world: for an all-too-brief minute, we see Sedov – along with the rest of the cinemagoers of the town of Ensk – visibly relax, even begin to laugh, and for a few brief moments he appears able (to paraphrase the *Song of the Motherland*) to breathe freely.

One of the primary concerns of *Defence Counsel Sedov* is with language, and the claustrophobia resulting from the inescapable centripetal forces in Stalinist discourse. As we have seen, these forces act to impose a unitary (and patriarchal) language, spoken by unified subjects, with as little room for ambiguity as possible. Furthermore, the resulting tendency towards monoglossia sets out to centralise cultural production, and *Circus* is no exception to this rule. Svetlana Boym points out how the *Song of the Motherland* reflects the centralising values of socialist realist discourse: 'In Stalin's time, geography was perhaps the most political of all sciences: in the song the multinational Soviet Union is presented as a

completely unified country with Moscow at its center and the center of ideological gravity.'[54] The ways in which attempts to unify the state reflect similar attempts on the part of the male ego to assume a unified subjectivity will be dealt with in more depth in chapter 5, as the parallels between the two become most obvious under threat of penetration. For the meantime, however, I shall concentrate on the idea of Moscow as the 'center of ideological gravity': although all of Aleksandrov's comedies display signs of the ideological pull of Moscow – attracting, and to a greater or lesser extent taming, jazzmen, circus artistes, singers and shock-workers alike – it is in Aleksandrov's next musical, *Volga-Volga*, of 1938, that the power of centripetal discursive forces is most obviously laid bare.

Volga-Volga: the centralisation of folklore

It is perhaps significant that, by the time *Volga-Volga* was released in 1938, the notorious show-trials hinted at by the unmasking of von Kneishitz in *Circus* were well underway. It should come as no surprise, then, that the ideological content of the film is much more deeply submerged beneath the guise of 'pure' entertainment. Furthermore, in an era of extreme centralising tendencies, the film charts the re-inscription into monoglot discourse of the potentially centrifugal music and non-hierarchical collective spirit at the heart of folklore. In fact, *Volga-Volga* can be seen as depicting the very process that Zipes laments: the imposition of absolute meaning on a cultural form that began life as an exemplar of dialogic discourse, the discussion and interpretation of phenomena carried out between the storyteller and the communities he visited.[55]

Although, as we have seen, all the musical comedies of the Stalin era may be read as fairy tales – with socialist realism sharing elements of both form and content with the Russian folklore tradition – there can be little doubt that *Volga-Volga* is the most self-consciously 'folksy' of all Aleksandrov's productions. First of all, the film is based on the 'Olympiads of Song' established under Stalin in order to showcase the talents of the common people as mediated through the refracting lens of Stalinist neo-folklore, as Richard Stites explains:

[A] nationwide network of amateur folk choirs and ensembles was sponsored by the state, thus making folk a participatory as well as a spectator art. Amateur choirs, bands, singers, reciters, solo instrumentalists, and dance companies from all over the country made pilgrimages to Moiseev's theatre in Moscow to perform folk and popular music ...[56]

Jay Leyda also points out how these events that inspired the film were designed 'to reveal the rich theatrical talents among the non-theatrical workers – amateur singers and dancers who earned their living as farmers, miners, book-keepers',[57] and in fact the heroine of *Volga-Volga*, Liubov' Orlova's Strelka, spends her days working as the postwoman in the sleepy town of Melkovodsk (literally translatable as 'Shallow Waters').

In addition to this, *Volga-Volga* makes explicit reference to the taming of the spirit of perhaps the greatest rebel of the Russian folk tradition, the cossack bandit Stenka Razin. The subject of numerous legends, songs, and even the first Russian narrative feature film released in 1908, Stites claims that Razin, and 'the image of cossack-bandits floating on the Volga with no apparent destination was firmly fixed in the popular memory'.[58] If this is the case, then it is hardly surprising that, with the completion of the Volga-Moscow canal, Strelka and her band of new-age Soviet folk heroes from Melkovodsk know exactly where they are heading: to the dizzy heights of success available only in the capital, even if they all have to take several duckings along the way.

By this point it may already have become clear that *Volga-Volga* bears a much closer surface relation to the show-making buffoonery of *The Happy Guys* rather than the comparatively sophisticated political nuances of *Circus*, and indeed stuffy classical forms are once again mercilessly parodied. The comedian Igor Il'inskii turns in a hilariously over-the-top performance as the local bureaucrat Byvalov ('*of the past*' – a name that explicitly denies any link he may claim to modernity), who refuses to believe that a town such as Melkovodsk – which he regards as merely a stepping-stone along his own path to Moscow – could possibly harbour any home-grown talent.

There is, however, an important distinction to be made between the two films, residing in the fact that *Volga-Volga* offers the audience the immense populist appeal of folk music – a form that was seen as very much of the people – in stark contrast to the real or perceived elitism of Utesov's jazz (however zanily executed). This populist ethic was reflected, as Stites indicates, in the lyrics of Lebedev-Kumach, extolling the rich and stirring beauty of the great Russian land.[59] Such eulogising must call to mind the later collective-farm (*kolkhoz*) musical comedies of Ivan Pyr'ev, which are to be discussed in the next chapter, and indeed Maya Turovskaya comments on the 'conflictless' nature of *Volga-Volga*'s plot, placing it on a par with Pyr'ev's notorious *Cossacks of the Kuban* [*Kubanskie kazaki*, 1949],[60] the 'conflictless' nature of which will come under scrutiny later on in this study.

Furthermore, *Volga-Volga* possesses a distinct linear plotline, and that line leads – more or less directly – to Moscow. The villagers are summoned to that 'center of ideological gravity' by the (retarded) arrival of a telegram notifying the town officials of an Olympiad of Song to be held in the capital. As we know, Byvalov does not believe in the idea of popular talent – despite a most absurd sequence in which he is confronted at every turn by more and more townspeople displaying their singing and dancing prowess – and he sets off for Moscow with the local classical ensemble, headed by Strelka's love-intrigue, a rather dull (although reasonably good-looking) composer, who displays a rather dangerous preference for Wagner over folk melodies. In one of the film's many displays of sheer madness, Strelka – with practically the entire village in tow – resolves to follow them by any means necessary or available.[61]

Of course, 'any means necessary' quickly becomes 'every means possible', as an assortment of boats of all shapes and sizes are leapt upon, and subsequently crashed and sunk. Turovskaya comments on this process of plot retardation, and in particular the inept pilots and helmsmen, who are seemingly unable to miss sandbanks, one of whom even falls through all the decks of his ship, having stamped his foot: 'It is as well that the "Great Helmsman" did not take account of this parody: people were being killed for much less.'[62] Turovskaya's suggestion that *Volga-Volga* may be read as a parody both of itself and of the Stalin era as a whole is a very interesting one. The most obvious object of satire is the fat, bumbling, and supremely self-interested portrayal of Byvalov, but, as Turovskaya notes, this satire is extended to the whole of the town under his control – where nothing seems to work, any more than anyone takes care of their business – as the entire town appears to be engaged in the sole pursuits of singing and dancing. The portrayal of Melkovodsk, and in particular of the delayed and inefficient arrival of the telegram announcing the Olympiad of Song, makes one wonder whether this place really has been touched by twenty years of Soviet power.[63]

The issue of the telegram brings up at once the theme of communication: the fact that its contents must ultimately be relayed to Byvalov by word of mouth also raises the theme of the voice as the one truly effective means of communication, thus fitting the film squarely into what Derrida characterises as the 'phonologocentrism' (the privileging of the words of the *speaking voice* over the written letter as the guarantor of truth) at the heart of the western metaphysical tradition. Furthermore, the fact that this most individual of media spends most of the film submerged in collective singing is just one of many ways in which *Volga-Volga* seems, at first

glance, to champion the populism of Strelka over the individualism of Byvalov. The implicit message is clear: self-interest must be sacrificed for the good of the people, or else, sooner or later, the people will leave you standing.

Whether or not Aleksandrov had made a parody without himself being aware of the fact, the themes of the need for progress (especially in the countryside), collectivism, and better lines of communication between town and country bring to mind a much earlier work in which the director had participated, Eisenstein's *The Old and the New*. It is entirely possible that the scriptwriter, Erdman, already in trouble with the authorities, was cocking something of a snook in his depiction of the madness that had taken over Soviet culture since the early 1930s: the idea of a musical comedy version of Eisenstein's classic certainly fits this bill rather nicely; the idea of *Volga-Volga* as a parody of itself – even better. However, whereas Eisenstein's film pushes home the symbolic representation of progress through solidarity and efficient communications, the lines of communication in *Volga-Volga* leave more than a little to be desired. We have already mentioned the delayed telegram and the succession of poorly maintained, and even more poorly managed, boats in the movie, but the centrepiece of the film – at least as far as communication channels are concerned – is the opening of the Volga-Moscow canal.

It is certainly true that the depiction of the canal is dazzling: temporal discontinuity is utilised to luxurious effect, lingering on the majestic sweep of the lock gates, as they open onto the gleaming, hyper-efficient realm (the by-now familiar constellation Moscow/Kremlin/All-Union Exhibition of Agriculture) that lies beyond. And yet, the introduction of the Melkovodsk folk into this realm only brings about an orgy of confusion, disorder, and slapstick mayhem including duckings and (one might have guessed) lost trousers: if it were not for the prize-winning melody that Strelka brings with them, you would think that the Muscovites – along with everyone else at the Olympiad, not to mention the river authorities – would have preferred them never to have left home.

Even if, on the other hand, we take the theme of communication further, and read *Volga-Volga* as a parable of the passage of the signifier from the centre to the periphery and back again, we are still struck by, first of all, the apparent near-impossibility of the journey, during which, more often than not, difficulties are overcome not by any skill on the part of the townspeople, but rather by happy chance, and the willing aid of passers-by. Furthermore, one cannot help but notice the frenzied eagerness exhibited by the inhabitants of Melkovodsk to clamber aboard for its return trip. Not only does

this bear out Richard Taylor's perceptive comments about *Circus*, and the degree to which people were willing to collude with the offer of escape presented to them by musical comedies,[64] but it also brings to mind three siblings from a different era of Russian history: unlike Chekhov's sisters, however, there is no way in the world that these provincials are going to pass up an opportunity to make it to the capital.[65]

Although a visit to Moscow was a rare and golden opportunity for the vast majority of Soviet citizens, most of whom knew it only from postcards – or indeed the painted backdrops used in musical comedies! – we should nevertheless note that the desire of the townspeople to see the capital can be seen to stem from two related sources. The first of these is a blatant wish for self-advancement: figured by the desire to be in on the winning of first prize at the Olympiad of Song, this not only raises the question of whether or not Byvalov really is so much worse than his comrades, but also rather brutally undercuts the ostensibly populist ethic of the entire movie. The wayward, somewhat haphazard passage of the signifier in the film calls to mind Lacan's celebrated seminar on Poe's *The Purloined Letter*, which Lacan uses to illustrate perhaps his most direct dictum, that 'a letter always arrives at its destination'.[66] One slightly less enthusiastic response to this seminar, however, is that of Derrida, who insists:

[A] letter does *not always* arrive at its destination, and from the moment that this possibility belongs to its structure one can say that it never truly arrives, that when it does arrive its capacity not to arrive torments it with an internal drifting.

The divisibility of the letter is also the divisibility of the signifier to which it gives rise, and therefore also of the 'subjects,' 'characters,' or 'positions' which are subjected to it and which 'represent' them.[67]

If, then, the delayed arrival of the telegram in Melkovodsk casts a certain shadow of doubt on the very identity of its addressees, such a threat impels the residents to travel to Moscow to acquire a fixed, unitary identity through the by-now standard cathartic and unforgettable pilgrimage to the centre of ideological gravity. But what kind of ideology are we dealing with here? It seems that whilst *Volga-Volga* satirises, on the one hand, a stereotyped middle-class obsession with classical forms and self-promotion (Byvalov), on the other – and despite its careful use of cross-cuts to resubmerge the ultimately successful Strelka with the collectivised society that (theoretically at least) enabled her to win through – the pinnacle of Soviet aspiration in the film is quite literally the promotion *of the self*, that is, the assumption of an *individual* (i.e. impossible to split) identity.[68]

The second motive for the peoples' near-desperation to reach Moscow is another illustration of the irresistible pull of the city. We have already cited Boym on the politicisation of geography in the Stalin era: the re-imagining of the Soviet Union in terms of its borders, for example, reflecting the more enclosed world-view promoted by socialist realism. The concept of Soviet cultural geography has also been explored in some depth by James von Geldern, with particular reference to the centralisation of culture following the Cultural Revolution; and the role of Moscow as 'focus of political and economic life, and the visible face of the Soviet Union, representing it to Soviet citizens and the world'.[69] Von Geldern argues that a new social ethic of inclusivity – coupled with the cultural shift from the practicality of the Cultural Revolution to the prestige values of high Stalinism – provides a key to the mass participation in the spectacles and record-breaking achievements of the Stalin era. In the same way that the entire nation was able to take pride in the dazzling feats of Stakhanov, or the monumental architecture and technological advances of the Moscow metro, for example, von Geldern points out that, although the capital was privileged, this did not necessarily exert too much detrimental influence on the periphery: 'Social legitimacy was concentrated in the centre not as a monopoly, but as a point of distribution.'[70]

The most obvious illustration of this role of the capital lies in the climax to Aleksandrov's musical comedies. With the exception of *The Happy Guys* (which, as we know, may be considered an imperfect model of the genre) the grand finales of *all* of these films figure a trip to Moscow for some form of life-changing encounter with Stalin, which acts to confer the kind of instant legitimacy and celebrity status that, according to von Geldern, 'allowed average citizens to bypass the middle ranks of society on their way to the top'.[71] An equally obvious representative of these middle ranks of Soviet society is, of course, the figure of Byvalov in *Volga-Volga*. We have already pointed him out as the object of the film's principal satirical drive, but perhaps we are now closer not only to finding out just why such a potentially disruptive parody as *Volga-Volga* was allowed a general release even under the constraints of socialist realism, but also to understanding the reasons why, at the height of his reign of terror, Stalin should be so pleased with the movie that he is reputed to have watched it over one hundred times, and even to have sent a copy to his wartime ally, President Roosevelt.[72]

At best, the case of *Volga-Volga* may be seen as indicative of the fickle power of a dictator's whim: the only man in the Soviet film industry who did not have to worry about passing a movie, runs the argument, was the 'Kremlin censor' himself. On the other hand, and

at worst, *Volga-Volga* could well be held up as a prime example of the mindless veneer of entertainment shielding Soviet citizens from the cries of the *Gulag* prisoners, whilst at the same time exemplifying Stalin's pitifully poor understanding of the nature of film art. However, the figure of Byvalov may be mobilised to refute both of these arguments at one and the same time.

First of all, and with reference to the historical background of the time, it is worth taking into account Graeme Gill's analysis of the Stalinist political hierarchy. Gill refutes the totalitarian model so often applied to the era, by acknowledging the relative independence of exactly the same type of local government bureaucrat as portrayed by Byvalov. Although the local bureaucrats were technically subordinate to central control, argues Gill,

the institutional machinery for exercising close, continuing control was lacking. Local party leaders were still able to follow substantially their own policy lines in local affairs; the levying of their own local taxes on top of central demands is one illustration of the room for manoeuvre they possessed ... The high level of centralisation at elite levels thus coexisted with significant looseness lower down the political structure.[73]

With this background in mind, we can perhaps begin to appreciate that Stalin quite possibly not only fully understood the satirical, parodic intentions of *Volga-Volga*, but may well even have welcomed the ridicule heaped upon both Byvalov and the provincial backwater under his control.

Furthermore, with its twin themes of modernisation and the good-heartedness of the Russian people, the film also taps into the classic spontaneity/consciousness debate – although here it is largely played out in terms of the *intelligentsiia/narod* divide. The puffed-up pretensions of Byvalov, as well as the 'false consciousness' of Strelka's composer boyfriend, are shown to be as helpless in the face of the 'Beauty of the People' (as Strelka's song has it), as are the formalised sheets of music in the teeth of the elemental gale that blows them out of the ship's window: not only does *Volga-Volga* appear to be playing to Stalin's notorious mistrust of intellectuals, but the modernisation of folklore also provides a legitimating sense of continuity for his regime. The role undertaken by the 'Great Helmsman' himself in this process of modernisation is made clear by the name of the final ship to transport the townspeople of Melkovodsk into the gleaming and hyper-efficient capital: 'Iosif Stalin'.

It is also worth noting that the elements – as representative of the 'spontaneous' side of the consciousness/spontaneity dialectic – do not prevail for long in the movie, and particularly not in the areas of

sexuality and masculinity as, at first glance at least, *Volga-Volga* once again displays more of an affinity to *The Happy Guys* than to *Circus*. Quite apart from the relentless frustration of any attempts on the part of the townspeople to execute a dance routine – that notoriously sexual metaphor of the Hollywood musical – as much is clear from the portrayal of Byvalov, who, like Utesov, is unable to 'perform' classic masculinity. In fact, the portly bureaucrat can be seen very much as an Oliver Hardy to our jazz hero's Stan Laurel, and all the more so for his inability to match Utesov's improvisational prowess. Moreover, his rather dull job allows little room for the kind of phallic posturing exemplified by Martynov in *Circus*. So does *Volga-Volga* – like *The Happy Guys* before it – mount a challenge to the phallocentric order of socialist realism and the Stalin era?

The answer is, unfortunately, no. In contrast to the unlikely hero Utesov, Il'inskii's Byvalov is a figure of pure satire, a grotesque self-parody eliciting not sympathy, but merely bellylaughs. In addition to this, and quite possibly as a result, Byvalov never quite performs on an equal pairing with Strelka: his role is strictly limited to making entrances that interrupt scenes already being played out. It is vital to note, however, that this downgrading of the central male role does not in fact disturb the movie's patriarchal assumptions, which run at a much deeper level; one or two obvious examples of *Volga-Volga*'s deep-seated patriarchy may be detailed briefly in conclusion here. First of all, and despite the fact that she is evidently more competent at most things than her male counterparts, there is Strelka's positioning throughout the film as the *pursuer*, rather than the leader, of the deputation from Melkovodsk: only at the very end of the picture, and *with permission*, is she allowed to take the centre stage of the musical, and prove to the nation her vocal talents. Furthermore, we have already mentioned the steamer 'Iosif Stalin' as being the agent of centralisation of folk discourse, and this image of Stalin as the only truly reliable guide for the passage of the signifier towards the centre not only brings to mind the 'paternal' role of the narrator of the mass mediated fairy tale, but also recalls the 'mentor' of socialist realism – the figure who acts to tame the elemental side of the positive hero, and bring it into line with Party-minded consciousness.

Once again, then, we have Stalin as the symbolic father to the nation – if not explicitly the handsome Prince, then at least figuring the site in which Strelka finally gets to don her sumptuous ball-gown. However, at this point we must also note his rather puzzling physical absence from any of Aleksandrov's musicals, over which he nonetheless quite clearly presides. The idea of Stalin's absence marking all the more clearly his implicit presence is one that will be

taken up following our discussion of *The Radiant Path* – a film which some might say takes this notion to its logical conclusion, and to which we must now turn.

Moscow dreamers: the *Radiant Path* to socialism

One of the major successes of Aleksandrov's musical comedies lies in the way in which the director imparted a sense of genuine community spirit to the story of one individual's rise to superstar status. We have already mentioned the social inclusivity that allowed members of the general public to take pride in the achievements of Stakhanovite heroes, as well as the monumental landmarks constructed in the new Moscow, and to a certain extent Aleksandrov's first three comedies rely on the efforts of the collective to ensure the accomplishment of such fantastical feats. Just as Utesov would be little more than an oddity without his jazz band, so are the triumphs of Martynov and Dixon in *Circus*, and of Strelka in *Volga-Volga*, underwritten by the support and participation of the common people. Furthermore, Liubov' Orlova's on-screen performances were appropriated off-screen by a public who still cheerfully referred to her as '*our* People's Actress' over thirty years after the original release of *The Radiant Path*.[74]

This community spirit demarcates a quasi-utopian space within the diegesis of the musical, into which the infectious enthusiasm of the performers, and devices such as Orlova's *regard*, beckon the spectator: all the utopian elements outlined by Richard Dyer – abundance, energy (of work or play), intensity, transparency and of course community[75] – are present and correct, as the extradiegetic audience, along with the diegetic spectators, are swept along the path to 'a better place'. By 1940, however, and with the so-called 'cult of personality' firmly established, *The Radiant Path*, perhaps Aleksandrov's greatest musical, managed to ditch both the fellow-travellers and diegetic spectatorship, concentrating instead solely on the success story of the individual heroine, the housemaid-turned-Stakhanovite weaver.

This sharpening of focus away from the collective and onto the superstar acts not only to legitimise the new spirit of individualism that was playing an increasingly central role in Stalinist culture, but also to promote the Party as the single necessary system of support for would-be hero(in)es as they ascend to the dizzying heights of state-sponsored glory. At the same time, however, the absence of the collective necessitated a shift in the stylistic mode of portraying a Utopia accessible in the here and now. Following Maya Turovskaya's work on Pyr'ev's kolkhoz comedies, Enzensberger has highlighted

the ways in which *The Radiant Path*, through its interweaving of realistic and symbolic discourses, 'elevates its subject matter into the realm of a "dream" or Utopia, enabling the spectator to "rise above" reality and regard it in a more sublime and optimistic manner'.[76]

The notion of the film-as-dream not only consolidates the efforts of the Soviet film industry to emulate the successes of Hollywood (the original 'dream factory') but also operates to involve the extradiegetic audience in the construction of what would otherwise be an intensely personal vision of Utopia. The message implicit in Orlova's portrayal of a humble maid with whom audiences could readily identify themselves – that we all share the same dreams – allows the public to share in the exhilaration of success when these dreams come true. As such, Freud's famous dictum that dreams represent the fulfilment of wishes provides an important key to unlock the mechanisms by which the movie situates its spectators in a drive towards individual fulfilment as circumscribed by the socialist realist master-plot.[77]

The tradition of the socialist dreamer may be traced back in the first instance to H. G. Wells' characterisation of Lenin as 'the dreamer in the Kremlin', although its roots go way back to the nineteenth-century radicalism of Pisarev and Chernyshevskii: 'Lenin has often been called in accusatory tones a utopian', remarks Stites; '[...] he was both a visionary inspired by outlandish dreams and a man of practical action and ruthless realism'.[78] This almost commonplace notion was, however, formulated most succinctly by Lunacharskii in 1933, when he explained that 'A Communist who cannot dream is a bad Communist. The Communist dream is not a flight from the earthly but a flight into the future.'[79] This repeated stress on the grounding of revolutionary dreams in reality became, as we have seen, a founding principle of socialist realism: the identification of the realm of dreams with an earthly Utopia in the 'shining future' of the single method also lies at the very heart of *The Radiant Path*.

Aleksandrov's masterpiece is, like *The Happy Guys* before it, very much a film of its times. Not only reflecting the Stalinist rhetoric of boundless opportunity in the new socialist wonderland, *The Radiant Path* laid claims to a basis in the objective reality of the contemporary Soviet weaver-superstars Dusia and Marusia Vinogradova, and, as Stites notes, 'asserts constantly that this is real life and not a fairy tale'.[80] On the other hand, the dreams of Orlova's character Tania Morozova (a relation of Pavlik's?), however much they may be rooted in Soviet reality, take on almost exactly the same fairy tale form as those of her predecessors in *The Happy Guys*, *Circus*, and *Volga-Volga*.

The relation between dreams and fairy tales was famously elaborated by Freud, who asserts: 'There can be no doubt that the connections between our typical dreams and fairy tales ... are neither few nor accidental',[81] and so perhaps we should not be surprised that, despite having left behind the collective, Aleksandrov was still focusing on fairy tale structures. In fact, as Oksana Bulgakova points out, Orlova 'always played "Cinderella" types, but in a distinctive Soviet version of the story'.[82] In *The Radiant Path*, however, the parallels of Orlova's passage from rags to riches with the story of Cinderella are made more explicit than in any other of Aleksandrov's musicals. Quite apart from Tania's lowly position as a maid in a guest-house (complete with ash-smudged nose) and the motif of making fairy tales come true (which receives a repeated and seemingly inordinate emphasis in the song words), the fact that the film was originally to be titled *Cinderella* should dispel any remaining doubts about the validity of this line of argument. I intend to use Bruno Bettelheim's analysis of the Cinderella tale to explore issues raised for psychoanalysis by *The Radiant Path*, but at the same time we must not lose sight of those elements of the fairy tale that were expunged in its translation from folk tradition to socialist realist blockbuster – that is, what makes Orlova's Cinderella so 'distinctively Soviet', as well as what makes the Cinderella story so well-suited for treatment by Stalinist cinema.

An analysis proceeding along these lines appears to bear fruit almost instantly, and especially in the light of our observations about the brothers and sisters in the great Soviet family: first and foremost, Bettelheim notes, '"Cinderella," as we know it, is experienced as a story about the agonies and hopes which form the essential content of sibling rivalry'.[83] The rivalry inherent in the folk-tale ties in neatly with the rather more healthy spirit of socialist competition in the newly-evolved Stalinist meritocracy: the Stakhanovite movement, as we have seen, offered substantial *material* rewards to those who could demonstrate themselves superior either physically – athletes, Arctic fliers, not to mention champion weavers – or spiritually – writers, poets, and of course film-makers. The only criterion for this kind of success, it seems, was a certain prerequisite humility that would acknowledge the mentorship of the Party – that is, the same spirit of *partiinost'* that infused all levels of Soviet culture. The limits of individual aspiration are made clear in a 1936 comedy by Semen Timoshenko: the eponymous *Goalie* [*Vratar'*] is only admitted to the national squad when he curbs his own personal ambitions of glory, and works as a true team player on his local side.

Incidentally, in Lebedev-Kumach's lyrics to the *Sportsman's March* from *Goalie*, comparisons are once again drawn with national

security: this time it is the goalkeeper, guarding his net, who is likened to the border guards defending the Soviet Union itself,[84] and our hero is ultimately called upon to participate in an international match against a composite black-shirted team of westerners! Again, we need only recall the mythologisation of the border guards in terms of their sibling attachments to recognise the pervasive warnings of the enemy at the walls: rivalry and competition are all well and good, but when push comes to shove, all Soviet siblings are required to play their role as part of the greatest family team of all to defend their adopted kin. Perhaps this is one reason why, in *The Radiant Path*, Tania's rivals are in no way portrayed in the more traditional, over-the-top, vile light of the ugly stepsisters of the Cinderella story with which we are more familiar in the West.

This role in fact falls to two 'exceptional' characters in the musical. First of all, there is Tania's mistress at the guest-house: clearly a residual *bourgeoise*, she is obsessed only by her own appearance (in much the same way as the fine ladies in *The Happy Guys*), painting her face, and posing in a fashion that she evidently feels will attract the dashing young engineer Lebedev, when he arrives to stay. The use of this excessive pantomime *grotesquerie* motivates the audience on two key issues: firstly, as in the classic version of the Cinderella story, Tania's innocence and virtue are thrown into sharp relief, unconsciously convincing both her and the spectator that she is in fact only persecuted for her superiority.[85] Secondly, on a more obvious level, Tania's mistress stands as a warning of the continued existence of class enemies in the Soviet Union, and the need for vigilance in order to 'unmask' these undesirable elements. Both of these functions are to an extent paralleled by the second 'exceptional' character: the arrival of Lebedev is followed by that of a more minor character, a former kulak from Tania's home village. Not only do the former kulak's lascivious attentions towards Tania cast Lebedev's obvious respect for the lowly housemaid into a good light, but the figure also functions as a more explicit reminder of the need for vigilance, as later on in the movie he does in fact turn out to be a wrecker and saboteur (although, characteristically for a musical, his evil actions are hardly dwelt upon).[86]

The characters of the landlady and the ex-kulak, then, perform important roles for the enlightenment of the film-going Soviet public, but they also illustrate rather nicely Bettelheim's point that the emotional turmoil of sibling rivalry is intimately bound up with the process of socialisation.[87] The story of Cinderella once again proves its worth for the purposes of socialist realism, insofar as the protagonist is exposed to prime examples of 'bad' – or antisocial – behaviour, and thus the essential elements of the *Bildungsroman* are set in

motion. There is no doubt that, of all Aleksandrov's musicals, *The Radiant Path* follows the course of the socialist realist 'master plot' most closely. We have already mentioned the triumph of Tania's personal and social development from lowly housemaid to weaver superstar and member of the Supreme Soviet – a fine illustration, as Turovskaya notes, of 'Lenin's dictum about every cook learning to govern'[88] – and we should also note that the 'Fairy Godmother' role for this Soviet Cinderella is played (in stark contrast to Tania's 'wicked stepmother' back at the guest house) by her local Party representative, Pronina.

The guiding hand of the Party in the form of Pronina sees Tania through all manner of characteristic fairy tale obstacles: the learning process, her rise up the ranks of the factory weavers, the news that a rival from another factory has bettered her previous record (a cause for joy – as Pronina reminds her – not sorrow), and of course her encounters not only with the 'class enemies' mentioned above, but also (like Gleb Chumalov, the hero of Fedor Gladkov's classic production novel *Cement*) with a bureaucratically-minded boss, Dorokhov, who is simply *too* careful. The final outcome is a stunning *tour de force* of musical finales – certainly the closest I have seen to a filmic representation of the notorious 'shining future' looked forward to by all socialist realist texts – as the record-breaking Tania travels to the Kremlin (the palace of the 'handsome prince') to receive her medal, engages in dialogue with her 'previous selves' through the device of talking mirrors, and sets out to fly over the capital in a magical car, to arrive at that great monument to the achievements of the heroic era of Stalinism, the All-Union Exhibition of Agriculture.

It should be quite clear, then, that by the end of *The Radiant Path*, the fairy tale has completely overtaken any semblance of realism that earlier portions of the movie might have promised. As in the case of Martynov's 'flight to the stratosphere', however, we are once more removed from the prosaic diegesis to be presented with things as they really are in *Soviet reality*. As much is made clear by the song that Tania sings into the mirrors: 'The fairy tale come true is being created by us.'[89] Meanwhile, the mirrors reflect back not only a foreshortened history of Tania's development (how quickly ordinary folk can become heroes in Soviet reality), but also, in the final reflection, a unitary identity that is as reassuring for Tania as it is misleading for psychoanalysts.[90] Aleksandrov's imagining of the utopian, ruthlessly exploiting every device available to the director of a musical, represents the pinnacle of personal fulfilment (as well as, to my mind, a pinnacle of film artistry), as Enzensberger explains: 'like bootlegging for an American gangster from an émigré

community, or boxing for a Black or Italian lad, Stakhanovism was the only way for an ordinary Soviet worker to outreach her or his rank.'[91] As in *Volga-Volga* – and as Enzensberger goes on to remark – such a dizzying *individual* success story is carefully recuperated by the social through cross-cuts of Tania's face with landmarks of Stalinist architecture: the message is that absolutely anyone can walk this 'shining path' out of her or his own particular ghetto, and this fits in very well with the spirit of inclusivity that we have already seen at work in the Stalin era – a belief in social regeneration that even underpinned the establishment of the Gulag.

All that is needed, it seems, is a combination of practical nous and political conscientiousness. Whilst the Party secretary Pronina provides the political framework, we are shown from the very start of the picture that Tania in no way lacks common sense and clever practical solutions. The opening shots that establish her lowly position in the 'Small Grand Hotel' also demonstrate Tania's seemingly boundless capacity for improvising labour-saving techniques and devices: whilst the landlady snoozes, Tania, significantly, responds to the wake-up call from Radio Moscow, and performs her own series of exercises that not only keep her in shape, but also feed the baby and start the day's cookery chores. This routine – performed to a variation on the *Happy Guys* theme – shows Tania, like Utesov, to be highly adept at *bricolage*, and once again her spatial practices represent an assertion of the self in conditions that are trying, to say the least. This self-assertion plays its role in the tale of a struggling woman who accepts assistance from a female representative of the Party to scale the heights of success – and all with apparently minimal reliance on men!

However, any final hopes that Aleksandrov may have at last produced a parable of women's liberation must once again be declared ill-founded. Just as the more serious-minded *Circus* followed the slapstick mayhem of *The Happy Guys*, so the visual humour of *Volga-Volga* became, in *The Radiant Path*, merely a device to open the film on a light-hearted note. The subsequent downgrading of Tania's *bricolage* of course also amounts to a limitation on her self-expression, and another significant change to the original plot of the film has been noted by Enzensberger – the recalcitrant boss, Dorokhov, was to have been replaced by Pronina, but the authorities saw fit to put the male engineer, Lebedev, in her place.[92] Such an action fits much better into the patriarchal framework of a film in which all the heroine's feats are presided over by men: 'The woman's power and independence are nevertheless circumscribed within the narrative by the invariable presence of "wiser" male superiors: she is the "doer", never the most authoritative "thinker" or "decision maker".'[93]

All of which, of course, brings us round to a discussion of relations of gender and power in Aleksandrov's musicals. As we have seen, throughout the 1930s Aleksandrov made use of the trope of the working-class woman made good, most particularly so in *The Radiant Path*, but he was by no means the only one to do so. In fact, from the earliest days of the Revolution, the Bolsheviks seized upon the figure of the working-class woman, for at least two reasons: first of all, they felt that a female figure would elicit a more ready supply of sympathy from audiences who might not entirely agree with some of the messages being put across. More important, however, is the idea that the working-class woman, suffering as she does from the twin oppressions of patriarchy and the class system, can be made to represent the ultimate in liberation. However, just as the 'woman question' was always shelved until 'the day after the Revolution', in Soviet iconography the woman only ever transcends *class* prejudice, remaining as she does the object of a patriarchal bargaining system: in fact, this partial liberation of the heroine in Soviet cinema often functions precisely as an implicit justification of the patriarchal order that allows such an event to take place at all!

The almost hysterical portrayal of, for example, Tania's happiness by the end of *The Radiant Path*, seeks to efface the ways in which the entire parable is informed by patriarchal assumptions. Quite apart from the extreme phallogocentrism implicit in discourse at the time, it is also obvious that, of the two modern versions of the Cinderella tale, the scenarists chose to base the story of Tania on Perrault's rather insipid and sanitised edition, rather than the considerably more earthy version set down by the Brothers Grimm.[94] In this case, the original tale of Cinderella has, by the time it becomes *The Radiant Path*, undergone a process of double-mediation: first of all, Perrault expunged elements that he considered vulgar or likely to upset the squeamish, so that the story could be told at court; secondly, this version was *then* refracted through the lens of socialist realism. If, as Bettelheim suggests, Perrault's Cinderella was somewhat less feisty than the heroine of the Grimm Brothers' version – voluntarily taking up residence in the ashes, for example, rather than being ordered there – by the time this heroine has transmogrified into Tania, it stands as a tribute to Orlova's acting skills that audiences were able to identify with such a fundamentally wet character at all. Although Tania is indeed the 'doer', the movie treads a narrow path, and Orlova is always having to battle with the machines for protagonist status: both can be seen to be under strict control, and if there is to be a 'happy ever after', it can only ever come about through male agency.

4 You *shall* go to the ball: Liubov' Orlova's Stakhanovite
Cinderella enters the socialist utopia with her surrogate
Prince Charming in *The Radiant Path* [*Svetlyi put'*, 1941]

Happy endings?

We have now reached a point in our discussion where we have seen
the textual and extratextual mechanisms by which an impression of
Utopia is produced in the musical comedies of Aleksandrov. In this
concluding section I would like to offer a brief account of the struc-
ture of that Utopia, and also to examine one or two motives behind
this very particular utopian vision. Having analysed the relation-
ships between symbolism and realism in the musicals, and the
resulting utopian 'feel' as an experience shared by the performers
and the diegetic and extradiegetic spectators, we could do worse
than to use *The Radiant Path* – 'the pinnacle of social and political
fantasy in pre-war Stalinist cinema'[95] – as a starting point for an
exploration of the topology of the socialist Utopia.

First of all, however, we must recall Dyer's utopian elements from
the classical Hollywood musical: his categories of abundance,
energy, intensity, transparency and community are on blatant dis-
play in all four of Aleksandrov's comedies analysed above. More
important, however, is Dyer's assertion that these categories offer an
explanation of why entertainment 'works', by demonstrating that
showbusiness 'is not simply the expression of eternal needs – it
responds to real needs *created by society*'.[96] Such an assertion not
only reflects exactly what Aleksandrov said of his very first musical,

The Happy Guys – that it represented a 'first response' to a specific demand of the era – but it also demands that we contextualise the Stalinist musical as both akin to, and distinct from, its Hollywood counterpart.

Of paramount importance in this act of contextualisation are two factors of the Stalinist musical that are not to be found in Hollywood, although, as we shall see, the one is in fact merely a subset of the other. As Collins has noted, despite scant reference to extradiegetic factors in the narrative of the Hollywood musical, the lyrics of the songs 'continually acknowledge some sort of difficult situation';[97] in the case of the title song of the 1937 Astaire/Rogers classic *Shall We Dance?* the lyrics 'Shall we dance, or keep on moping?' explicitly offer the 'liberation' of the dance as an antidote to the despair gripping the extradiegetic Depression-era America. The musical, then, attempts to protect itself from the harshness of the external economic climate by removing its protagonists to a utopian realm that is consciously distanced from the circumstances surrounding the production of the movie. In the Stalinist musical, however, it is precisely the extradiegetic circumstances that make the construction of Utopia possible: within the monoglot framework of socialist realism, no reference is made anywhere to social problems (with the exception of repeated rumours of specifically external threats to the happy existence of the 'real' people portrayed) and so, as Enzensberger points out: 'The Soviet musical enacts its Utopia in the here and now, in the present-day Soviet reality in which everyone works and, for that matter, works miracles.'[98]

We have already commented on the potential for conflating the condition of socialism with a state of Utopia, and at this point we should also bear in mind the 1936 constitution, which not only informed much of the plot of *Circus*, but also held as its cornerstone the dictum that the first stage of socialism was already achieved in the Soviet Union. The physical site of this Utopia was clearly Moscow in general – lavishly portrayed by landmarks of Stalinist architecture in all of Aleksandrov's musicals – and the Eden-like All-Union Exhibition of Agriculture in particular.

The constitution therefore legitimated the setting of the socialist Utopia in the Stalinist here and now, and certainly by the time of *Volga-Volga* and *The Radiant Path* all threat of hardship is removed from the world of the musical comedy. The principle that the only reason to go out to work in the first place is therefore not survival, but the improvement of both self and society, is one that runs consistently through Pyr'ev's *kolkhoz* comedies, and in Aleksandrov's *The Radiant Path*, as we have seen, it is figured specifically by competitive weaving. Any threat to the equilibrium of the utopian realm

of the musical posed by the individual's thirst for success or acknowledgement is also recuperated by her or his careful reintegration into the mass of society, all levels of which are able to take pride in the outstanding achievements of its heroes and heroines.

It would be fair to say that this drive towards improvement of the self and society mobilised the brothers and sisters of the Great Soviet Family into grand socialist competition between good and better. Rising to meet challenges and the conquering of nature had always played an integral role in the socialist realist text, but in cases such as *The Radiant Path*, the challenge is specifically laid down by a weaver from another factory who betters Tania's first record. Thus the theme of sibling rivalry is explicitly introduced, and we have already had occasion to comment upon it. However, I would like to extend the exploration of this topic to include a rather interesting angle thrown up by Bettelheim, who claims that, in modern versions of the Cinderella story (just such as *The Radiant Path*):

Sibling rivalry takes the place of an oedipal involvement that has been repressed, as the center of the plot. In real life, positive and negative oedipal relations, and guilt about these relations often remain hidden behind sibling rivalry. However, as happens frequently with complex psychological phenomena which arouse great guilt, all that the person consciously experiences is anxiety due to the guilt, and not the guilt itself, or what caused it.[99]

There can be little doubt that Tania is characterised as much by her anxiety as by her will to succeed: at every stage along her path to success she frets that she will fall behind, or fail to succeed. And yet, as we have seen, the threat of hardship is non-existent in the world of *The Radiant Path*, and so we must delve deeper, to try to find possible psychological motives for an anxiety that has apparently no basis in Tania's practical circumstances.

Another way in which sibling rivalry is intimately bound up with the oedipal triangle and socialisation is that its ultimate aim is to win approval for the child from her or his parents.[100] However, as we well know, the genre of socialist realism, and particularly its musical comedies, are characterised by absent parents and orphan protagonists. Enzensberger makes as much clear when she states: 'The absent family of the Soviet cinema of the 1930s and 1940s is a subject worthy of separate investigation.'[101] Although this study obviously does not represent such a full-blown investigation into this issue, I hope that I have at least demonstrated the role of the State in parenting these orphan hero(in)es, a theory that leads ultimately to the role of Stalin as father to the nation. If Stalin's appearance in Vertov's *Lullaby* [*Kolybel'naia*, 1937] were not enough to justify such a contention in the field of cinema, then we need look no further

than Friedrikh Ermler's 1936 film *Peasants* [*Krestian'e*] which features a mother's dream, in which she is walking along with her child and, in the place of his biological father, the figure of Stalin himself (and this is not even in the fantasy world of the musical!). The object of the frenetic sibling rivalry in Stalinist musicals, then, may be seen as the establishment of the self by winning the approval of Stalin.

This idea is exactly what I had in mind when I mentioned that Stalin presided over all of Aleksandrov's musicals, whilst remaining absent from them. The presence of the 'Father of the Nation' is marked all the more strongly by his absence, although signifiers of his might are scattered throughout – the icon-like portrait in the Red Square parade that closes *Circus*, for example, or his name lent to a steamer in *Volga-Volga* (and printed, in a classic mixture of realism and symbolism, on a life-buoy!). We have also already mentioned the Stalinist landmarks that signify the new Moscow, and it would not be an overstatement to suggest that Stalin was so closely identified with the capital as to necessitate no physical appearance: just as the children at the end of *Lullaby* rush into the arms of their symbolic father, we have seen the effects of the pull of Moscow as 'center of ideological gravity' on the protagonists of our musicals. Von Geldern has remarked on the structure of the new Moscow – concentric circles radiating outwards from the Kremlin, strengthening the idea of the ancient fortress at the very heart of the country[102] – and the logical conclusion implicit to this idea is that of Stalin at the heart of the heart, the holiest of holies.

In a sense, then, it could be argued that Stalin simply did not need to put in an appearance, and yet it is still possible to isolate one more reason why Stalin, as a physical entity (rather than the embodiment of an idea), remained absent from Aleksandrov's musical comedies. He was obviously not self-conscious about actors portraying him on countless other occasions – as well as *Lullaby*, the figure of Stalin also appears in Kalatozov's *Valerii Chkalov* [1941] and Kozintsev and Trauberg's *The Vyborg Side* [*Vyborgskaia storona*, 1938], among others.[103] On the other hand, in the case of Fridrikh Ermler's *The Great Citizen* [*Velikii grazhdanin*, two parts, 1937–39], which deals specifically with the purges and show trials, Stalin took a very close personal interest in the script, and reported a number of 'errors' to Shumiatskii including, rather bluntly, his third point: 'The reference to Stalin must be excluded. Instead of Stalin, the Central Committee of the Party must be mentioned.'[104]

Whilst there are fairly obvious reasons why Stalin might wish to dissociate himself from the subject matter of Ermler's film, we might also note that the purges and show trials were both manifestations of intra-necine feuding, key moments in Stalin's struggle (against

his erstwhile 'brothers') to secure and maintain the status of supreme patriarch. Not only is patriarchy, as we have already discussed, at its most powerful when it is able to render itself invisible; the cinematic representation of these struggles as taking place *solely amongst brothers* – along the 'horizontal' kinship axis – also entails the issue of a foreclosure, as in Margarita Barskaia's *Father and Son* [*Otets i syn*, 1937] and Eisenstein's abortive *Bezhin Meadow* [*Bezhin lug*], of father/son tension.

This being the case, it is not sufficient, to my mind at least, to suggest with Enzensberger that 'the conventions of comedy prohibited the appearance or even mention of Stalin in so light a genre'.[105] Whereas it is certainly true to say that the comedy genre with which we are dealing appears to be fairly light-hearted, we might also ask what, exactly, *are* the conventions specific to Soviet comedy – and what are the tensions inherent to Aleksandrov's musicals that would necessitate a repeated effacement of the Great Father? One argument that has recurred throughout this book so far is that, unlike other classics of socialist realism, which tend towards a depiction of an individual's path to consciousness, and her or his role in constructing the socialist Utopia, the musicals of Aleksandrov (and possibly to an even greater extent those of Pyr'ev) are actually set in, and concerned with, the depiction of that Utopia.

If we consider the comparisons between socialism – as the condition of a society – and Utopia, we may infer a model self-regulating community in which hierarchies and laws are made redundant. Not only does this justify, to a certain extent, the burlesque parodies of bureaucrats such as Byvalov in *Volga-Volga*, but it also lays down a principle of absolute equality, that would at first sight appear to circumvent the need for the law of the castrating father as the basis of social and, of course, gender relations. In fact, I would contend that a deeply symbolic reason for Stalin's absence from the musical genre has its roots at the very heart of the patriarchal system the leader established with the so-called 'cult of personality'.

The model fairy tale for this genre was, as we know, Cinderella. Not only does Bettelheim point out that the lowly position adopted by Cinderella 'in the ashes' was in fact a very highly-respected position under paganism – that is, until the switch from the worship of a mother goddess (Vesta) to that of an 'Almighty Father' – he goes further, to interpret Cinderella as a parable of the process of mourning the archaic (pre-oedipal) mother as a means by which to resolve the Oedipus complex.[106] In spite of Tania's song to her late mother – 'Mother, look, it's me, Tania. No longer downtrodden, but business-like and famous'[107] – I would argue that, in *The Radiant Path*, no such mourning process takes place, and this must

raise the question of whether the Oedipus complex is resolved at all by the children of the Great Soviet Family on screen.

Let us take another angle: the major crisis point of the Oedipus complex is the child's recognition of sexual difference. Aleksandrov's comedies, however, abound with an almost hysterical effacement of all types of difference. This is perhaps most obviously the case at the end of *Circus*, as Marion Dixon's black baby is passed around the multi-ethnic audience inside the Soviet big top, and lullabied in several different languages ('There are no longer black or coloured races'!). We may also see, however, that the androgynous dress code adopted by Tania in the workplace operated at a deeper level than the simple allaying of male fears of the female invasion of a space traditionally demarcated and gendered masculine. Finally, of course, the submerging of the individual into society (often, as we saw in the last chapter, worked out through a refusal to portray the psychological complexity of the 'living man' championed by RAPP) parallels the ultimate effacement of difference between the 'ordinary' performers in these musicals and the audiences watching them, by the tropes and figures of interpellation outlined throughout this chapter.

According to Bettelheim, the 'happy ever after' of most fairy tales amounts to a return to the pre-oedipal state of primary narcissism: 'the little boy's ideal is just he and his princess (Mother), all their needs and wishes taken care of, living by themselves and for each other forever'.[108] The frantic disavowal of difference in Aleksandrov's musicals backs up this quasi-utopian ideal, and I would argue that the effacement of Stalin-as-father from the oedipal triangle represents an almost tangible promise, a *sense of Utopia located in the here and now* of Stalin's Soviet Union.

Such a conclusion not only accounts for the apparent inactivity of male heroes in both *Volga-Volga* and *The Radiant Path*, but may also act as a starting point to understand the quasi-psychotic nature of socialist realist texts in the Stalin era as mentioned above. Obviously this is only offered as a tentative suggestion at this stage, but is it unfeasible that the absence of the symbolic father figure in Aleksandrov's musicals could account for the persecution complexes and rigorous internal consistencies of these socialist realist dreams? After all, as Freud remarked at the turn if the century, it is not only dreams that represent wish fulfilment, but also psychoses;[109] furthermore, we have already discussed the effacement of father/son tensions in more conventional Stalinist films, and it is precisely such a 'foreclosure of the Name-of-the-Father' – a failure of the originary paternal interdiction that projects the child into (and, ideally, through) the Oedipus complex – that Lacan sees at the

root of psychosis.[110] For now, however, we must leave this topic to one side, and go on to examine what other effects this failure to resolve the Oedipus complex may have had on the boys of the Great Soviet Family, and we shall do this through an examination of the *kolkhoz* musicals of Aleksandrov's rural counterpart, Ivan Pyr'ev.

Notes

1 Boris Shumiatskii, cited in Richard Taylor and Ian Christie (eds), *The Film Factory: Russian and Soviet Cinema in Documents, 1896–1939*, (London: Routledge, 1994), p. 369.

2 See especially Maya Turovskaya, 'I. A. Pyr'ev i ego muzykal'nye komedii. K probleme zhanra', *Kinovedcheskie zapiski*, 1 (1988), 111–46; Maria Enzensberger, '"We Were Born to Turn a Fairy Tale into Reality": Grigori Alexandrov's *The Radiant Path*', in Richard Taylor and Derek Spring (eds), *Stalinism and Soviet Cinema* (London: Routledge, 1993), pp. 97–108; the fairy tale approach is also used by Oksana Bulgakova, 'The Hydra of the Soviet Cinema: The Metamorphoses of the Soviet Film Heroine', in Lynne Attwood (ed.), *Red Women on the Silver Screen: Soviet Women and Cinema from the Beginning to the End of the Communist Era* (London: Pandora Press, 1993), pp. 149–74.

3 Cf. Rick Altman (ed.), *Genre: The Musical* (London: Routledge and Kegan Paul, 1981); Richard Dyer, 'Entertainment and Utopia' in *Only Entertainment* (London: Routledge, 1992), pp. 17–34.

4 Richard Stites, *Russian Popular Culture: Entertainment and Society Since 1900* (Cambridge: Cambridge University Press, 1992), p. 72.

5 Vladimir Propp, *Morphology of the Folktale*, 2nd edn, trans. Lawrence Scott (Austin and London: University of Texas Press, 1968), p. 23 (his italics).

6 Propp, *Morphology of the Folktale*, p. 7.

7 See Vladimir Propp, *Theory and History of Folklore*, trans. Ariadna Y. Martin and Richard P. Martin and several others, ed. Anatoly Liberman (Manchester: Manchester University Press, 1984), p. 22.

8 Jack Zipes, *Breaking the Magic Spell: Radical Theories of Folk and Fairy Tales* (London: Heinemann, 1979), p. 3.

9 Zipes, *Breaking the Magic Spell*, pp. 139–40.

10 Katerina Clark, *The Soviet Novel: History as Ritual*, 3rd edn (Bloomington and Indianapolis: Indiana University Press, 2000), pp. 15–24 (p. 19).

11 Reprinted in James von Geldern and Richard Stites (eds), *Mass Culture In Soviet Russia: Tales, Poems, Songs, Movies, Plays and Folklore, 1917–1953* (Bloomington and Indianapolis: Indiana University Press, 1995), pp. 237–8.

12 Clark, *Soviet Novel*, p. 116.

13 Jack Zipes, *Happily Ever After: Fairy Tales, Children and the Culture Industry* (London: Routledge, 1997), p. 66.

14 Bruno Bettelheim, *The Uses of Enchantment: The Meaning and Importance of Fairy Tales* (New York: Alfred A. Knopf, 1976), p. 5.

15 Bettelheim, *Uses of Enchantment*, p. 6.

16 Clark, *Soviet Novel*, p. 17.

17 Zipes, *Happily Ever After*, p. 78.

18 Zipes, *Happily Ever After*, p. 76.

19 Zipes, *Breaking the Magic Spell*, p. 17.

20 Zipes, *Happily Ever After*, p. 66.

21 It is perhaps also worth considering here the fate of Pinocchio, seen by Zipes as beaten into social submission by his symbolic father Gepetto, who, without any concern for the boy's identity or desires, wishes to use him simply as a 'meal ticket': Zipes, *Happily Ever After*, p. 80.

22 Peter Kenez, for example, refers to Soviet comedies as 'often silly', and comments on 'the vulgarity' of *The Radiant Path* as being 'most painful at the end of the film'. Peter Kenez, *Cinema and Soviet Society from the Revolution to the Death of Stalin*, 2nd edn (London and New York: I. B. Tauris, 2001), pp. 115, 161.

23 For a brief mention of the attempts to build a *Sovetskii Gollivud*, see Richard Taylor, 'Ideology as Mass Entertainment: Boris Shumyatsky and Soviet Cinema in the 1930s', in Richard Taylor and Ian Christie (eds), *Inside the Film Factory: New Approaches to Russian and Soviet Cinema* (London: Routledge, 1991), pp. 193–216 (pp. 214–15).

24 Bettelheim, *Uses of Enchantment*, p. 10.

25 Stites, *Russian Popular Culture*, p. 88; '*estrada*', or '*estradnaia muzyka*', may be loosely-defined as middle-or low-brow culture aiming to entertain, rather than stimulate the consumer: see Stites, *Russian Popular Culture*, pp. 16–22.

26 Stites, *Russian Popular Culture*, p. 89.

27 Stites, *Russian Popular Culture*, p. 89.

28 Katerina Clark, 'Aural Hieroglyphics? Some Reflections on the Role of Sound in Recent Russian Films and Its Historical Context', in Nancy Condee (ed.), *Soviet Hieroglyphics: Visual Culture in Late Twentieth-Century Russia* (Bloomington and London: Indiana University Press and BFI Publishing, 1995), pp. 1–21 (p. 3).

29 Svetlana Boym, *Common Places: Mythologies of Everyday Life in Russia* (Cambridge, Mass. and London: Harvard University Press, 1994), p. 112 (my italics).

30 Dyer, 'Entertainment and Utopia', pp. 18–19.

31 Dyer, 'Entertainment and Utopia', p. 18.

32 Jim Collins, 'Toward Defining a Matrix of the Musical Comedy: The Place of the Spectator Within the Textual Mechanisms', in Altman (ed.), *Genre: The Musical*, pp. 134–45 (p. 145).

33 These issues – in particular the look, or '*regard*', of the star directly at the cinemagoers – are explored in Collins, 'Toward Defining a Matrix', pp. 139–40.

34 Martin Sutton, 'Patterns of Meaning in the Musical', in Altman (ed.), *Genre: The Musical*, pp. 190–6 (p. 191).

35 Sutton, 'Patterns of Meaning', p. 195.

36 This clearly bears some relation to the positioning of the likes of Valerii Chkalov as action heroes. It is interesting, however, to note the different ways in which the musical attempts – if at all – to disavow the gaze of the spectator.

37 Steven Cohan, '"Feminizing" the Song-and-Dance Man: Fred Astaire and the spectacle of masculinity in the Hollywood musical', in Steven Cohan and Ina Rae Hark (eds), *Screening the Male: Exploring Masculinities in Hollywood Cinema* (London: Routledge, 1993), pp. 46–69 (p. 62).

38 Sutton, 'Patterns of Meaning', pp. 192–3.

39 Michel de Certeau, *The Practice of Everyday Life*, trans. David Rendall, (Berkeley: University of California Press, 1984), p. xv.

40 Mark Simpson, *Male Impersonators: Men Performing Masculinity* (London: Cassell, 1994), p. 276 (my italics).

41 Robin Wood, 'Art and Ideology: Notes on *Silk Stockings*', in Altman (ed.), *Genre: The Musical*, pp. 57–69 (p. 67).

42 For analyses of the plot structure of *Circus*, see Moira Ratchford, '*Circus* of 1936: Ideology and Entertainment Under the Big Top', in Andrew Horton (ed.), *Inside Soviet Film Satire: Laughter with a Lash* (Cambridge: Cambridge University Press, 1993), pp. 83–93; Richard Taylor, 'The Illusion of Happiness and the Happiness of Illusion: Grigorii Aleksandrov's *The Circus*', *The Slavonic and East European Review*, 74 (1996), 601–20 (p. 604).

43 Ratchford, '*Circus* of 1936', p. 84.

44 Ratchford, '*Circus* of 1936', p. 85.

45 Taylor, 'The Illusion of Happiness', p. 604.

46 Stites, *Russian Popular Culture*, p. 19.

47 Ratchford, '*Circus* of 1936', p. 86.

48 Reprinted in von Geldern and Stites (eds), *Mass Culture*, pp. 271–2.

49 Propp, *Theory and History of Folklore*, p. 26.

50 Ratchford, '*Circus* of 1936', p. 88.

51 Taylor, 'The Illusion of Happiness', p. 615. In fact, Dixon's self-confidence grows much faster than her linguistic competence, the development of which is pretty limited.

52 Ratchford, '*Circus* of 1936', p. 89.

53 Ratchford, '*Circus* of 1936', p. 88.

54 Boym, *Common Places*, p. 114.

55 Zipes, *Breaking the Magic Spell*, p. 17.

56 Stites, *Russian Popular Culture*, p. 79.

57 Jay Leyda, *Kino: A History of the Russian and Soviet Film* (London: George Allen and Unwin, 1960), p. 342.

58 Stites, *Russian Popular Culture*, pp. 17–18.

59 Stites, *Russian Popular Culture*, p. 91.

60 Maya Turovskaya, '"Volga-Volga" i ee vremia', *Iskusstvo kino* 3 (1998), 59–64 (p. 59). An English translation of an earlier version of this paper is also available as 'The Strange Case of the Making of

Volga, Volga', trans. Andrew Andreyev, in Horton (ed.), *Inside Soviet Film Satire*, pp. 75–82.

61 Once again a parallel is established here with *The Happy Guys* and Utesov's shepherd hero, for whom morality is less of an issue than success.

62 Turovskaya, '"Volga-Volga" i ee vremia', p. 63. The 'Great Helmsman' in question is, of course, a reference to Stalin's image as 'driving' the Soviet Union towards its shining future.

63 Turovskaya, '"Volga-Volga" i ee vremia', p. 62.

64 Taylor, 'The Illusion of Happiness', p. 619.

65 One of the structuring motifs of Anton Chekhov's play *Three Sisters* [*Tri sestry*], which opened in Moscow in 1901, is not only the dull frustration of the provincial daily grind, but also the increasingly-apparent incapacity on the part of its eponymous heroines to realise their dreams of relocating to Moscow.

66 Jacques Lacan, 'Seminar on *The Purloined Letter*', trans. Jeffrey Mehlman, *Yale French Studies*, 48 (1972), 38–72 (72).

67 Jacques Derrida, 'Le Facteur de la Vérité', in *The Post Card: From Socrates to Freud and Beyond*, trans. Alan Bass (Chicago and London: University of Chicago Press, 1987), pp. 411–96 (p. 489, his italics).

68 As such, the film represents a cinematic counterpart to an analogous development in literature – the creeping return of bourgeois values in socialist realism. See Vera Dunham, *In Stalin's Time: Middle-Class Values in Soviet Fiction* (Cambridge: Cambridge University Press, 1976).

69 James von Geldern, 'The Centre and the Periphery: Cultural and Social Geography in the Mass Culture of the 1930s', in Stephen White (ed.), *New Directions in Soviet History* (Cambridge: Cambridge University Press, 1992), pp. 62–80 (p. 62).

70 Von Geldern, 'The Centre and the Periphery', p. 68.

71 Von Geldern, 'The Centre and the Periphery', p. 70.

72 Mentioned by Maya Turovskaya in Dana Ranga's 1997 documentary film *East Side Story* (produced by Andrew Horne, in association with WDR and Docstar/Canal +).

73 Graeme Gill, *Stalinism*, 2nd edn (Basingstoke: Macmillan Press, 1998), p. 34.

74 Letter to Orlova from textile workers, cited in Enzensberger, '"We Were Born to Turn a Fairy Tale into Reality"', p. 108 (my italics).

75 Dyer, 'Entertainment and Utopia', p. 24.

76 Enzensberger, '"We Were Born to Turn a Fairy Tale into Reality"', p. 97.

77 The idea of dreams representing wish-fulfilment is one of the major theses of Freud's *The Interpretation of Dreams*, trans. James Strachey, ed. Strachey, Alan Tyson and Angela Richards, *Penguin Freud Library*, *vol. 4* (Harmondsworth: Penguin, 1991).

78 Richard Stites, *Revolutionary Dreams: Utopian Vision and Experimental Life in the Russian Revolution* (Oxford: Oxford University Press, 1989), p. 41.

79 Cited in Taylor and Christie (eds), *Film Factory*, p. 327.

80 Stites, *Russian Popular Culture*, p. 91.

81 Freud, *Interpretation of Dreams*, p. 345.

82 Bulgakova, 'The Hydra of the Soviet Cinema', p. 158.

83 Bettelheim, *Uses of Enchantment*, p. 236.

84 Von Geldern and Stites (eds), *Mass Culture*, pp. 235–6.

85 Bettelheim, *Uses of Enchantment*, p. 241.

86 Enzensberger, '"We Were Born to Turn a Fairy Tale into Reality"', pp. 101–2.

87 Bettelheim, *Uses of Enchantment*, p. 242.

88 Maya Turovskaya, 'Woman and the "Woman Question" in the USSR', in Attwood (ed.), *Red Women*, pp. 133–40 (p. 138).

89 Quoted by Enzensberger, '"We Were Born to Turn a Fairy Tale into Reality"', p. 105.

90 See the remarks on Lacan's 'mirror stage' in the first chapter of this book.

91 Enzensberger, '"We Were Born to Turn a Fairy Tale into Reality"', p. 105.

92 *Ibid.*

93 Enzensberger, '"We Were Born to Turn a Fairy Tale into Reality"', p. 100.

94 For a more detailed discussion of the relative merits of the two versions of 'Cinderella', see Bettelheim, *Uses of Enchantment*, pp. 250 ff.

95 Stites, *Russian Popular Culture*, p. 91.

96 Dyer, 'Entertainment and Utopia', p. 24 (his italics).

97 Collins, 'Toward Defining a Matrix', p. 136.

98 Enzensberger, '"We Were Born to Turn a Fairy Tale into Reality"', p. 98.

99 Bettelheim, *Uses of Enchantment*, p. 249.

100 See Bettelheim, *Uses of Enchantment*, p. 238.

101 Enzensberger, '"We Were Born to Turn a Fairy Tale into Reality"', p. 99.

102 Von Geldern, 'The Centre and the Periphery', p. 64.

103 In fact, as Ian Christie remarks, 'After 1939 it became customary to include scenes involving Stalin whenever possible and these soon became climactic.' Christie also offers one of numerous examples of a revised print (of Kozintsev and Trauberg's *The Vyborg Side* [*Vyborgskaia storona*, 1939] – released in a quite literally 'de-stalinised' version – that complements my own comments on the post-Stalin 're-touching' of *Valerii Chkalov*. See Ian Christie, 'Canons and Careers: The Director in Soviet Cinema', in Taylor and Spring (eds), *Stalinism and Soviet Cinema*, pp. 142–70 (pp. 162–63).

104 The letter is quoted in more detail in Kenez, *Cinema and Soviet Society*, p. 133.

105 Enzensberger, '"We Were Born to Turn a Fairy Tale into Reality"', p. 104.

106 Bettelheim, *Uses of Enchantment*, pp. 254–7.

107 Quoted by Enzensberger, '"We Were Born to Turn a Fairy Tale into Reality"', p. 104.

108 Bettelheim, *Uses of Enchantment*, p. 112.

109 Freud, *Interpretation of Dreams*, p. 163.

110 See Jacques Lacan, 'On a Question Preliminary to Any Possible Treatment of Psychosis', in *Ecrits: A Selection* (London: Tavistock, 1977), pp. 179–225; also, more exhaustively, his *Seminar 3: The Psychoses*, trans. Russell Grigg (London: Routledge, 1993).

Countryphile: men in labour in the collective farm comedies of Ivan Pyr'ev

All boys want to drive tractors. (Judy Finnegan)[1]

Virgin soil and scorched earth: the battle for the countryside

From the earliest days of the Revolution, the Bolsheviks had always realised the paramount importance of winning the support of the Russian peasantry. Russia's history from the time of Peter the Great onwards is a long litany of centralised reforms failing to penetrate deep into the countryside, and the traditional backwardness of the peasants lies at the heart of the *intelligentsiia/narod* dichotomy – the divide between the men of letters in the cities and the uneducated rural masses – that acts as a structuring binary of so much Russian culture. In this respect, Lenin's decree on land rights, announced just days after the Revolution, demonstrated that the Party was not willing to become similarly bogged down in such a politically-charged ideological minefield: by abolishing private land ownership and redistributing the land among the peasantry, as Geoffrey Hosking points out, the decree 'gave the peasants what most of them wanted at the time, while making no mention of the ultimate Bolshevik aim of nationalization of the land'.[2]

I shall begin this chapter with a brief outline of the drive to wholesale collectivisation of the countryside, a process that more or less coincided with the first Five Year Plan in the Soviet city. I also hope to demonstrate the ways in which rural culture was shaped through the turbulent era of Cultural Revolution, just as we saw in the towns in chapter 2, into a containing and masculinising discourse that would

'tame' not only renegade discursive forms, but the very 'femininity' of the Russian land.

Lenin also quickly realised that decrees alone would be insufficient to gain the level of support the Bolsheviks needed in the provinces. More importantly, the peasantry needed to learn, in a sense, a whole new way of thinking: the purpose of the 'agit-trains' that we mentioned at the start of chapter 2 resided principally in instilling such new political and cultural points of reference into the peasant psyche. For all their missionary zeal, however, rural support for the Bolsheviks remained insecure throughout the 1920s, with the peasants rather perversely refusing to play the roles allotted to them by Marxist materialist history, and simply making what they could of the situation. From one point of view, of course, the peasants had never exactly had an easy time under any centralised administration, and it would be harsh to blame them for taking advantage of the cautious liberalism of the New Economic Policy (which allowed for a certain degree of private enterprise in the country as much as the city) to try to better their lot. By the late 1920s, however, the State held rather a different opinion on the subject: a grain procurement crisis early in 1928 was threatening to starve the major cities of the Soviet Union, and with Stalin's defeat of the market-oriented Right Opposition in April of the same year, 'Revolution from above' – the rallying cry of the plan economists – put collectivisation and grain requisition to the top of the agenda, and at the same time signalled an end to NEP.

Of course, collectivisation was hardly a new idea by 1928 but, as Moshe Lewin points out, the established collective and state farms (the *kolkhozy* and *sovkhozy*) had always been seen by the State as the poor relations of the countryside: now, however, with Stalin characterising the disparity between socialist cities and private farmsteads as equivalent to the nation 'walking on two unequal legs', forced collectivisation and amalgamation of farms appeared to represent a tactical pre-emptive strike against any further grain crises.[3] If the regime was indeed being held to ransom by the richer peasants (known as the *kulaki*) hoarding their grain in order to wring more and more concessions to private enterprise, then it would obviously make sense to appropriate their land for the benefit of the nation – just as private landowners had been dispossessed in October 1917. The 'liquidation of kulaks as a class' was announced in December 1929, and at the same time the notion of voluntarism was eliminated from the process of collectivisation.

There followed one of the most bitter and hard-fought struggles of the entire Stalin era. The frantic pace of collectivisation, combined with the sheer lack of co-ordinated action on the part of the

government, and almost pathological obstinacy on the part of the peasants, all make for a distinctly chaotic and troubled period throughout the Soviet countryside. The State's plans were at best provisional and lacking much in the way of long-term vision (aside, of course, from the ultimate goal of wholesale collectivisation): the peasantry – and naturally the kulaks first and foremost amongst them – were blamed for the increasingly obvious shortcomings of the Five Year Plan in the cities; emergency powers were requested and granted to establish a more ruthlessly efficient system of grain acquisition and to punish the 'enemies of the people' who, it seemed, were pouring out of the woodwork of the old peasant holdings; and of course the mass-media was mobilised to enlist popular support, as Lewin remarks:

[T]he press was to be full of denunciations of the kulaks and appeals for mass collectivisation. The incitement to violent methods was barely concealed, though no definite indication was given about the nature or extent of these methods, or how they were to be applied. This was no accident. The leadership had now opted not for reforms but for revolution.[4]

The addition of press campaigns to the physical attacks on the peasantry perhaps characterises the era as a kind of precursor to the 'Terror' unleashed in the cities in the second half of the 1930s, and the waves of articles followed by arrests, imprisonments and executions are indeed, with hindsight, reminiscent of this era of 'show-trials' and Orwellian 'doublethink'. In fact, as we have seen, the tone of the articles, as well as the broader cultural production of the time, harked back more to the days of the Civil War, with ideological zeal and utopian fervour very much the order of the day. Not only was the rhetoric of struggle revived at the time, as Graeme Gill points out, to impart a heroic meaning to the lives and actions of the Red Army Officers sent out into the countryside,[5] but Hosking also cites two examples of the concrete terms in which the leadership viewed the situation. From the pages of *Pravda* and *Izvestiia* Maxim Gorky told readers that the country could consider itself 'in a state of civil war', whilst from the Kremlin, Stalin himself reminded the novelist Mikhail Sholokhov, who had protested about the violent coercion at work in the villages, that the kulaks were fighting 'a silent war against Soviet power'.[6]

Stalin is almost uncannily accurate here, at least as far as the silence of the peasants is concerned: without a voice of their own, the details of the peasants' resistance to the 'Revolution from above', both by taking up arms, and the more traditional scorched earth tactic, have only recently been pieced together.[7] Confusion appeared to reign in the villages: peasants wary of over-production – and the

concomitant danger of being labelled a *kulak* – sowed grain on ever-decreasing areas of land, and slaughtered great herds of cattle rather than surrender them to the *kolkhoz*.

Representing the country

The rhetorical portrayal of the chaotic elemental masses in the countryside, so desperately in need of enlightenment and political consciousness, also recalls Civil War culture, when the Bolsheviks had been depicted as bringing their Enlightenment patrimony to the reason-starved outposts of the former Russian Empire. Again there is a difference with later Stalinist culture in that, as we shall see, the *kolkhoz* comedies of Ivan Pyr'ev rely very heavily on a pre-existing hierarchical order across the steppes, and in fact take for granted a certain level of *kul'turnost'* in the civilised 'Potemkin villages' in which they are set.[8] Furthermore, just as Pyr'ev's films reflect the slick production values and 'pure entertainment' ethos of the Hollywood musical, one of the most famous Soviet films from the time of the collectivisation process – although not itself directly linked with the campaign – is of course Eisenstein's *The Old and the New* [*Staroe i novoe*, 1929], a solid example of the avant-garde film techniques pioneered in cinematography during the first decade of Soviet power.

The plot of *The Old and the New* charts the personal and professional development of a humble peasant woman, Marfa Lapkina, as she rises from being a simple farm labourer to become the politically-conscious head of her now-prosperous collective. From this synopsis alone, it would appear to have plenty in common with the later works of Aleksandrov, who worked on the movie as Eisenstein's assistant. On closer examination, however, Lapkina reveals herself to be little more than a cipher representing the Soviet land, unlike the positive heroines later played by Liubov' Orlova, who were able to attract a great deal of human sympathy. Although, in a parallel with Orlova's characters, success here is not measured in terms of personal autonomy – the figure of the Party agronomist looms ever-present in the background – the action of the film documents not so much Lapkina's development as that of the farm itself, proof of which is offered by the collective's new acquisitions: a bull, a tractor, and a milk separator that has become somewhat notorious amongst film analysts. Along the way, great pains are taken to portray the liberation of the countryside from the anachronistic, and frankly unreliable yoke of patriarchal Orthodox Christianity, but it should be noted that the plot merely replaces one patriarchal dogma with another (figured rather magnificently by the rampant bull) and, as

Lynne Attwood points out, 'the machines are the film's real heroes. The milk separator is depicted as a virtual god, promising the peasants heaven on earth; but unlike the one they worshipped in the past ... this one will not let them down.'[9]

The machines themselves are in fact no less potent symbols of masculinity than the bull, and none more so than the milk separator. The sequence of shots in which it is first set up and demonstrated is a cinematic *tour de force*, recalling the tense expectancy of an earlier scene in which peasants await in vain an answer to their prayers for rain. On this occasion, however, their prayers receive an unequivocal response, as Eisenstein has the separator shower Lapkina's face with cream, and makes no attempt to disguise the evident pleasure experienced by the recipient of this modern-day holy spirit.

The regular, controlled rhythms of the hero-machine reverberated throughout all Five Year Plan culture, and provided a rather neat metaphor for the horizontal, egalitarian kinship model for a society in which all men played their own part in the smooth running of the Soviet machine: with the smallest nuts and bolts as valuable as the largest 'driving axle', the emphasis was still very much at this point on the teleological subjugation of natural resources to the will of the proletarian dictatorship. As we suggested in chapter 2, this involved the implicit imposition of masculinised 'consciousness' over the elemental spontaneity of not only the countryside but also discursive formations in general. As we shall see, the theme of man (*as man*) conquering nature never really went away, although on the surface the presumed mastery of man over nature allowed, as von Geldern remarks, for 'a great pride in the vast frontier, which, as it had for nineteenth-century Americans, provided a new source for the national identity. There was consonance between Soviet man and the periphery.'[10]

To continue our discussion from chapter 2, however, we may recall how Susan Faludi has pointed out the ways in which the American frontier narratives of the nineteenth century became themselves involved in an ideological battle for a dominant paradigm of masculinity in the middle of the twentieth century. An immensely popular figure of frontier folklore, Daniel Boone, represents for Faludi a specific ideal of masculinity that held sway until shortly after the end of the Second World War: a frontier hero who went out to tame the wilderness, but with the specific goal of creating a space within which to settle and raise a family, Boone epitomises a utilitarian, nurturing masculinity that involved taking care of one's fellow man as much as protecting womenfolk. Set against Boone, however, was of course the figure of the 'king of the wild frontier' himself, Davy Crockett. Crockett has little truck with utilitarianism: using the frontier almost as a stage, he is pictured by

Faludi as typifying an intensely spectacular masculinity – one that performs feats of strength, even hypermasculinity, purely as display. The ornamental nature of this masculinity is condensed into Crockett's most famous accessory, his coonskin hat. The fact that Crockett, wearing the spoils of war on his head, became a walking advertisement for his own spectacular macho masculinity sets him apart from the self-effacing Boone, but for Faludi it is the advent of the mass-mediated 'American century' that decided the outcome of the discursive struggle of these paradigms: 'In his incarnation as a cleaned-up Walt Disney television character in 1955, Davy Crockett would eclipse Daniel Boone for good.'[11]

In the same way, as the Soviet Union left behind its utilitarian origins and developed into an altogether more spectacular society, the 'living man' – that everyday member of society – took on the status of Soviet superhero. Whereas the 'living men' had been extraordinarily ordinary, the 'New Soviet Men' were ordinarily extraordinary, and from the pages of books and newspapers, from the radio and the silver screen, the message was, as von Geldern points out, one of inclusivity[12] – encapsulated in, for example, Liubov' Orlova's winks to camera. In another parallel with the 'land of opportunity', then, the notion that *anybody could become a hero* was instilled into the masses. The extent to which ordinary Soviet citizens were effectively wandering around in a constantly-projected film will come up for discussion in our concluding remarks.

First of all, however, we may establish that by the middle of the 1930s, two main drives are to be detected behind the impulse to make a series of films that has been consistently decried and lampooned in roughly equal measure ever since. To begin with, of course, there was the sheer practical necessity of producing films depicting the 'correctness of the Party line' in the countryside, but this was clearly nothing new. Katerina Clark has demonstrated the ways in which socialist realism as a genre was constructed so as to legitimise the Revolution itself, which for more conventional Marxists was an act of heresy.[13]

It is true that non-official culture was never completely foreclosed, but, as we suggested earlier, the social group with the least possibility of voicing its 'true' opinions must surely have been the peasantry. Just as documented evidence of the peasants' resistance to collectivisation has proved difficult to come by, forms of rural culture more 'authentic' than the mass-produced folklorism with which we are primarily concerned are only just coming to light. Maya Turovskaya points out that there was effectively no *samizdat*, or independent publishing, at the time, but there was always a certain marginal culture thriving at the limits of the politically and

legally acceptable.[14] A common form of this underground culture of opposition is the *chastushka*, or popular song, such as one quoted by Sarah Davies which beautifully subverts the official myth equating collectivisation with prosperity: 'I went into the *kolkhoz* slowly, / and left it at top speed / I went into the *kolkhoz* in shoes / and left it barefoot'.[15] It would therefore be interesting (although, I suspect, ultimately futile) to speculate about how theories of audience identification would deal with the *kolkhoz* workers watching Pyr'ev's final musical comedy, the all-singing, all-dancing extravaganza *Cossacks of the Kuban* [*Kubanskie kazaki*, 1949] as it formed part of a morale-boosting tour around the country.

It is perhaps more pertinent simply to note that at the top of the tour's bill was the future Soviet leader Nikita Khrushchev,[16] in what was presumably a formative experience which may or may not lie at the heart of his subsequent critique of films that attempted to 'varnish reality' in his 'Secret' speech. Not only had such films, he declared, 'dressed up and beautified the existing situation in agriculture', but he also makes reference to Stalin's evident satisfaction upon seeing them, as though they provided some kind of documentary proof to the leader that life had indeed got better and happier in the provinces.[17]

The ups and downs of Khrushchev's relations with Pyr'ev must, unfortunately, remain beyond the scope of this study (as Richard Taylor notes, just a year after the First Secretary's comments in the 'secret' speech, Pyr'ev was appointed head of the Organising Committee of the Union of Soviet Cinematographers),[18] but quite whether Stalin's fabled lack of understanding of the medium went so far as to convince him that these movies actually represented reality is still, in some quarters, a moot point. I have already commented on this too readily accepted assessment of Stalin's critical faculties, and it is a point to which I shall have to return – my own opinion is that the 'Kremlin censor', whilst hardly André Bazin, was well-enough aware of cinema's 'illusory' powers to know exactly what Pyr'ev's comedies were portraying (*Soviet reality*) as well as how and why such portrayals were to be operated.

The second drive discernible behind the production of Pyr'ev's *kolkhoz* musicals is not unrelated, but is more concerned with our earlier discussions of the 'masculinising' attributes of the socialist realist genre, as it may be applied to its very specific portrayal of a rural Utopia. We have already suggested that the machine-heroes of *The Old and the New* represented the bringing of masculine order (equated by the machines, of course, with progress) to the unpredictable 'female' land symbolised by Lapkina, and how this leads to a questionable 'liberation' for her. Although in a form less blatant

than that represented by Eisenstein's milk separator, this containment remained central to cinematic portrayals of the countryside, as Hans Günther has made clear:

Steel, iron, machinery, and factories are all symbols of masculinity in Soviet culture and are counterposed to those of the opposite archetype – the fertility of the earth and of women ... The image of a tractor plowing a field revives the ancient mythological image of matter's insemination by the spirit of the father.[19]

Quite apart from the latent sexual imagery implicit in scenes of mass ploughing and reaping, then, we may further see how the insemination of the field – the attempt to make it bring forth the specific fruits demanded – is accomplished by a process analogous to the writing of a masculine history on the very body of 'mother' Russia.[20] Just as Freud lays bare the etymology of 'the uncanny' (in German, *unheimlich* is defined as a place that is quite literally 'not homely') and traces dread to its origins in the fantasy of intra-uterine existence,[21] Carol Clover has pointed out that a form of 'urbanoia' has transplanted the locus of civilised man's encounter with this horror out of the towns and into the countryside, in a tradition that she sees as culminating in the modern horror film:

The eternally popular haunted house story is typically set, if not in the country, then at the edge of town, and summer camps set in deep forests are a favorite setting of slasher films [...] Going from city to country in horror film is in any case very much like going from village to deep, dark forest in traditional fairy tales.[22]

Clover hints at how the post-enlightenment struggle against 'unreason' led to the urban subject fearing a 'threatening rural Other', who is of course based rather tellingly in a place 'like the forests of Central Europe ... where the rules of civilisation do not obtain'.[23] I would argue that the portrayal of smoothly-functioning collective farms, inhabited and run by peasants with a fixed smile on their lips and a song in their hearts, quite apart from reproducing one of Freud's own 'uncanny effects', was a 'varnishing of reality' on quite another level: the almost hysterical disavowal of elemental (coded feminine) forces in the very heart of their traditional stronghold amongst the 'dull' and 'backward' peasantry reveals itself as a near-desperate attempt to fend off the threat to 'patriarchal civilisation' posed by the countryside. In the case of the *kolkhoz* comedies of Ivan Pyr'ev, whilst we should not be surprised by the absence of gap-toothed axe-wielding rednecks, the lack of *any threat whatsoever* to the rural idyll is itself a very telling one. Whereas socialist realist novels, poems and songs all tirelessly repeated the theme of vigilance – the almost obsessional need to 'unmask enemies of the people' lurking around every corner – in Pyr'ev's cosmogony evil is

only ever of a very minor hue – as long as the borders hold fast – and always redeemable. The same hegemony that tried to convince the slaves of the Gulag that they were in fact rehabilitating themselves – a classic example of the inclusivity of Stalinist culture mentioned above – in this most utopian of schemas attempted to deny the existence of evil itself. Far from wrecking machinery and passing intelligence onto western spymasters, the most obvious trait of a character that is not quite up to scratch is, for Pyr'ev, below-average productivity. Furthermore, this failing is invariably, and quite literally, 'made good' by the time of the grand finale.

It has become something of a commonplace to assert that Stalin's administration needed to legitimise its policy decisions through the medium of cinema, and that, as a result, many films of the time are guilty of 'varnishing reality'. The idea that Pyr'ev's films were equally an attempt to impose a patriarchal symbolic order on the chaos of the Soviet countryside – 'varnishing the Lacanian Real', perhaps – may encounter rather more resistance, but I shall return to this later. For the moment we need only note that the finished products were rewarded not only with Stalin Prizes, but with the somewhat less flattering notoriety of epitomising, in a particularly extreme way, the 'lack of conflict' (*beskonfliktnost'*) for which Stalinist culture was critically decried in the West and, following Khrushchev's secret speech, within the Soviet Union itself.

It has often been said that conflict is the essence of drama. Such an assumption certainly lay behind the foreign success of 1920s directors such as Eisenstein and Vsevolod Pudovkin, who took a radically conflictual approach to the notion of film as the art of juxtaposition.[24] The principal charge levelled at Pyr'ev, then, seems to be that he quite voluntarily abandoned his heritage as a truly 'Soviet' director to produce rather clumsy and unmotivated parables set in a Stalinist Eden. Pyr'ev certainly did pass up the chance to direct a silver screen adaptation of Gogol's *Dead Souls* in 1936.[25] Opting not to work with such old-guard giants as Bulgakov, Meyerhold and Shostakovich on a production that would almost certainly have catapulted him to international celebrity – providing, of course, the film could be completed and distributed – Pyr'ev instead threw himself into directing *Party Card* [*Partiinyi bilet*, 1936], a film described by Peter Kenez as 'Perhaps the most morally reprehensible Soviet film of the 1930s.'[26]

Not all critics have such a jaundiced view of the director, however: Maya Turovskaya suggests that, having found his niche in the *kolkhoz* musical, Pyr'ev managed to convert practical necessity into artistic freedom;[27] meanwhile, Evgeny Dobrenko adds that the director in fact became one of the sharpest refracting lenses of the

'mentality' of the Stalin era.[28] If we are to search for the conflict so essential to Pyr'ev's cinema, argues Turovskaya, then we have only to consider the delicate balance in which his creative and personal freedom hung for so long to appreciate at least the extradiegetic drama of his works.[29] I would go further to suggest that searching for conflict *outside* of Pyr'ev's films – in the circumstances of their production, reproduction and reception – whilst rewarding enough in itself, ultimately fails to grasp the very real *textual* drama of his features.

We have already seen how the characters in Pyr'ev's musicals are evaluated largely in terms of their aptitude for work (which, hardly coincidentally, appears to be in direct proportion to their classical good looks), and it will come as no surprise to the seasoned viewer that all four of his *kolkhoz* comedies, in the best fairy tale tradition, re-enact formulaic love stories. With this sole reliance on love and work, therefore, an examination of the conflicts *inherent* to Pyr'ev's *kolkhoz* comedies might well repay further investigation. After all, Robert Lapsley and Michael Westlake have already demonstrated that, even in the Hollywood mould, romantic comedy is never quite as straightforward as it would have us think,[30] and later on we shall ourselves examine the depth of Soviet romance's relation to the work ethic informing so much of Stalinist culture.

With this framework in mind, we should take a closer look at Pyr'ev's comedies, but it is worth briefly raising the question of whether or not, given the traditional 'feminine' coding of the countryside, it is worth seeking out the ideal 'New Soviet Man' in the *kolkhoz* comedy genre. I would suggest that such a search would not be fruitless: in contrast to Aleksandrov's leading men – largely strong, silent types, when they were not stock figures of fun – Pyr'ev's male heroes generally come across as affable types, with a ready wit and great good humour. Alongside their female work mates, such characters really do bear out the official dictum that 'the victorious class wants to laugh with joy': as Richard Taylor remarks, *Cossacks of the Kuban* in particular 'fulfils Shumiatskii's original 1933 requirements for "cheerfulness, joie de vivre and laughter" and "a Bolshevik scale of work"'.[31]

With such a model of the victorious class on hand to analyse, it would be interesting to find out whether this figurehead of collective culture really did fit into Faludi's mould of a collectively-utilitarian, rather than ornamental masculinity – that is, whether the consonance between man and the periphery that von Geldern suggests really existed, as a harmonious marriage of spontaneity and consciousness for the better common good, or whether Pyr'ev's heroes will stick to the more conventional conflation of 'harmony' and

'mastery', using the new frontier as a stage upon which to flaunt their feats of masculinity as a purely ornamental commodity. In other words, could the 'New Soviet Man' of the steppes be more Daniel Boone than Davy Crockett? To elaborate the question, we must now turn to the man and his films in more detail.

Ivan Pyr'ev and the collective farm musical: variations on a theme

If, by the middle of the 1930s, anybody did wish to portray an authentic, utilitarian masculinity on screen, they could not have had a better schooling than Ivan Pyr'ev. Having served at the front in the Civil War, the young Pyr'ev was taken on to work at the avant-garde Proletkul't Theatre. He subsequently appeared in Eisenstein's very first productions, both for stage (an adaptation of Jack London's *The Mexican*, in which the 'crude and uncompromising' Pyr'ev climaxed the show by destroying his opponent in the boxing ring) and for screen (in *Glumov's Diary*, a short comic film inserted into the Proletkul't production of Ostrovskii's *Enough Simplicity for Every Wise Man*).[32] Whilst his friend Aleksandrov stayed with his Proletkul't mentor, however, Pyr'ev set out, if not to seek his fortune, then at least to find his artistic niche. With Old Bolshevik credentials firmly established by early satires on the hypocrisy of middle-class mores and petty bureaucracy, and an anti-fascist subtext in *Conveyer-Belt of Death* [*Konveier smerti*, 1933] (which, after fourteen re-writes, garnered a fair level of critical acclaim)[33] Pyr'ev took the perhaps surprising step of turning down a production of Gogol's *Dead Souls* to plunge instead headlong into the 'morally reprehensible' *Party Card* in 1936.

Pyr'ev's apparent about-turn came at roughly the same time that the Bolshevik 'Old Guard' seemed to be developing an alarming propensity for self-accusation writ large in the infamous series of 'show trials', which began in August 1936, and this was possibly no coincidence. In all probability, in fact, Pyr'ev realised only too well the danger of his being found guilty purely by his association with figures such as Meyerhold, Bulgakov and Shostakovich, none of whom were doing much either to adapt to the new political atmosphere, or to ingratiate themselves with a regime that was busy betraying the Revolution, depending on your point of view.[34]

Needless to say, the latter opinion remains to this day the more commonly-held, and it must be admitted that Pyr'ev's actions, on occasion, do appear to more than justify the moral censure surrounding his films. Surely a major lesson to be drawn from Stalin's purges, however, must be that one should never take an accusation

on trust, whether it originates in the heart of the Kremlin, the nether-world of the Gulag, or dissident exile: denunciations breed denunciations from all quarters, and even Eisenstein (almost canonised in the West) was himself decried as 'an arse-licker, obeying a vile dog's order' by one of Solzhenitsyn's rather self-righteous 'zeks' in *One Day in the Life of Ivan Denisovich*.[35]

We should remember, therefore, that by this time, as we saw in chapter 2, no film could be produced or distributed without almost constant Party supervision: as such, it would not be unfair to say that absolutely any film on general release in the Soviet Union of the mid-1930s must have been, to a greater or lesser extent, tailored to the whim of a tyrant, in spite of Solzhenitsyn's claims to the contrary. Although Turovskaya highlights a certain degree of autonomy in the development of Stalinist culture, she also underlines the fact that any opposition constituted the crime of being 'a generic "enemy of the people" who was, as is well-known, subject to extermination'.[36] Furthermore, the familiar knee-jerk reaction to so-called 'totalitarian kitsch', although not necessarily blinding the critic to any subtlety inherent in the work in question, almost always operates to exonerate such a critic from any responsibility to make coherent sense of it,[37] particularly if such a work helped a director into a lengthy career at the head of the Moscow film studio.

As for the director in question, it is precisely Pyr'ev's subtlety, or rather lack of it, that has proved a second major stumbling-block on his wayward route to international recognition. Writing after the end of the Great Patriotic War, Eisenstein assesses the problem:

Snobs and aesthetes may splutter that Pyriev's work is not always refined. But even they find it difficult to deny that it has a quality that rings true and hits the mark, or to dispute its thematic power, temperament and honest inspiration.

The fact stares us in the face: Ivan Pyriev has won the Stalin Prize four times.[38]

Although his article is full of such back-handed compliments as this one, by the end even Eisenstein has to admit that 'you have to hit in a hard, accurate and timely fashion. It is no calamity if not every blow has style. There are times when it is more important for the blow to be forceful than elegant.'[39] Any intended irony here is surely deflated by Eisenstein's own early cinematic and theatrical output, backed up by his substantial theoretical papers on the subject of 'conflictual montage', especially as this theory was developed at around the same time as the director claims to have been so struck by Pyr'ev's own preference for fist-fighting above the 'regulated movements and aesthetic rules' of boxing.[40] Furthermore, at the time of writing, Eisenstein had himself just received a Stalin Prize

for the first part of *Ivan the Terrible* [*Ivan Groznyi*, 1944-45]. So we should now turn to Pyr'ev's *kolkhoz* musicals – the recipients of the medals in such hot dispute.

The Rich Bride: the origins of the kolkhoz musical[41]

In fact, life for Pyr'ev had not always been such a bed of roses as his subsequent notoriety might suggest, and in fact what may seem to some an astute political move, in opting for *Party Card* instead of *Dead Souls*, backfired on him almost instantly, as he had to appeal for Stalin's personal intervention to have the film released at all. He was subsequently suspended from Mosfil'm for a couple of years, before being invited to work at Ukrainfil'm in Kiev, where the manager was so impressed by *Party Card* that he offered to shoulder any future trouble from the authorities himself.[42]

So it was that Pyr'ev set what Evgeny Dobrenko sees as the pattern for all his films, and moved away from Moscow.[43] Whilst it is tempting to construct a certain rivalry between Pyr'ev and Aleksandrov as illustrated by the tension between the obvious centripetality of the latter and a resistant centrifugality on the part of the former, as Richard Taylor points out, it 'would be more accurate to argue that Pyr'ev explores the periphery, sometimes in relation to the capital (both centrifugally and centripetally), and sometimes not'.[44] To add my own opinion to the fray, I would suggest that, just as Aleksandrov's musicals are structured by the centripetal pull of the Soviet Union's 'ideological centre of gravity' – Moscow/ Kremlin/Stalin – so Pyr'ev's have at their heart man's *relation to* space, rather than any particularly-organised movement through it.[45] My argument is that Pyr'ev's prime concern – from the time of *Party Card* onward – was with man's relation to his environment, and in particular the possibility of its transformation.

The Rich Bride [*Bogataia nevesta*] was released in 1938 (again, only after the personal intervention of Stalin), and established a structuring pattern for the *kolkhoz* comedy genre. The transformation of space here, as in Pyr'ev's three other collective farm musicals, entails at the most obvious level the successful planting and harvesting of vast tracts of land in the expanses of Ukraine. The audience is also introduced for the first time to Pyr'ev's leading lady and future wife, Marina Ladynina, who on this occasion plays a young *kolkhoz* shock-worker who, although clearly no slouch, has yet to be decorated with the honours and trappings of true stakhanovite status. Once again, it is tempting to establish a retroactively-constructed parallel with Aleksandrov and his relationship to Liubov' Orlova, and in fact Orlova's humble origins as a housemaid in *The Happy Guys* do bear a

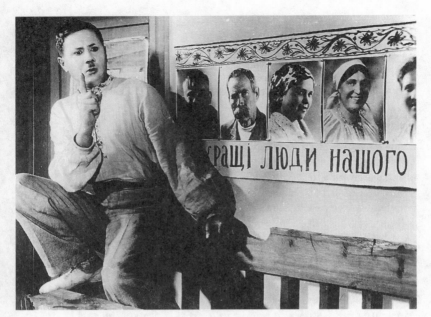

5 The petty dictator: Ivan Liubeznov, as the 'unproductive'
book-keeper Aleksei Kovin'ko in *The Rich Bride*
[*Bogataia nevesta*, 1938], is contrasted against a range of truly
new Soviet men and women

certain resemblance to those of fresh-faced Ladynina in *The Rich Bride*, as she too sets out on the Cinderella path to self-fulfilment.[46]

Furthermore, the background action of *The Rich Bride* is also littered with protracted misunderstandings and slapstick situation comedy, although in a much more minor key than that of the farcical *Happy Guys*, as the romance between Ladynina's Marinka, and her dashing would-be Prince Charming Pavlo (played almost hyperactively by Boris Bezgin), develops and is retarded in roughly equal measure. Characteristically, the path of true socialist love never runs smooth, for the farm's book-keeper Aleksei Kovin'ko also has designs on Marinka, and, as may be surmised from his 'non-productive' occupation,[47] Kovin'ko – whilst hardly the incarnation of social evil – is not exactly the ideal suitor for such a well-respected shock-worker.

However unproductive his job may be, Kovin'ko is nevertheless in a very strong position to make or break the romance between Marinka and Pavlo: in a setting where the signifying economy is largely based on productivity, the book-keeper maintains control of the signifier, and manipulates it so as to persuade both protagonists that their respective sweethearts should spend less time singing

and more time on their work. From his panoptic position of visual mastery at the centre of the *kolkhoz*, Kovin'ko is able to recognise both Marinka and Pavlo as they approach, giving him time to falsify the workers' publicly displayed records of achievement: the only seeds sown by the book-keeper, then, are ones of doubt.

Ultimately, however, Kovin'ko's position as watchman reverts to working towards the common good: spying dark clouds looming on the horizon, the book-keeper recognises that the harvest is in danger and requisitions a bicycle to speed away to the fields and warn the (beautifully-choreographed) workers of the coming storm, before finally throwing himself with comical ineptitude into the combined efforts of the collective. Of course a record harvest is gathered safely in, and, more to the point, Pavlo and Marinka are able to see for themselves one another's true capacity for 'a Bolshevik scale of work'. As such, at the celebratory dance, the couple's pairing is given the blessing of their respective brigade leaders – who clearly represent the protagonists' surrogate parents in the Great Family of the Soviet State and smile on their union, pronouncing everything to be 'in order'.

Even at this early stage, however, Pyr'ev's gender politics are making themselves clear: not just in terms of the distribution of labour between the male tractor drivers and the female harvesters, but also more particularly in relation to the male and female 'parents', and their role in the intrigue of the film. Marinka's female supervisor actively engages in rumour-mongering, encouraging her to pay heed to the slurs against Pavlo's good name; on the other hand Pavlo's tractor brigadier, whilst refraining (of course) from discussing romance with his charge, is characteristically dismissive of any such unsubstantiated innuendo: 'get together with a tractor driver', he advises her, 'and you can't go wrong!' Not only do we witness the cast-iron self-assurance of the New Soviet Man here, we are also subjected to a glowing endorsement of the trappings of hero-status. In spite of all these machinations, to which we shall return, resolution is always just around the corner, and a never seriously threatened order is, by the end of the film, jubilantly re-established.

Tractor Drivers: who's wearing the trousers?

By the time of Pyr'ev's next musical comedy, however, Ladynina appears to have overcome the sexist stereotyping and taken women's emancipation to dizzying new heights. In *Tractor Drivers* [*Traktoristy*, 1939] she plays Marianna Bazhan, who not only leads her shock-brigade, but also drives her own tractor.

The film opens with a scene set in a railway carriage, as three comrades return from military service in the far East, singing *The Song of the Three Tank Drivers*; each one in turn tells the others where he is heading, until the third, our hero Klim Iarko, informs his friends that he is travelling to meet his sweetheart, and even produces a picture of her – although she as yet has no idea of her love for him. The picture in question is a photograph of Bazhan in *Pravda*, which has been published there to commend her exemplary record-breaking farming achievements. She is thus introduced to us by the classic fairy tale device of a picture coming to life, as straight away we cut to the dynamic Marianna (with a copy of the newspaper in her pocket), who yells out 'Let's go!' – and throws herself into a highly-disciplined frenzy of strong leadership and hyper-efficient organisation as, dressed in a rather butch boiler suit, she leaps from tractor to motorbike, and zips about the *kolkhoz* overseeing the ploughing of the lush fields beneath the blazing Ukrainian sun.

As such, Marianna is quite clearly an inspired and inspiring leader, and totally self-sufficient as the new model *kolkhoz* woman. In fact, at the start of the movie, it really does appear that the harmony of male and female elements – figured by a woman (as the land) guiding the traditionally 'masculine' tractor (a well-recognised symbol of progress) – might finally have come about. Unfortunately, however, this glimpse of Utopia is short-lived, and the masculinisation of Marianna has gone as far as it will be allowed, for not long afterwards Klim arrives at the village, and a quite startling transformation occurs not only in the case of Marianna, but also in that of the entire female population of the microcosmic *kolkhoz*.

Our hero is dropped off by a truck on the outskirts of the village as dusk is falling, and reaching the brow of a hill, the first thing he sees is the woman of his dreams: Marianna, however, is lying helpless on the ground following a fall from her motorbike, and in spite of her refusal of help from Klim – 'I can manage alone', she tells him – when she finally does attempt to stand up, she collapses immediately into his strong arms. Klim, with the air of a true professional in everything he does, bandages up her leg, diagnoses and fixes the problem with her motorcycle, and takes her back home, where we next see her in bed wearing a distinctly girlish frilly nightdress. In addition to this, she is fussed over by a stereotypical *baba*, and when her friend rushes in to announce that a tractor has broken down, she can hardly speak for her hysterical fits of giggles. In a trice, therefore, the model efficiency of the female-run *kolkhoz* is ruthlessly undercut, and after token resistance, Marianna accepts her re-domestication and subordination to Klim, almost as though it would be quite simply unnatural not to do so.

We shall be discussing this issue of re-domestication, not least in relation to the threats of war rumbling in 1939, later on in this chapter, as I would like to analyse *Tractor Drivers* – to my mind the essence of Pyr'ev in terms of gender – in some depth. For the moment, however, we need only note rather briefly that Klim effectively takes over the smooth-running of the farm, whilst having his shyness towards Marianna exploited by the local idler Nazar Duma, who needless to say has his own designs on her. Although there is less slapstick in the background than there had been in *The Rich Bride*, there are still numerous minor trials and tribulations to be overcome on the path to true socialist love (the nature of which, again, I shall explore) before the film ends with the only *actual* depiction of a wedding in any of Pyr'ev's musicals.

The Swinemaiden and the Shepherd: a Soviet countryside alliance

By the time Pyr'ev's third kolkhoz comedy The Swinemaiden and the Shepherd [*Svinarka i pastukh*] was released to coincide with the anniversary of the Revolution in November 1941, the war that had been rumbling in the distance in The Rich Bride (mostly just hinted at in the songs) and looming over the horizon with the documentary footage of tank manoeuvres in Tractor Drivers, had of course burst onto centre stage. Perhaps surprisingly, however, The Swinemaiden and the Shepherd is much less outwardly-concerned with the Nazi threat – quite possibly because of the calamitous defeats suffered under the onslaught of Operation Barbarossa, and of course Stalin's own semi-legendary initial incapacity in the face of the enemy.

Instead, like Aleksandrov's *Circus* before it, this musical focuses more on developing the theme of the much-trumpeted 'friendship of peoples' that had been such a cornerstone of the 1936 Constitution. However, just as Aleksandrov had not pulled the theme out of thin air, but directed *Circus* specifically to glorify the Constitution, so Pyr'ev may be seen as concerned with the unity of the Soviet peoples against their common enemy. Although Russia had always considered itself to be first among equals, and despite the declarations of both the Constitution and *The Song of the Motherland* (with its apparently non-ironic dictum that 'there are no longer any black or coloured races')[48] the Motherland was in fact as unpopular with her satellite states before and during the Great Patriotic War as she was to prove in Central and Eastern Europe during the Cold War. I address this problematical (for Russia) situation further in the next chapter, but for now we may

establish, at the very least, that a film such as *The Swinemaiden and the Shepherd*, celebrating unity in ethnic diversity, was important – if not necessary – during the first months of the Great Patriotic War for the simple reason that, in some regions of Belorussia and the Ukraine, local villagers were actually welcoming the Nazis *as liberators*. Perhaps more than anything else, this demonstrates that the ideological battle in the countryside had not been so decisively won as the government – and of course films such as *Tractor Drivers* – would claim.

But to our tale: Glasha Novikova, the eponymous record-breaking swinemaiden (again played by Marina Ladynina), is rewarded for her Stakhanovism in animal husbandry by a trip to the All-Union Exhibition of Agriculture in Moscow. Such rewards were not too unusual, although they were very highly prized, and while Glasha is wandering awe-struck around the Exhibition, she sees a giant portrait of Musaib Gatuev, a shock-shepherd from Daghestan. True to fairytale form, the shepherd himself appears, and the pair roam the pavilions together, lost in mutual respect. The commitment they make to one another before they part, characteristically, appears to be contingent on each one's commitment to her or his work: the couple promise to meet again at the exhibition the following year.

Critical debate rages – albeit in a very mild way – over exactly what it is that happens next, and whether or not all narrative coherence is lost at the point at which the two protagonists go their separate ways, but the basic premise is that, as in *Circus*, a language barrier comes between the couple's love. Glasha, who conversed quite happily in Russian with Musaib in Moscow, is unable to understand a letter that she subsequently receives from him, a situation that is taken advantage of by Kuz'ma Petrov (the stock idler on Glasha's *kolkhoz*), who arranges for a false 'translation' to be made, which informs Glasha that Musaib has married someone else. We need hardly mention that Kuz'ma would like to win Glasha's hand for himself, not least because on this occasion he has bet the elderly Ivan Ivanovich his fine pocket-watch that he will do so.

The confusion surrounding exactly why Glasha cannot understand the letter is perhaps cleared up if we recognise that, rather than dictating the letter to his companion Abdulsalam, Musaib actually requests that he write down the lament he has been singing concerning the vast distance between the protagonists. It is quite possible (at least in the interests of intrigue) that Abdulsalam actually wrote down his own lament in his own language, the Caucasian dialect that nobody in Glasha's village (not even the 'languages expert') is able to fathom.

Notwithstanding, Richard Taylor is correct to suggest that there is a certain anomaly at work here, in that, 'although the film is set roughly a quarter of a century after the revolution, the shock-shepherd is apparently functionally *illiterate* and unable to write his own letters'.[49] In fact, it is not the only such anomaly – the idler Kuz'ma, for example, clearly has not earned his place on the trip to Moscow, and yet there he is, with a cigarette dangling from the corner of his mouth. Just as we saw in *Circus* how a language barrier was erected and then falsely broken-down in the interests of a spurious 'emancipation' for Marion Dixon, in *The Swinemaiden and the Shepherd* it would be equally fair to say that the language barrier is falsely erected from the start for the purpose of plot retardation – as though 'conflict' needed dreaming-up in late 1941, with the Nazis waging *Blitzkrieg* warfare across the provinces.

The next year finds Musaib back, as promised, at the Moscow exhibition, and yet Glasha's presence is marked only by her giant portrait. Not only is such a portrait a mark of our heroine's official canonisation into the realm of Soviet superheroes (as is the case, on a smaller scale, with Marianna Bazhan's photograph in *Pravda*), but (like the mirrors that respond to Tania in Aleksandrov's *The Radiant Path*) it also offers up an apparently fixed, stable and unitary identity – that is, one freed from ambiguity and, therefore, self-doubt. In front of this portrait, Musaib delivers a rousing speech, before he is informed that his sweetheart has finally relented and agreed to marry the conniving Kuz'ma. Naturally, Musaib leaps onto his horse and rides like the wind to the northern Vologda region, where he arrives in the nick of time to stride into the wedding preparations and give the cynical Kuz'ma the elbow: Ivan Ivanovich reclaims his pocket-watch, and our hero manages, as Taylor points out, 'to convert this false wedding into a real one'.[50]

Cossacks of the Kuban: larger than life

After *The Swinemaiden and the Shepherd*, Pyr'ev abandoned the *kolkhoz* comedy genre he had created for a spell, to produce three other films – *Secretary of the District Committee* [*Sekretar' raikoma*, 1942], *At Six O'clock in the Evening After the War* [*V shest' chasov vechera posle voiny*, 1944], and *A Tale of the Siberian Land* [*Skazanie o zemle sibirskoi*, 1948] – nonetheless remaining true, as Evgeny Dobrenko points out, to his mission of eulogising the vastness of Soviet space.[51]

However, when the director finally returned in 1949 to the genre that he considered his creative niche, it was to devastating effect, with the quite magnificent *Cossacks of the Kuban* [*Kubanskie kazaki*], possibly his finest work – and without a doubt his most reviled. The

reasons behind the general distaste felt towards the film can perhaps be best understood with reference to Richard Taylor's exquisite description of its overture, which is well worth quoting at some length. It is, says Taylor:

> one of the most bizarre sequences in Soviet cinema and, at the same time, one that is often regarded – wrongly – as stereotypical of the kolkhoz musical, or indeed of the socialist realist film. Abandoning wholesale the conventions of realism and plunging headlong into revolutionary romanticism, Pyr'ev gives the audience a choral combine-harvesting scene that pushes the successful techniques of the opening sequence of *The Wealthy Bride* well beyond the point of excess. The activity is frenetic and the collective joie de vivre beyond belief ... The opening and closing sequences of the film are in fact the only ones in which any productive agricultural activity takes place, which perhaps makes the film a more accurate portrayal of life in the countryside than it has historically been given credit for.[52]

The fact that the main body of the film takes place at the annual agricultural fair celebrating the harvest is a good indicator of the triumphal tone of the movie: all the harvesting activity is condensed into a frenetic opening, leaving the *kolkhoz* workers all the remaining reels to relax and enjoy the fruits of their labours. In the same way as the British Labour Party suggested to the electorate that, having won the war, they should 'Now win the peace' (a classic piece of propaganda in itself), the triumph and satisfaction that structure *Cossacks of the Kuban* lead to the final appearance of the protagonist pair in a *Pobeda* ('Victory') car.

As far as the plot is concerned, these 'Cossacks' have plenty to smile about, as they are celebrating (amongst other things) the early delivery of that year's grain quota to the Soviet State. This may seem strange in light of the fact that, in the 1930s, as Viktor Danilov and N. V. Teptsov point out: 'In the Kuban region the populations of whole villages were deported to the northern regions of the country as punishment for non-fulfilment of the grain collection plan'.[53] The apparent anomaly did not seem to bother Pyr'ev, however – after all, if his film is anything to go by, a lot had changed since the 1930s. On the other hand, we should note that it is not only the overture that 'plunges headlong into revolutionary romanticism'. The depiction of specifically *Soviet* reality, which we have seen interrupting the narrative at specific key points in other films, *subsumes the entire action* (such as it is) of *Cossacks of the Kuban*; the whole film is set in a quasi-Edenic condition of absolute plenitude. That is, if a film such as *Circus* took as its starting point the declaration enshrined in the 1936 constitution, that the Soviet Union was half-way to the construction of socialism, *Cossacks of the Kuban* – even more than any

other of Pyr'ev's *kolkhoz* comedies – marks a complete break with all residual elements of class struggle, and celebrates nothing other than the 'happy ever after'. Whilst hardly wishing to whitewash Pyr'ev, however, I would argue that what is often regarded as his patent dishonesty – the notorious 'varnishing of reality' with which *Cossacks of the Kuban* is especially associated – went hand-in-hand with a depiction of masculinity which, for reasons and under circumstances that I hope to elucidate in the next chapter, was in fact much more true-to-life and pessimistic – more descriptive than prescriptive – than had hitherto been the case.

In fact, *Cossacks of the Kuban* raises many interesting points for the gender analyst: in spite of (or, quite possibly, precisely *because of*) its apparently pre-oedipal setting, and as though to shore up any ground potentially lost by patriarchy in a scenario which, technically, should not involve portrayals of sexual difference, the movie is very rigidly and hierarchically structured around the male/female binary, and revolves to a large extent around the interaction of men and women – including several exchanges of gazes – and the conventionalised roles allotted to, and expected of, either sex. This is a point that is rammed home – again well beyond the point of excess – during the performances at the fair's amateur talent show. First of all, a group of women dressed in flowing white dresses and veils shuffle daintily onto the stage and, holding hands in a large circle, perform a gentle dance which they accompany, singing in soft treble voices. The women all belong to the Red Partisan *kolkhoz*, chaired by Ladynina's Galina Peresvetova, and their dance number is greeted with rapturous applause. Within seconds, however, the stage is suddenly filled with a terrifying group of whirling men from Gordei Voron's rival farm, dressed all in black and kicking their way through a wild Cossack dance routine, not even pausing whilst other pairs of men leap out of the wings and engage one another in a blindingly fast, apparently to-the-death display of flashing swordsmanship. The boys receive a standing ovation, and next on the bill is a weightlifting record-attempt.

Such events on the margins of the film provide the viewer with a framework for concentrating on the movie's central plot-line, which involves on this occasion two parallel love intrigues. The first, as may already have become obvious, is the re-kindling of a former romance between Galina Peresvetova and Gordei Voron: Galina, however, is all too aware of the shortcomings of Gordei's Cossack nature, and for much of the film appears unwilling to accept him the way he is; much is made of Gordei's insatiable competitiveness, which reaches the extent of his attempting to go one-up on Galina's purchase of a grand piano in a music shop.

The second romantic entanglement is less problematical, but nonetheless requires a certain degree of sensitivity towards the handling of delicate issues. One of Gordei's shock-workers, Dasha, is clearly in love with a member of Galina's collective, Nikolai, who is more than willing to reciprocate. The problem lies, as might be expected, with Gordei: not only is the old Cossack unhappy about losing one of his best workers to Galina's *kolkhoz*, but, as Taylor points out, he also 'feels that his past role as Dasha's father figure entitles him to impose conditions on her marriage'.[54] Gordei's unwillingness to relinquish his father-power epitomises his authoritarianism, but also points the way towards the film's rather subtle treatment of masculinity.

Quite clearly, Gordei's 'Cossack nature' is presumed *essential* – almost an accident of birth – which in itself is heresy to the environmentalist tradition of Marxism, where social being defines consciousness:[55] like Musaib's 'functional illiteracy' in *The Swinemaiden and the Shepherd*, this must come as something of a surprise after more than thirty years of Soviet power. Furthermore, the principal point of departure of *Cossacks of the Kuban* from its genre predecessors lies in the fact that what had previously been depicted as a struggle (in a very loose sense) between two types of men – generally between 'good' and 'getting there' – was now condensed onto the figure of one man with rather obvious personality difficulties, portrayed by Taylor as the tension between 'his love for Galina and his pride as a Cossack and as a man'.[56]

I would therefore like to call into question Maya Turovskaya's judgement that 'categories of personality are inherently alien to Pyr'ev's plots',[57] arguing instead that the character of Gordei Voron constitutes a special case, in which Pyr'ev rather boldly attempts to tackle issues of 'psychologism' that, as we saw in chapter 2, had been more or less off-limits in official Soviet culture since the end of the Cultural Revolution. Whilst stopping short of a radical resettling of gender roles, Pyr'ev's classic does articulate, on a level, a far from life-affirming picture of socialist equality: this particular 'battle of the sexes' has turned into a war of attrition, and the 'winner' can only be the one who refuses to budge.

As his name 'Proud Raven' might suggest, it is Gordei who scores this fairly hollow victory, partly through a combination of bloody-minded obstinacy and loud argumentation, but most notably thanks to Galina's apparent capitulation. This act is set at the climax of the film, the show-stopping buggy race between the pair where, as in the stage show earlier, categories of masculinity and femininity are colour-coded black and white respectively. Towards the end of the race, Galina catches up with Gordei – who has quite possibly worn his

horse into the ground with his Cossack equestrian histrionics – but, apparently thinking better of pushing home the advantage, she reins her horse in and allows her rival to hold first place. Just as Galina's surname Peresvetova shares a root with the Russian word for 'enlightenment' (*svet* – not to mention the *pere*- prefix, which may, rather tellingly, denote excess!), so her conclusions – that socialist competition between good and better is all very well, but true progress must be made together, and with the man allowed to take the lead – are grimly reminiscent of Bolshevik and particularly Stalinist propaganda on the subject of the so-called 'woman question'.

That Gordei's unreconstructed masculinity is so indulged at the very moment it should be challenged and found wanting, is – like Marianna's re-domestication when the men have stopped playing soldiers in *Tractor Drivers* – both a blow to hopes for putting gender issues back onto the agenda, but at the same time uncannily accurate as a diagnosis of the ills of the era of 'imperial'-style Stalinism. Furthermore, Galina's moral and even physical superiority are never in question – her final 'moral' act of magnanimity is paralleled on a 'physical' level by the scene at the opening of the fair, in which it is announced that her *kolkhoz* has beaten Gordei's to win the Red Banner for productivity – and in fact Gordei's sense of pride is more or less a structuring joke for the film as a whole, lampooned in any number of situations.

In fact I would argue that the possibilities of reading *Cossacks of the Kuban* against the grain are manifold: with considerations of taste put aside, and *read as a satire* (if, in certain respects, a rather bleak one) Pyr'ev's last musical comedy becomes by far and away his most radically successful. Such a hypothesis merits a much more detailed analysis than I have room for in this study, but I do believe it would more than repay the pains taken. In support of such a hypothesis, however, and without wishing to stray too far from the point at issue here, it is certainly worth noting that, if Gordei's masculinity is depicted as redundant, it is done so within a framework which in the same way rejects the conventions of linear narrative. In fact, the inherent lack of conflict so central to the arguments of Pyr'ev's detractors (and there are many of them who look no further than this first hurdle) produces a situation in which the linear plot of the film is quite frankly incapable of carrying out its function as 'super-ego' to the unruly 'id' of the musical numbers, which we discussed at length in relation to Aleksandrov's musicals and classical Hollywood conventions. Hence the 'excess' noted by Taylor in the choral combine-harvesting scene is just one occasion among many upon which the conservative (and masculinising) narrative economy of the film is put under unbearable pressure from the 'feminine'

libidinal economy of the 'show-stopping' star turns, which it can no longer hope to contain.

I shall make just one more point on this topic, before it begins to compromise my own linear narrative. Dobrenko sees *Cossacks of the Kuban* as Pyr'ev's final and incontrovertible 'victory' over Aleksandrov, and whilst I shall once again emphasise the dangers of retroactively constructing such a neat rivalry between the two – although some degree of rivalry did undoubtedly exist – it is more worthwhile to note Dobrenko's evidence for Pyr'ev's 'victory'.[58] As part of the 'show-within-a-show' (always more Aleksandrov's signature than a 'pyr'evesque' device), at the height of a film that is framed – if at all – only by the boundless space of the Russian countryside (with references to Moscow highly conspicuous by their absence), Pyr'ev has an actor from Aleksandrov's stable sing a song which includes the line 'Not *People's Artists*, but *artists from the people*'. Whilst this is clearly a characteristically blunt snipe at Aleksandrov's championing of officially-sanctioned *People's Artists* at the expense of finding 'real' talent outside of Moscow, it is perhaps more interesting to note that Dobrenko takes the argument one stage further, seeing the film as a whole as the final victory won by Pyr'ev for the *narod* – the unruly masses on one side of the Russian cultural schism – against the urban *intelligentsiia*. This, of course, is the point at which our discussion of the culture of collectivisation began, and so the reader is invited to formulate her or his own conclusions on the 'special case' of *Cossacks of the Kuban*, whilst we must return to Pyr'ev's other, rather more conventional musicals, with a view to unravelling the sexual politics informing *Tractor Drivers*, which was the director's most popular and successful fusion of entertainment and ideology.

Men, women and tractors

Richard Taylor sums up the plot – such as it is – of *Tractor Drivers*, in much the same way as he sums up *The Rich Bride* and *The Swinemaiden and the Shepherd*, as containing:

all the key elements of the kolkhoz musical: a love triangle, a light-hearted conflict between good (Klim) and redeemable evil (Nazar), a plot prolonged by a misunderstanding, and, of course, plenty of music, which is both integral to the plot and firmly rooted in the tradition of both folk and also military music.[59]

Once again, the cynical critic – the rule to which scholars such as Taylor provide the exception – tends to allow the formulaic nature of these films to excuse a general lack of engagement with the many

side-issues raised during their course. This also applied in the case of the socialist realist novelistic tradition, until Katerina Clark pointed out the value of exploring the subplots and digressions threaded together by the overarching, formulaic macrostructure of the Soviet novel:

If a novel is looked at in terms of these smaller units, much of it will be found to be somewhat journalistic and topical; it may, for instance, be geared to praising a recent Soviet achievement or to broadcasting or rationalising a new decree or official policy. In other words, much of it is based on ephemeral material.[60]

This idea constitutes one of the cornerstones of the present study: the flexibility inherent to the constantly shifting canon of socialist realist culture always allows for concerns external to the specific genre to surface for a time, before once again being hidden from view. I would like to echo Maya Turovskaya's seminal claim that the background action in Pyr'ev's musicals is in fact a far cry from the 'conflictless' frivolity informing their plots.[61] This, as we have just seen, is certainly the case of *Cossacks of the Kuban*.

Similarly, the thrust of this section of the study takes as its starting point *Tractor Drivers'* 'broadcasting' and 'rationalisation' of a policy the Soviet government never quite had the nerve to make official, but which we have already discussed in a minor key: that a woman's duty involves (amongst other things) driving tractors, *but only so long as their men are away driving tanks*. *Tractor Drivers* foresees a post-war crisis that affected the whole of Europe and much of North America – the disappointment that faced millions of women who were just beginning to discover the world of work when they were sent back to find 'fulfilment' in the minding of their homes and hearths.[62]

The threat of war, as we have already suggested, was present as early as the time of *The Rich Bride*:[63] Pavlo's tractor brigadier inspects his men as though they were on military parade, and reminds them that a harvest is a 'tactical strike' which may be likened to a military operation, whilst the women spend much of the movie marching in loose formation with their spades, rakes and hoes shouldered like rifles. The theme is in fact introduced in the very first song, which eulogises the 'horses of steel – fighting tractor-friends!' which have come, as we shall see, to fight rather a singular battle in the countryside.

By the time of *Tractor Drivers*, however, preoccupation with warfare had reached, as Dobrenko suggests, dizzying heights of paranoid psychosis, with not only the already customary references in the film's songs – we have already mentioned that the film opens in the railway carriage with the *Song of the Three Tank Drivers* – but also

the inclusion, mentioned above, of documentary footage of tank manoeuvres, and for those who really needed the message spelling out, the bald statement of Soviet fact: 'A tractor is a tank!' Still, by keeping such themes broadly on the margins, Pyr'ev managed to score a runaway success even at a time when people who were declaring the (very genuine) Nazi threat with less subtlety were being quite severely punished. What Pyr'ev had actually done, with some degree of success, was to tap into the growing cult of the border guard that we have already mentioned in relation to Aleksandrov's portrayal of the Great Soviet Family, and which will return as an inevitable part of our discussion of Soviet war movies *per se* in the next chapter.

In a sense, this was simply a logical extension of Pyr'ev's – and socialist realism's – preoccupation with the 'need for vigilance', precisely the quality of *Party Card* that Kenez finds so disturbing. Von Geldern points out the role played by the border in constructing a culture of inclusivity under Stalinism, with the maps redrawn to include *all* the expanses of land within it, rather than merely charting 'a set of socialist islands' rising up from the hostile sea of open space,[64] and this idea ties in with our exploration of the imposition of a 'progressive', masculinising order on the countryside, which had hitherto been perceived as chaotic, and radically Other. Both of these themes are explored in a rather amusing scene from *Tractor Drivers*, in which one of the ploughs strikes against a half-buried German *Pickelhaube* – a spiked military dress-helmet from the First World War: it is of course possible (although, I would think, fairly unlikely) that Pyr'ev had read or heard of Freud's theory of German National socialism as the 'return of the repressed', but I hope to show that one of the primary concerns of Pyr'ev's *kolkhoz* comedies resides precisely in this sort of fascination with what lies half-buried beneath the neatly-ploughed Soviet soil. Furthermore, it is important to note that the very vastness of the land so celebrated by the director had always proved to be Russia's first – and broadest – line of defence against invasion.

To return to sexual politics, we may recall the theme of women's re-domestication – particularly obvious in *Tractor Drivers* – in which, as we have already mentioned, Marianna's protests that she can manage alone fall on deaf ears as she is literally carried back into domestic space, and put to bed – from which point onwards she is not to be seen again in her boiler-suit. Apart from the change of clothing, another facet of women's domestic self-fulfilment is, of course, that they must find themselves husbands. This idea is taken to an extreme in *The Swinemaiden and the Shepherd*, in which, as we know, Glasha is prepared to marry Kuz'ma Petrov – a man who takes

the idea seriously purely insofar as it appeals to his sporting nature – rather than live her life without a man. Even in *Cossacks of the Kuban*, Galina accepts love and life with a confirmed male chauvinist pig rather than face her old age as a withered spinster. It is not merely a question of a moral imperative at work here – within the framework of the genre, it would quite simply be 'unnatural' not to marry.[65]

On the other hand, it is also true that in *The Rich Bride* and *Tractor Drivers*, there is a key lesson learned by both Pavlo and Klim. Each one – Pavlo as he has the *kolkhoz* barber shave him, Klim of course in the railway carriage – announces his intentions to his male comrades *before even meeting the woman involved*, but as the plot is frustrated in either case, our hero learns that the woman of his dreams is not his by right: he must 'earn' his wife. Nonetheless, whilst Richard Taylor correctly sees evidence of another precondition of marriage in the hero's acknowledgement of his 'feminine', emotional side, I do not share his rather optimistic conclusion that the heroine thereby, as it were, steals the decision-making role of 'masculine' leadership.[66]

I would argue instead that the greatest extent of the decision-making role allotted to women in Pyr'ev's musicals amounts to a choice of *which man* she should marry, the question of staying single being foreclosed – and often even that decision is taken for her. It is, however, worth examining the textual strategies that lead our heroines to the 'correct' choice, and these are generally more subtle than the rather crude 'eyeing-up' that passes for romance in *Cossacks of the Kuban*.

In the case of *Tractor Drivers*, for example, there is a treat in store for anthropologists, as the outsider Klim mounts his challenge for position of 'dominant male'. After a couple of verbal sallies, he is asked to dance before the group of men, at which, to the accompaniment of an accordion, he executes a dashing folk dance which leaves Nazar Duma looking as though he has two left feet. The trial is not yet over, however, for the New Soviet Man should not rely solely on repartee and being able to strut his stuff like a peacock: it is not enough simply to 'talk the talk' and 'walk the walk'. However devastating his display, our hero must also face the final challenge of being able to fix a tractor. Needless to say, Klim's mechanical-mindedness does not let him down in front of the boys, and from this point on the rest of the males learn, quite literally, to sing his song.

This example alone should be sufficient to demonstrate that there is more to 'getting the girl' than even the most sincere acknowledgement of a man's feminine side, but the romantic intrigue at the heart

of all Pyr'ev's *kolkhoz* musicals, in the best possible fairy tale tradition, always tends towards some kind of union of male and female prefigured by opening sequences depicting land under mechanisation. This is, of course, only one of many folk motifs structuring Pyr'ev's works, which also include, as we have seen, pictures coming to life; the use of symbolic names;[67] true and false weddings; and of course the choice of music rooted in a folk tradition and mediated through marching bands. It would certainly be foolish to underemphasise the centrality of music to Pyr'ev's *kolkhoz* comedies, but since we have already discussed the uses and abuses of popular song with reference to Aleksandrov, we need only comment here that a similar purpose is fulfilled by the songs of the *kolkhoz* musicals, with the added dimension, as we have seen, of subverting (to an extent) the centripetality of the mainstream of Stalinist culture. As to the potential for success of this process, however, we should perhaps bear in mind that, when pushed to its limits (as in *The Swinemaiden and the Shepherd*, for example, where the dialogue is delivered in rhyming couplets), the form may prove fundamentally limiting, which simply makes obvious the imposition of order that lies at the heart of folk culture as much as that of Stalinism itself.

Facing the female: mother nature's revenge

The issue of the imposition of order onto chaos has been a subtext of this chapter so far, but perhaps it is time now to bring it out into the open, particularly inasmuch as it relates to the final fairy tale convention of the 'happy ending' – the resolution of conflict and re-establishment of order made explicit, for example, at the end of *The Rich Bride*. When Pavlo and Marinka's parent-figures smile on their union, and pronounce 'Everything is in order', it does, to a certain extent, beg the question of quite what it was that needed putting in order to begin with. If a film really is 'conflictless', then what resolution is necessary – given that the 'everything' refers specifically to the ending, rather than being a comment on the film as a whole? Where are we to find the drama? One provisional solution might involve the re-introduction of my other major subtext, the assertion that Pyr'ev is concerned not so much with *movement through* space as with the human *relationship to* it – and more specifically with the possibility of the New Soviet Man's transformation of his environment. This is a good Marxist subtext, and it is surely not unreasonable to assume that Pyr'ev would have had at least a passing acquaintance with it.

The theme of man's relationship to his environment, then, must surely call to mind our earlier reference to von Geldern's notion that,

by the mid-1930s, 'there was consonance between Soviet man and the periphery', as well as our subsequent discussion of the struggle between two radically different paradigms of masculinity in North American culture, as articulated through frontier narratives: the utilitarian Daniel Boone, conquering the wilderness to create a home in which to raise a family, and seen by Susan Faludi as emblematic of a kind of 'nurturing' masculinity, which was left behind as the advent of the mass-media propelled the strictly 'ornamental' Davy Crockett into the limelight.

With these contrasting paradigms in mind, we may return to the issue of whether Pyr'ev would be able to produce a genuinely 'collective' hero for the collective farms. At first glance, it would appear that he made an heroic attempt. Pyr'ev's heroes all seem to want to be utilitarian, nurturing Boones: they work in harmony with one another, as evidenced by the beautifully choreographed harvesting scenes, in which our heroes move heaven and earth in a massive effort that, by the look of it, could in fact feed the entire Soviet Union. It is also true that, as Richard Taylor pointed out, they do make the effort to get in touch, to a greater or lesser extent, with their 'feminine' side. The one exception to this otherwise fairly rigid law is the book-keeper from *The Rich Bride*, Aleksei Kovin'ko, who declares very bluntly that he is fed up of the lack of glamour in his profession, and wants to be a tank driver – or even a pilot![68] Finally, we may also assume that the drive towards marriage is as strong in Pyr'ev's leading men as it appears to be in Marina Ladynina (in her various guises). After all, as we have just noted, the plots all move towards this conclusion, and there is never any question of the heroine cynically attempting to 'trap' a man.

I would suggest, if we may return to Kovin'ko's career aspirations, that the book-keeper is perhaps just being a little more honest about his true feelings than Pyr'ev's more 'positive' heroes, for, as Maya Turovskaya points out, the director was incapable of making an unconventional film,[69] and for better or worse this inability not to hide behind conventions can be seen to extend to his treatments of masculinity. Kovin'ko is quicker than most to catch on to the glamour and excitement of driving a tractor, but Pyr'ev's heroes too, whilst being very concerned for the 'common good', are nevertheless themselves unable to resist macho displays that serve little or no 'nurturing' function. This is particularly obvious in the case of the power struggle between Klim and Nazar Duma (although it is somewhat complicated by Klim's acceptance of Nazar's impending marriage to Marianna, and his subsequent attempts to 'reconstruct' the idler so as to make him worthy of the honour), and of course in the displays of tank driving and the compensatory equation of tractors

with tanks, not to mention the pseudo-military organisation of the work brigades.

Furthermore, although in a less obvious way, Pyr'ev's heroes are just as caught up in a fascination with fame and fortune as any of Aleksandrov's Cinderellas. Not least among these glory-seekers is the apparently humble Musaib Gatuev: he is quite literally 'brought to life' by his picture at the All-Union Agricultural Exhibition, and, having developed a taste for the trappings of glory (including, of course, a woman more or less falling at his feet) he is naturally eager for another bite at the apple – particularly if it means he can keep his date with Glasha. In the meantime he entertains himself by wrestling bare-handed with wild wolves in the mountains of Daghestan. I am not suggesting, of course, that a love of work does not come into this at all (in fact, that will be dealt with directly), but it is worth making the point that not even positive heroes' motives are always as clean-cut as they may at first appear.

By far and away the most telling example for our study, however, must be that of Klim Iarko's re-domestication of Marianna Bazhan, and his subsequent assumption of the role of cock of the *kolkhoz*. I have already expanded upon the ideological undertones of this phenomenal process, but would like briefly to extend the discussion to take in the psychosexual context. For nowhere else is it quite so strongly suggested that the apparent 'harmony' of man and nature – the 'consonance between Soviet man and the periphery' – is in fact only apparent, and has as its prime motive force a deep-seated fear of a feminine Other. This perceived threat of a feminised rural Other is brilliantly figured by Marianna Bazhan, whose evident competence, strength, and organisational talent may well be seen as ready to de-stabilise the patriarchal assumptions underpinning the pervasively masculine signifying economy of high Stalinist culture.

As such, Marianna represents a grave danger to the very fabric of socialist realism itself, and this is a threat that can only be mastered by a hysterical re-domestication that is well in excess of the narrative – even extending, as we have seen, to an actual depiction of a wedding. Although this may seem an innocuous point at first, it is worth noting that all three of Pyr'ev's other *kolkhoz* comedies – following the Hollywood convention – end at the more traditional fairy tale moment of 'happily ever after' with, as Lapsley and Westlake put it, 'rapport deferred'.[70] Marianna's explicit wedding, then, may be read as a kind of emergency measure on the part of the text – it is certainly unique not only in Pyr'ev's musical comedies, but also in those of Aleksandrov – and we should note that a good number of the couples' 'relatives' from the extended Great Soviet Family of the State are on hand to oversee proceedings.

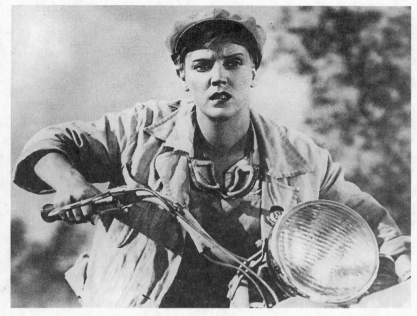

6 In the driving seat: a butch (and remarkably Brando-esque)
Marina Ladynina is firmly in control as collective farm chairperson
Marianna Bazhan – at least until her man arrives – in *Tractor Drivers*
[*Traktoristy*, 1939]

Furthermore, such a reading of *Tractor Drivers* is bound to shed
light on Pyr'ev's other comedies, and it does so very much in terms
of sexuality. If we recall the connection made early on in this chap-
ter between the notion of the threatening rural Other and its rela-
tion through Freud's *The Uncanny* to the female genitals, then I
suggest we would be close to some kind of an answer to the ques-
tion of our heroes' apparent timidity towards sex. Writing from an
anti-enlightenment perspective, Camille Paglia has suggested that
'from the beginning of time, woman has seemed an uncanny
being',[71] and although I am very much aware of the methodolog-
ical minefield I am treading here, I must insist again that the bulk
of this study is concentrating on the *self-image* of the New Soviet
Man as depicted in cinema, and that 'the identification of women
with the countryside, and thus subliminally with backwardness,
passivity, and nurturing', as Richard Stites makes clear, was a clas-
sic trope of the officially-sponsored *kolkhoz* comedy genre.[72] I sug-
gest that the wholesome heroines of Pyr'ev's musicals symbolised
more than simply the union of the 'female' land and 'masculine'
progress through mechanisation, and perhaps the best way to

Countryphile

demonstrate this is with reference to the symbolic impossibility of such a union within the framework of socialist realism.

Socialist realist love of work

Klim Iarko, at the very moment when the shot/reverse-shot sequence would seem to demand the first kiss of *Tractor Drivers*, races out of the room upon hearing a woman scream that a tractor has broken down. Musaib Gatuev, at one yelp of his trusty sheepdog, instantly stops wallowing in narcissistic self-pity over the lack of word from Glasha, and hurls himself into an almost absurd struggle against three ravening wolves, who are clearly intending to make a good meal of his flock. Suppression of the depiction of sex existed in Russia long before the Revolution. The hysterical aversion to even minor acts of affection, however, could repay further investigation.

As we saw in relation to Stalin's non-appearances in Aleksandrov's musicals, absences can speak louder than one might think. In that chapter, we reached the conclusion that, in this most Utopian of genres, the 'happy ending' was offering the New Soviet Man an uninterrupted mother/child dyad – the very stuff of fairy tales. We have already pointed out one major absence from Pyr'ev's own brand of Utopian comedies – the apparent lack of conflict. This, as we have seen, is telling enough as it is, but it also pointed us towards the conclusion that the only motives behind any plot development lay in romance and honest hard work. There is rarely a shortage of hard work in Pyr'ev, even if – as in the case of *Cossacks of the Kuban* – it is only performed in frenetic bouts. There are also, as we have just seen, loud declarations of love (although often under duress), but the kind of romantic actions that might be construed as speaking louder than words are only conspicuous by their absence.

In the previous chapter, we discussed the signifying potential of elements absent from a film's text, and saw how Maria Enzensberger explained Stalin's absence from Aleksandrov's comedies by insisting that the levity of the genre would detract from the leader's *gravitas*.[73] In the same way Turovskaya – whose article so informed Enzensberger – dismisses the lack of sensuality in Pyr'ev's comedies by invoking a contemporary taboo on love scenes.[74] As it stands, I feel that this is simply inadequate – even Turovskaya admits she is hard-pressed to find many examples of the most chaste form of kissing, which no cinematic genre (and certainly not romantic comedy) has ever, to my knowledge, considered taboo.

In Freudian theory, of course, the most ancient of all taboos is the ban on incest – more specifically the prohibition of the child's union with the mother, that for both Freud and Lacan, in different

ways, acts as the gateway to the child's path to socialisation. For Lacan, the child's growing awareness of lack prompts him to construct retroactively a myth of a lost 'Edenic plenitude' from the time before he even recognised that he was a separate being from the mother. As we concluded at the end of the last chapter, this myth informed the topography of the socialist Utopia that seemed to be offered to Soviet citizens under Stalin not in the life to come, but *in the here and now*, through the effacement of the Father Stalin from the Oedipal triangle.

Such an apparent offer also seems to inform the topography of the socialist Utopia presented in the *kolkhoz* musicals of Ivan Pyr'ev, but this Eden is more problematical here for the following reasons. First of all, the identification of the land with a mother-figure long predates the Revolution – it was in fact only one of many elements of Russian Orthodox iconography that we have seen hijacked by the Bolsheviks, and brought to some degree of maturity under Stalin. The offer of a harmonious union with the Mother-land was therefore much more of a real presence in a genre that encoded all women as 'the land', than in Aleksandrov's urban myths, where such a union was a much more distant promise.

Secondly, although such an offer appeared to hold good on the surface, I have suggested that Pyr'ev is in fact held by a fascination with what lies buried beneath the soil. The real sense of opportunity to achieve a union with the mother-land, therefore, brings the breaking of the incest taboo – like the *Pickelhaube* – to the surface, and yet this is unbearable for both Pyr'ev and his male heroes. Not only would such an act violate the very basis of society as we know it, but, much more horrifically, it would also involve a confrontation with the mother's castration – the prototype signifier of difference which, as we have seen, lies at the heart of the sense of the uncanny. Faced with this dread, the hero immediately responds to any call that will give him an opportunity to tear himself away – and does so to a degree of textual excess, which allows the analyst to recognise his symptom (a symptom, for psychoanalysis, always combines both the unconscious wish and its prohibition).

Finally, these escape routes always take the form of a call to work – to mend a tractor, protect one's flock, and so on. The only exception to this rule is in *The Rich Bride*, which as an underdeveloped form of the *kolkhoz* musical, handles it in rather a different way: the elderly Ded Naum ('old man wisdom') steps in to stop first the dance – which here, as in the classical Hollywood musical, is an encoded release of libidinal energy – and then to separate couples who are canoodling in various locations around the village. In return for his sterling work, he is presented at the end of the movie with a double-barrelled

shotgun – possibly the finest symbol of phallic state power to be found in any of Pyr'ev's films.

For the most part, however, any hint of romance – and its attendant horror – is curtailed, as we have seen, by a call to work. The corollary of this is the certainty that any idler is apt to take a blatantly sexualised interest in the heroine: witness in particular Kuz'ma Petrov in *The Swinemaiden and the Shepherd*, who leers at Glasha Novikova with a puny and grizzled phallic cigarette drooping from the corner of his mouth. Naturally the women have little time themselves for this kind of tomfoolery: Marianna Bazhan, for example, refuses to indulge herself by reading her stacks of fanmail, for not only would that be vanity, but there is quite simply far too much work to do. Xenia Gasiorowska has come up with several interesting parallels from contemporary novels, in which work is set before love. In one of these, it is actually the man himself who succeeds in diverting away unwanted attention: girl meets boy at an All-Union Komsomol dance, and tries to ingratiate herself; she tells him that, in a way, they already know each other, as she works in the factory where they make the lamps that he uses in his job as a miner. When she asks him if he is not glad at this happy meeting, he replies rather sternly: 'No reason for joy, they are poor lamps. Improve the quality of your production and then I'll be happy to know you better.'[75]

The same holds true of Musaib's fight with the wolves, or Klim's apparently boundless energy when it comes to work – not to mention his frenetic singing and dancing. Time and again, the sexual drive is repressed and subordinated to the work ethic, in a displacement that Freud sees, most famously, as lying at the heart of Michelangelo's 'inscrutable and wonderful' statue of Moses in the church of San Pietro in Rome, in which 'the giant frame with its tremendous power becomes only a concrete expression of *the highest mental achievement that is possible in a man, that of struggling successfully against an inward passion for the sake of a cause to which he has devoted himself*'.[76] Furthermore, in his discussion of Freud and the development of psychoanalytic theory, Terry Eagleton elaborates the issue of this type of repression:

One way in which we cope with desires we cannot fulfil is by 'sublimating' them, by which Freud means directing them to a more socially-valued end ... For Freud, it is by virtue of such sublimation that civilisation itself comes about: by switching and harnessing our instincts to these higher goals, cultural history itself is created.[77]

Meanwhile, away from Vienna and Rome, Igor Kon contends that the Bolsheviks had always found sexuality problematic, as the one

spontaneous element that was almost impossible to regulate; and Kon makes some comments that are also highly appropriate to this study:

> In order to ensure total control over the individual, it [the Soviet State] had fully to 'deindividualise' the individual, to emasculate the individual's autonomy. To those ends the totalitarian state began consistently to root out and disparage all that was erotic in human beings.[78]

The sublimation of libidinal energy we have seen at work in Pyr'ev's *kolkhoz* comedies, then, can be seen as attempting to impose some kind of symbolic order of 'political consciousness' on the elemental spontaneity of Soviet sexuality, as well as suiting the government's drive for socialist construction. Although it would be an over-simplification to suggest that the Soviet viewer, readily identifying with the apparent unity of heroes such as Klim Iarko, would leave the cinema ready to throw himself into the construction of both socialism and the personality cult that lay at its heart, the sudden and very forceful appearance of the law of the Father could be seen as having one final useful side-effect.

We have already seen, in chapter 2 that Stalin stood at the head of the Great Soviet Family, and how the apogee of self-realisation for his children was to become his model sons – figured perhaps most tellingly in the characterisation of the Arctic flying heroes such as Valerii Chkalov as 'the fledgling children of Stalin'. Now, to this sheer practical impossibility of challenging such a mighty Father figure, we may add a series of *symbolic* representations that aims to prevent the New Soviet Man assuming the self-image of a father. Put simply, our study of Stalinist musical comedies has reached the conclusion that the 'sons' of the Great Soviet Family were kept in a state of arrested symbolic development – a situation that can only be characterised as a crisis of masculinity under Stalin.

Notes

1 *This Morning*, (Granada Television, 8 December, 1999).

2 Geoffrey Hosking, *A History of the Soviet Union* (London: Fontana Press/Collins, 1985), p. 58.

3 Moshe Lewin, 'Collectivisation: The Reasons', in Robert V. Daniels (ed.), *The Stalin Revolution: Foundations of the Totalitarian Era*, 3rd edn (Lexington, Mass. and Toronto: D. C. Heath and Co., 1990), pp. 97–114 (p. 98).

4 Lewin, 'Collectivisation', p. 105.

5 Graeme Gill, *Stalinism*, 2nd edn (Basingstoke: Macmillan Press, 1998), p. 18.

6 Hosking, *History of the Soviet Union*, p. 163.

7 See in particular Lynne Viola, *Peasant Rebels Under Stalin: Collectivisation and the Culture of Peasant Resistance* (New York and Oxford: Oxford University Press, 1996), and Sheila Fitzpatrick, *Stalin's Peasants: Resistance and Survival in the Russian Village After Collectivisation* (New York and Oxford: Oxford University Press, 1994).

8 Fitzpatrick describes 'Potemkinism' as 'the state's idealized and distorted representation of rural life [...] the real-life counterpart of the discourse of socialist realism in literature and the arts': Fitzpatrick, *Stalin's Peasants*, p. 16.

9 Lynne Attwood (ed.), *Red Women on the Silver Screen: Soviet Women and Cinema from the Beginning to the End of the Communist Era* (London: Pandora Press, 1993), p. 38.

10 James von Geldern, 'The Centre and the Periphery: Cultural and Social Geography in the Mass Culture of the 1930s', in Stephen White (ed.), *New Directions in Soviet History* (Cambridge: Cambridge University Press, 1992), pp. 62–80 (p. 65).

11 Susan Faludi, *Stiffed: The Betrayal of the Modern Man* (London: Chatto and Windus, 1999), p. 12.

12 Von Geldern, 'The Centre and the Periphery', p. 69.

13 Lenin had, as we have seen, departed from the traditional Marxist line by bringing revolution to a country that – in terms of conventional Marxist social theory – was not technically ready for it. See Katerina Clark, *The Soviet Novel: History as Ritual*, 3rd edn (Bloomington and Indianapolis: Indiana University Press, 2000), pp. 18–19.

14 Maya Turovskaya, 'I. A. Pyr'ev i ego muzykal'nye komedii: k probleme zhanra', *Kinovedcheskie zapiski* 1 (1988), 111–46 (116).

15 Sarah Davies, *Popular Opinion in Stalin's Russia: Terror, Propaganda and Dissent, 1934–1941* (Cambridge: Cambridge University Press, 1997), p. 52.

16 Mentioned in Richard Taylor, 'Singing on the Steppes for Stalin: Ivan Pyr'ev and the Kolkhoz Musical in Soviet Cinema', *Slavic Review* 58: 1 (1999), 143–59 (159); referenced back to Rostislav Iurenev's introduction to G. B. Mar'iamov's *Ivan Pyr'ev v zhizni i na ekrane: Stranitsy vospominanii* (Moscow, 1994), pp. 52–3.

17 'Many films so pictured kolkhoz life that the tables were bending from the weight of turkeys and geese. Evidently Stalin thought that it was actually so.' From 'Khrushchev's Secret Speech', in *Khrushchev Remembers*, trans. Strobe Talbot (London: Sphere Books, 1971), pp. 503–62 (p. 554).

18 Taylor, 'Singing on the Steppes', pp. 143–4.

19 Hans Günther, 'Wise Father Stalin and his Family in Soviet Cinema', in Thomas Lahusen and Evgeny Dobrenko (eds), *Socialist Realism Without Shores* (Durham and London: Duke University Press, 1997), pp. 178–90 (pp. 187–8).

20 A brief shot in a ploughing sequence in *Tractor Drivers* in fact depicts the tractors engraving regular furrows on a landscape that is almost hellish.

21 Sigmund Freud, 'The Uncanny', in Albert Dickson (ed.), *Art and Literature*, trans. James Strachey, *Penguin Freud Library, vol. 14* (Harmondsworth: Penguin, 1990), pp. 335–76 (p. 368).

22 Carol J. Clover, *Men, Women and Chain Saws: Gender in the Modern Horror Film* (London: BFI Publishing, 1992), p. 124.

23 *Ibid.*

24 We need only recall the *Statement on Sound* quoted in chapter 2, to which Eisenstein, Aleksandrov and Pudovkin put their signatures.

25 Evgeny Dobrenko, '"Iazyk prostranstva, szhatogo do tochki", ili estetika sotsial'noi klaustrofobii', *Iskusstvo kino* 1996, no. 9 (September), pp. 108–17 (p. 109).

26 Peter Kenez, *Cinema and Soviet Society from the Revolution to the Death of Stalin*, 2nd edn (London and New York: I. B. Tauris, 2001), p. 132. Kenez appears especially troubled by the extension of the 'need for vigilance' theme to the point where a woman denounces her husband as an enemy of the people.

27 Turovskaya, 'I. A. Pyr'ev', p. 122.

28 Dobrenko, '"Iazyk prostranstva"', p. 110.

29 Turovskaya, 'I. A. Pyr'ev', p. 122.

30 Robert Lapsley and Michael Westlake, 'From *Casablanca* to *Pretty Woman*: The Politics of Romance', *Screen* 33: 1 (Spring 1992), 27–49.

31 Taylor, 'Singing on the Steppes', p. 156.

32 See Eisenstein, 'About Ivan Pyriev', in Richard Taylor (ed.), *Selected Works, vol. III: Writings, 1934–47*, trans. William Powell (London: BFI Publishing, 1996), pp. 292–4 (p. 292); I retain William Powell's transliteration of Pyr'ev's name.

33 Kenez, *Cinema and Soviet Society*, pp. 108, 129.

34 For example, Shostakovich's opera score for *Lady Macbeth of Mtensk* was the subject of a particularly virulent attack in *Pravda* in January 1936.

35 Alexander Solzhenitsyn, *One Day in the Life of Ivan Denisovich*, trans. Ralph Parker (Harmondsworth: Penguin, 1963), p. 71.

36 Turovskaya, 'I. A. Pyr'ev', pp. 112–14 (p. 114).

37 Solzhenitsyn's prisoner X123 himself reverts to ill-defined critical categories, damning anything that 'doesn't arouse good feelings in me'. Solzhenitsyn, *One Day in the Life*, p. 71.

38 Eisenstein, 'About Ivan Pyriev', p. 293.

39 Eisenstein, 'About Ivan Pyriev', p. 294.

40 Eisenstein, 'About Ivan Pyriev', p. 292; it is also worth noting, from around this time, Eisenstein's definition in *Lef* of the base unit of showbusiness – the 'attraction' – as '*any aggressive moment in theatre ... mathematically calculated to produce specific emotional shocks in the spectator in their proper order within the whole*' (his italics), reprinted in Richard Taylor and Ian Christie (eds), *The Film Factory: Russian and Soviet Cinema in Documents, 1896–1939* (London: Routledge, 1994), pp. 87–9 (p. 87).

41 This is perhaps a little unfair to Savchenko, whose *Accordion* [*Garmon'*] was made in 1934. On the other hand, it is unquestionably Pyr'ev who is most closely identified with Stalinist cinematic visions of the *kolkhoz*.

42 The whole sorry saga is recounted in Taylor, 'Singing on the Steppes', p. 149.

43 Dobrenko, '"Iazyk prostranstva"', p. 110.

44 Taylor, 'Singing on the Steppes', p. 147.

45 I am using the masculine form advisedly.

46 There does seem to be something of a tradition of such preferment in Soviet entertainment (although possibly no more than in contemporary Hollywood), dating back at least to Commissar for Enlightenment Anatolii Lunacharskii scripting Konstantin Eggert's *The Bear's Wedding* [*Medvezh'ia svad'ba*, 1926] for his wife.

47 Taylor, 'Singing on the Steppes', p. 149; Taylor also notes Kovin'ko's more than passing resemblance to Boris Shumiatskii – certainly worth bearing in mind as we examine his characterisation.

48 Reprinted in James von Geldern and Richard Stites (eds), *Mass Culture in Soviet Russia: Tales, Poems, Songs, Movies, Plays and Folklore, 1917–1953* (Bloomington and Indianapolis: Indiana University Press, 1995), pp. 271–2 (p. 272).

49 Taylor, 'Singing on the Steppes', p. 154.

50 Taylor, 'Singing on the Steppes', p. 155. Although the procession through the village is depicted, the wedding itself is not.

51 Dobrenko notes particularly, in the case of *A Tale of the Siberian Land*, the constant juxtaposition of enclosed, claustrophobic spaces in Moscow with wide-open panoramic vistas of the Enisei River, and that the film ends with a 'hymn' to Siberia and the absolute self-sufficiency of the periphery: Dobrenko, '"Iazyk prostranstva"', p.114.

52 Taylor, 'Singing on the Steppes', p. 156.

53 Viktor Danilov and N. V. Teptsov, 'Collectivisation: The Results', in Daniels, *The Stalin Revolution*, pp. 114–29 (p. 126).

54 Taylor, 'Singing on the Steppes', p. 157.

55 And yet Galina obstinately repeats, 'That's how he was, and that's how he still is ...'. Attention should also be drawn to Gordei Gordeevich Voron's name and patronymic: as 'Proud Raven, son of the Proud', Gordei genuinely does appear to have inherited his character traits through a blood-line of 'proud ravens'. Galina's chances of reconstructing Gordei, then, appear to be severely limited from the start!

56 Taylor, 'Singing on the Steppes', p. 157.

57 Turovskaya, 'I. A. Pyr'ev', p. 128.

58 Dobrenko, '"Iazyk prostranstva"', p. 117.

59 Taylor, 'Singing on the Steppes', p. 152.

60 Clark, *Soviet Novel*, p. 5.

61 Turovskaya, 'I. A. Pyr'ev', p. 122

62 The fact that Galina Peresvetova has escaped such a fate in *Cossacks of the Kuban* – thereby, to an extent, disrupting the patriarchal order it depicts – may be read as another potentially subversive element of the film.

63 Many of my own observations here are also noted by Dobrenko in '"Iazyk prostranstva"', especially p. 110.

64 Von Geldern, 'The Centre and the Periphery', p. 65.

65 Cf. the more contemporary western mythology of women's 'biological clock', the mobilisation of which in the fight against feminism is

charted in Susan Faludi's *Backlash: The Undeclared War Against Women* (London: Vintage, 1992), especially pp. 46, 125–6.

66 Taylor, 'Singing on the Steppes', p. 153.

67 In addition to Gordei Voron and Galina Peresvetova from *Cossacks of the Kuban*, we should also mention that in *The Swinemaiden and the Shepherd*, Glasha Novikova's surname derives from the Russian word for 'new', and in *Tractor Drivers*, Klim 'Iarko' is quite literally 'bright', 'brilliant', and 'striking'.

68 See Taylor, 'Singing on the Steppes', p. 153. This should also bring to mind Faludi's other examples of the two paradigms of masculinity, the Infantry 'grunts' and the glamorous Air Force 'flyboys', discussed with reference to Kalatozov's *Valerii Chkalov* in chapter 2.

69 Turovskaya, 'I. A. Pyr'ev', p. 118.

70 Lapsley and Westlake, 'From *Casablanca* to *Pretty Woman*', especially pp. 37–41. The ending of films at the climactic moment – the point of greatest potential before the protagonist pairing are resubmerged into regular, everyday existence – is one of the tactics that Lapsley and Westlake see Hollywood deploying in order to sustain the myth that romantic love is both possible and sustainable. The ramifications of this point for theorising the operations of desire in Stalinist cinema will be discussed in the conclusion to this study.

71 Camille Paglia, *Sexual Personae: Art and Decadence from Nefertiti to Emily Dickinson* (Harmondsworth: Penguin, 1992), p. 9.

72 Richard Stites, *Russian Popular Culture: Entertainment and Society Since 1900* (Cambridge: Cambridge University Press, 1992), p. 83.

73 Maria Enzensberger, '"We Were Born to Turn a Fairy Tale Into Reality": Grigori Alexandrov's *The Radiant Path*', in Richard Taylor and Derek Spring (eds), *Stalinism and Soviet Cinema* (London: Routledge, 1993), pp. 97–108 (p. 104).

74 Turovskaya, 'I. A. Pyr'ev', p. 134.

75 Cited in Xenia Gasiorowska, *Women in Soviet Fiction, 1917–1964* (Madison: University of Wisconsin Press, 1968), p. 109; see also pp. 110, 119–21.

76 Sigmund Freud, 'The Moses of Michelangelo', in *Art and Literature*, pp. 249–82 (pp. 255, 277, my italics).

77 Terry Eagleton, *Literary Theory: An Introduction* (Oxford: Basil Blackwell, 1983), p. 152.

78 Igor Kon, 'Sexuality and Culture', in Igor Kon and James Riordan (eds), *Sex and Russian Society* (Bloomington and Indianapolis: Indiana University Press, 1993), pp. 15–44 (p. 24).

5 Brothers in arms: the changing face of the Soviet soldier in Stalinist cinema

The Russian will know no mercy in his just anger, but the blood he sheds will bring bitterness to his heart. (Eisenstein)[1]

Revolution, entropy, and Stalin's overcoat

Evgeny Dobrenko asserts, in relation to his spatialised models of Stalinist musical comedies, that by the end of Pyr'ev's *Cossacks of the Kuban*, the sense of movement that had informed the structure of his best-known films had come to an end. Pyr'ev's mastery of space had finally overcome the tensions implicit in the centre–periphery binary by celebrating the complete self-sufficiency of the country-side, and, further: 'This stasis on the spatial axis corresponds to a stasis on the temporal axis: *Utopia had turned to stone*.'[2] Clearly, this bears some resemblance to Abram Terts' observation that under the hegemony of socialist realism, 'the river of art is covered-over by the ice of classicism',[3] although Terts is by no means the first to lament the imposition of a formalising order over the chaotic flux of life (and, by extension, creativity) – and of course the analysis of such an imposition remains a central concern of this study.

Even in the early 1920s, the author Evgenii Zamiatin was expressing his concern about utopian novels, and the ways in which idealising such Utopias invariably leads to formal stasis: 'the Utopia is always a description, and contains little – if any – dynamic of plot'.[4] Zamiatin is in fact very much an admirer of the British 'Godfather of Science Fiction', H. G. Wells, precisely inasmuch as Wells is not afraid to portray the dynamic conflict at the heart of his own society – thinly-disguised and projected into the near-future –

and as such acts as an exemplary precedent for Zamiatin's own concept of the artist-as-heretic. In another article, Zamiatin – best-known in the West for his own anti-utopian novel *We* [*My*] – describes such heretics as 'the only (bitter) medicine against the entropy of human thought',[5] and clarifies his view of their role in the perpetuation of the dialectic of revolution. Perhaps most importantly for our study, Zamiatin sees such heretical artists as necessary to rekindle the 'fiery magma' of revolution which, once cooled, 'becomes covered-over by a hard, ossified, motionless crust of dogma'.[6]

Long before Pyr'ev's Utopia had 'turned to stone' in *Cossacks of the Kuban*, many thousands of tonnes of fluid, molten metal had already been cast into cold, hard statues across the Soviet Union as part of the rites of the notorious 'cult of personality' of Stalin. Furthermore, as in the political posters of the time, the representation of the leader had undergone a change since Stalin's consolidation of power at the end of the 1920s, and this is nowhere more apparent than in the differing portrayals of Stalin and his predecessor – to whom he so often appealed for legitimation of his grip on power.

If we look at posters and statues of Lenin, we cannot fail to be struck by the sheer *dynamism* of the imagery: for the architect of the Revolution is almost always depicted striding ever forwards, arm outstretched, coat tails flapping out behind him in the wind of revolutionary change. Such a portrayal, it seems, befits the man at the centre of the campaigns for technology, electrification, and the cult of the machine that lasted, as we have seen, well into the first Five Year Plan and Cultural Revolution.

However, we have also seen how the Plan years heralded a genuinely revolutionary, qualitative shift in Soviet culture, and representations of the leader were to be at the forefront of that revolution. In the same way that the cult of the machine became the cult of personality, the omnipresent revolutionary technolatry of the 1920s became an all-pervasive idolatry, at the heart of which stood motionless, impassive, monolithic, the 'Father of the people' and head of the Soviet patriarchal order, Stalin himself. Furthermore, just as Lenin's activity had identified him with a classically masculine process of disavowing his position as object of the gaze,[7] Stalin, with characteristic arrogance, more or less presents himself *as a statue*. One illustration of this is the way in which, in contrast to Lenin's billowing coat tails, Stalin's overcoat is almost always buttoned right up to conceal any layers or texture beneath. As such, the leader stands solid, resisting penetration or interpretation (even his mouth is protected by his thick moustache) in much the same way

that – as we discussed in our introduction – patriarchy passes itself off as solid, monolithic and consistent: beyond question and impervious to analysis.

It is precisely such a disavowal of the layers and textures of split subjectivity that lies at the centre of the construction of the New Soviet Man. We have only to recall Leonid Trauberg's ambiguous announcement to the 1935 All-Union Creative Conference of Workers in Soviet Cinema, that 'in these five years we got away from the accursed legacy of "fractured consciousness"',[8] to recognise that the ideal Stalinist model of the male ego is very much one that is seen as the same all the way through. And yet men are not statues, as Antony Easthope points out:

The human ego identifies its unity above all in an image of the body as a unified whole and fears above all the image of the body in pieces. But it goes deeper than that, for the two images depend on each other. Since the ego was never there in the first place, it has been organized out of fragments bound together by force to make a unity. The energy that binds it is always likely to be released against anything that tends to pull it to pieces again. That is why for psychoanalysis aggression is an effect of the ego and the ego's struggle to maintain itself.[9]

Masculinity in crisis, and men at war: from hero to zero

Scratch the surface of a well-sculpted statue, and you may presume to find solid metal beneath. Having scratched at the surface of the male heroes of Stalinist musical comedies, however, we have discovered not solid metal, but complex interplays of drives that highlight the socially constructed nature of both masculinity and patriarchy. Yet the socialist realist ideal of masculinity, as we can see from Easthope's observations above, was only an extreme form of the idealised unitary identity classically misrecognised at Lacan's 'mirror stage' and appropriated by modern man as his idealised self-image.

In our own study, however, quite apart from his state of arrested development – which, as we concluded in the last chapter, precipitated a crisis in Soviet masculinity unable to assume the self-image of a father[10] – the impossibility of living up to the ideal of 'solid' masculinity added a further source of pressure to the Stalinist male psyche; and as we have seen, a characteristic reaction of crisis-stricken masculinity is to respond with violent aggression. I hope to plot the trajectory of the collapsing subjectivity of the New Soviet Man through the figure of the soldier hero in Soviet cinema, as he passes through the trauma of war, and as good a place as any to start is with another acknowledged classic of socialist realist cinema.

In November 1934, an editorial appeared in *Pravda* that encapsulated the triumphal sloganeering of the new face of Soviet cinema: 'The whole country is watching *Chapaev*.'[11] Despite the fact that, behind the scenes, the film industry of the USSR was being squeezed more and more tightly by restrictions on form and content, with both manpower and technical equipment in woefully short supply, and creative freedom subjected to increasingly dangerous and hysterical levels of censorship and praise, audiences were indeed flocking to the cinemas to see the Vasil'ev brothers' greatest ever success, and only a year later the head of the Soviet film industry Boris Shumiatskii went so far as to label the film 'the real summit of Soviet film art'.[12]

Given the very genuine popularity of the film – attested to not only by staggering ticket sales, but also by the semi-legendary status accorded the figure of Chapaev himself – it is certainly worth inquiring into the reasons behind this apparent fascination: did the protagonist really strike a chord with the people of the Soviet Union, or were the authorities simply keen to profess him a hero in order to set an example for the young men of a nation that had only recently rediscovered a penchant for exemplary figures, following the mixed successes of the collective-oriented first Five Year Plan? It would appear that both factors were playing their distinct roles, but *Chapaev*'s reputation was secured for two simple reasons: firstly, the film was canonised as a model of socialist realist cinema; and secondly, in a state that, as we know, had a very specific cultural plan for constructing the New Soviet Man, Chapaev himself – apparently secure in the knowledge of the victory to come – is without a doubt a good example of what Graham Dawson has termed 'the soldier hero ... as a hegemonic form of masculinity'.[13]

If we too watch Chapaev-as-archetype, we may indeed follow the progress of the Soviet soldier hero on screen from 1934, through the Great Patriotic War, and out the other side of Stalinism into the period of the 'thaw'. In many ways, Sergei Bondarchuk's 1959 film *The Fate of a Man* is as typical of the cinema of this new era as *Chapaev* is of socialist realism. First, rather than a Stalinist classic, the film is based on a story by the much more problematic writer Sholokhov; its hero, Andrei Sokolov, is unkempt, alcoholic, and plagued by uncertainties, self-doubt and anxiety; he is nonetheless a hero, and, most important of all, a survivor. However, unlike Chapaev, who maintains an implicit and explicit faith in the glorious future he is helping to build, Sokolov is distinctly lacking in optimism, and yearns for what he sees as the golden years of his past. Furthermore, the story leaves us with nothing but loose ends – a lack of resolution that characterises the new cultural myths of the

'thaw', and deliberately shuns the moralising discourse of narrative closure: we are left pondering Sokolov's distinctly uncertain fate.

Before we can begin to examine the effects of the symbolically named Great Patriotic War on this crisis-ridden new model man, however, we need to take a brief look at the more widespread cult of the soldier, and the ways in which men can be persuaded to put their fragile ego at risk, and go out to kill and be killed.

Dawson's strong argument that the soldier hero constitutes 'a hegemonic form of masculinity' provides us with a useful key with which to unlock this theme: just as hegemony works to make certain ideological positions quite literally 'unthinkable', it also serves to delimit the spectrum of available choices in life for individuals, and often entire social classes. From a very early age, 'suitable' toys and reading matter are offered to children, usually along the lines of class and gender: for the young boy, seeking role models with whom to identify as his ego develops, the classic toy is either a gun or a soldier, and the archetypal reading matter, adventure stories and comics.

Dawson also makes the point that dominant notions of masculinity are always specifically bound up with the concept of the nation state: 'Within nationalist discourse, narratives about soldier heroes are both underpinned by, and powerfully reproduce, conceptions of gender and nation as unchanging essences.'[14]

First of all, this may be seen as a logical extension of Easthope's discussion of the male ego as characteristically structured on the model of a fortress.[15] Easthope goes on to cite the cinema advertisement for *Rambo* (1982) ('A one-man vengeance machine! No man, no law, no war can stop him!') in his chapter on the male body – all of which is more than borne out by the star of *Rambo*, Sylvester Stallone himself, telling Susan Faludi: 'The man, he's on his own. I have to be my own country. I have to be my own citadel. No one's gonna watch my back.'[16]

Stallone's reference to being 'his own country' is also a particularly telling one for our study, and leads us via Dawson to this chapter's second major methodological strand. If we recall from chapter 2 that the denial of split subjectivity is akin to 'a somatic assumption of monoglossia', then we are already more than half-way to positing a correlation between the classic model of the male ego and the structure of the bourgeois, patriarchal state. Indeed, no modern nation can be seen as the same all the way through – a solid monument to itself made up of like-minded and conforming individuals – and yet centripetal discursive forces operate to bind this diversity into an illusory unity, which is in turn constantly reflected back to its subjects through the institutionalised mass-media.

The misrecognition of a unified national essence is analogous to that of the Lacanian infant before the mirror, and to a certain extent affords a similar degree of pleasure. The necessary fragility of this construction, however, can be seen to motivate the cult of the soldier as defender of the state from divisive penetration, and here we may also recall von Geldern's observation that, by the mid-1930s, 'Socialist conflict arose not when the centre penetrated the periphery, but when outsiders (foreigners) violated the outer boundary ... The border was inviolable, and its sanctity gave mass culture a new adventure hero: the border guard (NKVD *pogranichnik*).'[17]

Quite apart from the fact that Stalinist culture was attempting to designate a homogeneous cultural Other ('foreigners') to set against the supposedly unified 'Sovietness' of all its various nationalities, at the same time as its Constitution was declaring its inherent lack of racism – 'There are no black or coloured people', in the words of *Song of the Motherland* – von Geldern's point is important for our study in one more way. His evocation of the contemporary rhetoric of the 'violation' of the border brings us back to the issue of the masculine ego's ideal impenetrability already suggested by Stallone's 'No one's gonna watch my back': any form of masculinity presumed defective is figured in such a climate as a threat to national security – the body politic becomes aggressively heterosexual.[18]

The cult of the soldier, then, constitutes the summit of the workings of dominant ideologies concerned with maintaining a state of permanent battle-readiness among male populations, which in turn involves fostering a certain level of 'natural' male aggression – a delicate balancing act indeed. A vast amount of research has already been undertaken on the nature of institutionalised male violence,[19] of which two ideas are of especial significance to us in terms of Stalinist repression of masculinity and the cult of the soldier. First of all, as Lynne Segal points out about modern-day western males: 'It is the sharp and frustrating conflict between the lives of lower working-class men and the image of masculinity as power, which informs the adoption and, for some, the enactment, of a more aggressive masculinity.'[20]

The notion that male violence can arise in the gap that opens up as men struggle to resolve the dichotomy between, on the one hand, assurances that, under patriarchy, men occupy a privileged and powerful position, and, on the other, very real feelings of impotency in the face of larger political processes, certainly provides food for thought. In Soviet cinema of the 1930s and beyond, these assurances of power were trumpeted ever more loudly, as men were encouraged to play ever greater roles in the construction of the socialist Utopia, and yet, as we have seen, on a symbolic level the

men of the country were in fact portrayed as themselves fundamentally impotent.

Equally important, however, is the idea that dominant patriarchal ideology actually has a vested interest in the construction and maintenance of an aggressive male underclass. Such a situation first of all allows for the principle of divide and rule – in the recent past, the British Conservative Party could not have promoted itself as 'the Party of law and order' without crime and civil disruption; furthermore, as we have just explained, it promotes a state of permanent battle-readiness in men of all classes – a prerequisite for national security; but, perhaps most importantly, the institutionalisation of male violence allows for the promotion of the state's own security forces – the police, army, SAS, NKVD and so forth – as an escapist realm (join the army, see the world) where violence and aggression are legitimised, and the ideological subject may finally assume the self-image of the comic-book heroes and adventurers presented to him in his youth.

To sum up, then, if we accept the concepts of aggression as an unavoidable characteristic of the ego, and man as the sex socially permitted (more or less) to display and utilise it, we can now return to the question of whether the Great Patriotic War – war being the 'most complete social expression' of male aggression[21] – did indeed bring to the surface the crisis of masculinity that had been bubbling under throughout the 1930s. To judge by the stark contrasts between the figures of Chapaev and Sokolov, it would certainly seem that it did.

Is it possible to isolate a simple cause for the absolute *volte face* we have witnessed on the part of the Soviet soldier hero? Obviously, the acknowledgement of Stalin's 'reign of terror' made explicit in Khrushchev's so-called 'secret speech' plays its role in undermining the quasi-religious faith in leadership that constituted so much of Chapaev's heroic status, but that alone cannot account for the emotionally-battered figure of Sokolov. Surely the 'thaw' was more than just an historical era – rather, it was characterised by a state of mind, a *zeitgeist* that was physically and psychically at the end of its tether, and a huge factor involved for the figure of the soldier hero must be the experience of the Great Patriotic War. The horrors of the Nazi advance and occupation, coupled with the crippling sieges (especially of the symbolically-named Leningrad and Stalingrad) famine, and devastation of both rural and urban land and industry, were enacted on a scale that is almost impossible for westerners to comprehend. Above all, there were also the estimated millions of dead – the majority of whom would certainly be young males – a factor which could hardly help but have a colossal impact

on Soviet masculinity at large: as *Untermenschen* the Slavic peoples faced an onslaught of Nazi barbarity that left them no choice but to fight for the Motherland. The same applied to Soviet cinema, which was once again mobilised as a front-line propaganda tool, just as it had been in its heyday of the Revolution and Civil War.

The remainder of this study aims to chart the path of the Soviet soldier hero from Chapaev to Sokolov by way of two more films made during and, to a greater or lesser extent, about the Great Patriotic War, both with important ramifications for gender studies. After *Chapaev*, we shall look at Mark Donskoi's *The Rainbow* [*Raduga*, 1944]. *The Rainbow* is an acknowledged classic example of a particular genre of Soviet war films featuring women as fighters (and often avenging angels) and is representative not only for its extreme typology of women as the touchstones of social class and behaviour, but also for the way in which the men of the film fail to confront this very real issue, and at the same time display a characteristically masculine lack of awareness of their own actions and motives.

We shall also take a close look at Eisenstein's wartime masterpiece *Ivan the Terrible* [*Ivan Groznyi*, 1944–45] as a unique and important portrayal of a form of masculinity that is not absolved from such self-analysis, and which may even be described as *at war with itself*. Although it is set four hundred years in the past, it is widely acknowledged that the film says a great deal about its own times, and the figure of Ivan clearly marks a crisis point along the path to the self-awareness and spiritual collapse that characterise Sokolov more than a decade later. Mention will also be made of Eisenstein's *Alexander Nevskii* [1938] as a kind of precursor to Ivan, although still very much more in the mould of a Chapaev than a Sokolov. Without wishing to get bogged down too much in the debate surrounding Eisenstein's real or perceived 'selling out', we should nonetheless examine the changes in the type of hero portrayed by the director, in particular his extreme homing-in on one individual's psychic topography, paving the way for 'thaw' heroes such as Sokolov.

Chapaev: accentuating the positive hero

As the rave reviews and enthusiastic critical plaudits poured in for the Vasil'ev Brothers' 1934 classic *Chapaev*, it seemed that the new 'single method' of socialist realism in art had got off to a flying start. The marriage of action and ideology proved to be a match made, if not in heaven, then at least in the socialist Utopia foreseen by the hero – a point that did not go unnoticed by the *Pravda* editorial quoted above of this study, which continues: 'The Party has been given a new and powerful means of educating the class consciousness of the

7 Grasping the essentials: Boris Babochkin as the eponymous
Chapaev [1934] discusses strategy with Party mentor Furmanov
(a suitably radiant Boris Blinov)

young [...] *Chapaev* will be shown in every corner of our immense country.'[22]

The key to *Chapaev*'s success clearly lies in the film's simplicity and directness: a good story with a message, about an ordinary man made extraordinary by force of circumstance and the inexorable march of History. Like his civilian counterpart Maksim in the trilogy by Kozintsev and Trauberg, Chapaev's status as a positive hero is guaranteed not only by his lowly origins, but also by his rising to the challenges thrown up along the road to political consciousness. In line with the basic principles of socialist realism's 'master plot', *Chapaev* re-enacts the resolution of the consciousness/spontaneity dialectic through the figure of its hero, a peasant commander of the Civil War, who is guided towards tempering his wilful side the better to serve the needs of the nascent Soviet Union.

Chapaev's mentor is the Commissar Furmanov, on whose equally classic autobiography the film is based. It is he who provides the series of 'lessons' on such subjects as personal behaviour, leadership, strategy, and (needless to say) politics, which add elements of 'consciousness' to Chapaev's 'natural' or 'spontaneous' qualities (not to mention his 'innate' Communism), to produce a fully-rounded version of the New Soviet Man, who finally becomes ready to make

the ultimate Christ-like sacrifice in the name of the shining future that he predicts on the eve of what is to be his final battle. The relationship between the commander and the Commissar lies at the heart of *Chapaev*, initial mistrust turning gradually into friendship, until, by the end of the film, as Furmanov is called away, the parting handshake between the pair becomes a manly embrace, and the male bond is legitimised. This legitimisation also performs the function of bestowing the Party's blessing on the men of the camp as a microcosm of the Great Soviet Family: the spiritual (and of course, physically absent) father-figure of Lenin, the avuncular Furmanov, and finally Chapaev himself, who, as the eldest and most boisterous of the brothers, is very much the first among equals.

Chapaev, then, does contain certain elements of the classic 'buddy' movie: two men with 'their own way of doing things' are paired in a fight against a common enemy. However, in *Chapaev*, it is the voice of reason which triumphs, in perfect accordance with the Leninist resolution of the consciousness/spontaneity dialectic, in which the conscious side 'tames' the elemental to its own ends. We have already seen how the taming of the elements was a central theme of socialist realism – whether to conform to basic formal principles of the genre, or to portray a masculinity able to overcome certain primal urges in the name of the building of socialism. We shall see that *Chapaev* proved no exception on either level.

First of all, the wild ambiguities of visual art are downgraded in the film to allow centre stage to a more straightforward, plot-driven narrative. One example of this is the acclaimed 'subtle' portrayal of the enemy, in the form of the White Colonel Borozdin, who, despite his shaved head, monocle, and love of bourgeois music, is nonetheless a far cry indeed from the extreme grotesqueries of 1920s cinema, not least because his atrocities are generally performed off-camera. On a deeper level, we can also see ways in which apparently 'folksy' elements of *Chapaev* themselves defer to a more 'reasoned' approach to revolutionary cinema.

There is a strong case for ranking the figure of Chapaev alongside such legendary Russian folk heroes as Stepan Razin, Pugachev *et al.*, and indeed this particular peasant leader does fit squarely into the long tradition of the *buntar'*, or folk rebel: a close contact with both the land and the people who work it is complemented by a feisty spirit, and the ability to inspire the *narod* to the point of self-sacrifice in the name of revolution against the aristocratic oppressors. Both the film and its star, Boris Babochkin, became an intrinsic part of the Soviet collective unconscious, with references to *Chapaev* still being casually dropped even today. More importantly, in terms of Soviet men at war, Richard Taylor points out:

The character of Chapaev penetrated into popular culture and every-day life in a way that few other screen characters have done, even if only as a butt for schoolchildren's jokes. Babochkin was even recalled from theatre work in 1941 to recreate his Chapaev role in a little-known wartime morale-booster called *Chapaev Is with Us* [*Chapaev s nami*].[23]

Folk elements abound in the film, but in combination with what are clearly motifs from contemporary Hollywood Westerns: with scenes of the brigade sitting on the steps of what might as well be a Soviet ranch-house, the images of rolling plains, guns and horses, and the use of collective song, *Chapaev* is without question a film not only about a modern-day *bogatyr'*, but also one implicitly dedicated to the cowboy ideal of forging a new life in the land of the free.

The action elements of the film, then, represent a fairly sophisti-cated marriage of Russian epic history with what are widely acknowledged as legitimising 'frontier' narratives – apologia for bloody and brutal wars waged in the name of a cause higher than the rights or wrongs of human suffering. More importantly for us, however, this 'cowboy' ideal also entails a 'conquering of nature' in the names of both a great future, and a symbolic father figure. In the framework of socialist realism, and the publicistic discourse so rife at the time, this ideal must surely be connected to those of the Arctic Fliers ('the fledgling children of Stalin',[24] including of course Valerii Chkalov) and the champion Stakhanovites of both urban and rural industry who feature so prominently in the films of Aleksandrov and Pyr'ev. As we have seen, a conquering of nature – in Stalinist cinema at least – entails more than a simple re-enactment of the Materialist philosophy of History: it also involves an extreme degree of self-denial, especially in terms of male sexuality.

As such, it important to note that, whilst Chapaev's self-assur-ance and his apparent dealings only in certainties – his catch-phrase 'I am Chapaev!' represents nothing if not an assumption of an inte-grated, unified subjectivity – fit him squarely into the canon of socialist realist positive heroes, we can see gaps open right across this surface cast-iron personality. Although, for example, Chapaev clearly feels an instinctive certainty that Communism is a generally good cause, his profession of faith is embedded in a scene which lays bare his complete lack of knowledge about politics. Once again, we are dealing here with one of socialist realist cinema's frozen moments, in which the didacticism comes to the forefront, and we witness the elaboration of 'Soviet reality' – things *as they really are* in the socialist realist world view. We should note a distinction, how-ever, between, for example, Tania's 'jubilant assumption of [her] specular image' in front of the mirrors at the climax of

Aleksandrov's *The Shining Path*,[25] and the apparent desperation with which the embattled Chapaev re-enacts this process as a means to shore up a self-identity under the threat of the insistent questioning of Furmanov – not to mention the evident amusement of the men he commands. On the surface, the humour may help to make the political message more palatable, but cracks are already appearing in the subjective armour of the Soviet soldier hero, and *Chapaev* is ranked very firmly within a series of films that implicitly detail the crisis of Soviet masculinity of the 1930s.

The Rainbow: sometimes it's hard to be a woman

Chapaev's 'I am Chapaev!' mantra, then – repeated especially at points in the film where the commander's personality, or authority, is called into question – represents what can be seen as an almost pathological compulsion to re-enact the Lacanian 'mirror stage', and it should come as no surprise, then, that this bolstering-up of the male ego and its concomitant self-mythologising, is complemented by a natural flair for battle strategies. As such, Chapaev not only exemplifies Easthope's comments on male aggression, but also epitomises the seeming inability of the New Soviet Man to progress past the imaginary to full integration into the symbolic order.

This enforced self-assurance on the part of male positive heroes is also a major feature of Mark Donskoi's wartime film *The Rainbow*. Although the Red male partisans only make a belated and somewhat marginal appearance in the film, when they do finally arrive on the scene, their certain knowledge of what they must do puts a sudden end to all kinds of uncertainties problematised in the main body of the picture. The decisive actions taken go to the extreme of their leader's summary execution of his own wife, Pusia, for her collaboration – a public disloyalty mirrored by her sexual infidelity with the Nazi Commandant Kurt.

The Rainbow is just one of a number of Soviet war films concerned with female partisan heroines, a genre that includes, amongst others, Fridrikh Ermler's *She Defends the Motherland* [*Ona zashchishchaet rodinu*, 1943], Leo Arnshtam's *Zoia* (1944), and Vera Stroeva's *Marite* (1947). All of them follow the wartime trend in Soviet cinema towards an emphasis on realism, accompanied by graphic portrayals of both horrific violence on the part of the invaders, and of the need for vengeance. The overt ideological charge of these films, then, appears to be fairly straightforward, as Kenez notes: 'By showing the courage and suffering of women, these works aroused hatred for the cruel enemy and at the same time taught that men could do no less than these women.'[26] This reading

holds true, up to a point: there is nothing new in Soviet cinema using female characters to gain the sympathy of the audience. On a deeper level, however, this can be seen as a gross over-simplification of the roles of the partisan heroines. For beneath the graphic realism, we can detect layers of symbolism, and, more specifically, the portrayal of instantly recognisable types. This is most particularly obvious in *The Rainbow*'s representation of women: the film's realism is in fact countered – and some would even say marred – by its typology of women who, in spite of their carefully-drawn characters, would not have been out of place in Eisenstein's *October* as touchstones of the best and worst in human nature.

The Rainbow tells the story of a woman partisan, Olena Kostiukh, who returns to her occupied home village to give birth. She is captured by the Nazis, and unsuccessfully tortured (in gruesome detail) for the names of her resistance comrades, until first her new-born baby, and finally Olena herself, are executed. The sacrifice of the baby in the name of the Motherland is a common device in films of the Great Patriotic War, and Olena mirrors Leo Arnshtam's Zoia, in that, as Lynne Attwood points out, 'the character was not offered merely as a product of her country. Rather, she was her country'.[27] Without wishing to get too involved in a discussion of this image of the Motherland sacrificing her babies for the cause of socialism, we shall simply suggest that Olena is a descendant of a line of Soviet heroines representing the motherland (*rodina-mat'*) who are rallied in times of crisis to elicit a strong emotional response. As such, she figures the Freudian 'good mother' – an object of love, but again not of sensuality.

At this point, it is interesting to note that, in the darkest hours of the War, Stalin had made an uneasy alliance with that other great propagandiser of patriarchy, the Orthodox Church. The theme of the earthly and heavenly Tsars will come up in our discussion of *Ivan the Terrible*, but for the moment we shall look further into the return of the age-old Madonna/Whore split in iconography of women – a tradition largely submerged in the 1930s comedies of Aleksandrov and Pyr'ev beneath idealised socialist competition between good and better. If Olena, as we have seen, represents the Madonna, then her counterpart is clearly figured by the character of Pusia: despite being the wife of the partisan leader, she nonetheless sets herself up as the mistress of the Nazi Commandant Kurt, readily accepting luxurious gifts of chocolates and stockings very early on in the picture. Furthermore, she represents the return of a hitherto repressed predatory, appetitive female: the chocolate is accompanied by a passionate kiss, and the stockings provide ample opportunity for her to flash her legs at the camera, displaying, in the manner of a

Hollywood noir *femme fatale*, the attractiveness of evil. Put simply, the lady is a tramp.

We have already mentioned the power of the female figure to bring out an emotional reaction in the cinema-going public, and now the question arises: if we are to feel sympathy for Olena (not least on seeing her new-born baby put to death) then what are we to feel for Pusia? Quite apart from being unmistakably wicked, Pusia is the embodiment of sensual pleasures: her self-indulgence in the luxuries of chocolate, silk and kisses provide the spectator with a true scopophilic feast. In spite of the obvious equation of sensuality and evil, her appearances on screen lull the viewer into voyeuristic and fetishistic pleasures which, arguably, make her sudden execution even more shocking than those of Olena or her baby.

This execution carries with it a number of overt and tacit messages for the spectator. First of all, as in the case of Olena's baby, blood ties are downgraded in favour of the great family of the State – the ghost of Pavlik Morozov is still haunting the Soviet screen with, quite literally, a vengeance. On a symbolic level, Pusia must be shot to avenge the death of Olena and her child, and in fact the action of the film tries to make it clear that her death comes as a direct result *only* of her collaboration, and *not* her philandering. This is achieved, with some degree of success, by the portrayal of a typical masculine clarity of thought and decision on the part of her husband, who makes no mention of her infidelity: once again, the male ego mirrors the State by lashing out against an external threat to its unity.

This threat, of course, is figured by Pusia, who, quite apart from her being an unfaithful wife, is clearly associated with death by her collaboration with the Germans. Furthermore, in case the message was not already crystal clear to the viewers, she is mirrored throughout the bulk of the picture by the weak, cowardly, and decidedly non-virile figure of the old collaborator Gaplik, who is also executed by the returning partisans. The motives behind Pusia's death cannot possibly be as clear cut as the film would have us believe: identified with both Gaplik and the Nazis, she represents a threat to her husband's sense of masculinity, and, ultimately, to his life – a twin onslaught the husband can only master by killing its signifiers.

To an extent, the belated arrival on the scene of hegemonic masculinity (in the form of the Red partisans and their ruthless actions) represents a desperate attempt – like the marriage of Klim and Marianna in Pyr'ev's *Tractor Drivers* – to reinscribe a dangerously wayward film text into the 'objective' discourse of socialist realism. At the same time, it may also be read as another attempt to shore up Soviet subjectivity against the threat of 'fractured consciousness'

8 Tempting but treacherous: Nina Alisova vamps it up as
femme fatale Pusia in *The Rainbow* [*Raduga*, 1944]

elicited by Pusia's gloriously vampish behaviour. The fact that the
role of male violence as the ultimate guarantor of 'correct behav-
iour' is here made explicit once again indicates a certain 'emergency
measure' undertaken on the part of the patriarchal assumptions
underpinning socialist realist discourse: it is worth repeating that
patriarchy is most powerful when it can remain invisible, fade into
the background and pass itself off as a 'natural' part of the scenery;
when patriarchy shows its hand in such an obvious way, it is only
because it has been forced to do so – no matter how much it attempts
to authorise itself by appeals to a 'natural' law or sense of justice.

There is, then, clearly more to Pusia's death than a simple demand
for vengeance, but the story does not end here: we have already noted
the implicit rejection of sensuality in comedies of the 1930s, and

now we are in a position to isolate perhaps the most important sub-textual reason behind the return to the screen of an explicit female sexuality. If the sublimation of the sexual drive into labour had been a feature of musical comedies, the need to deny sensual appeal and bodily sexuality had become even more pressing within the context of waging a bloody and brutal war. The fact that this call was now made explicit – and the extreme measures undertaken to follow it – clearly demonstrate a rising to the surface of the crisis of masculinity under Stalin.

Ivan the Terrible: patriarchal (dis)order

Whatever the implications of Pusia's execution, for the purposes of the next section of our study we need only really note that the film itself makes absolutely no reference to her husband's internal dilemmas: like Chapaev, the partisan leader is barely aware that he is following either external or internal laws, and yet, of course, he is. As such, both positive heroes play the classic masculine card of failing to analyse their own discourse. This characteristic lack of self-awareness on the part of men allows patriarchy to flourish – it is also arguably responsible for the failure to establish a 'women's cinema' in the Soviet Union of the 1920s. As long as men are able to feel privileged, they will never question the workings of the patriarchal order that positions and, to a degree, oppresses them. This brings us to Eisenstein's *Ivan the Terrible*, a singular example of an explicit treatment of the inner traumas of a masculinity that, by the end of the war, was reaching critical mass. The film abounds with uncertainties, self-doubt, and interior monologues, and the fact that Eisenstein elected to project these crises onto the figure of a patriarch is just one feature that makes the history of the film as twisted and compelling as the final product itself.[28]

Originally commissioned as one of a series of historical biopics, *Ivan the Terrible* may be seen as a natural successor to films of the 1920s, such as Esfir Shub's *Fall of the Romanov Dynasty* [*Padenie dinastii Romanovykh*, 1927], or Eisenstein's own *October* and *Battleship Potemkin* [*Oktiabr'*, 1928, and *Bronenosets 'Potemkin'*, 1926], which sought to justify the Revolution, and thus provide legitimising narratives for the Bolshevik government. This trend continued into the 1930s to encompass such films as *Chapaev*, but there was a notable shift *backwards* to events and characters dating from long before the Revolution, and with little apparent significance to it: Peter the First, Stepan Razin and Aleksandr Nevskii, to name but three.

Whether or not this upsurge of heroes of Russian nationalism and patriotism unconsciously acknowledged both the Nazi threat

and the failure to kindle world-wide revolution, we are nonetheless presented with a long line of great exemplary patriarchal figures from the pages of history, all of whom acted as popular leaders: standing out *alone* from the masses; defending Russia so courageously in the past; and having their logical heir in Stalin. The re-establishment of patriarchal family values in the 1930s entailed an anthropological shift from 'horizontal' to 'vertical' kinship axis – from the 'massist' ideals of the first Five Year Plan to an emphasis on individual leaders – and cultural myth necessarily followed suit. Furthermore, the patrilineal nature of the vertical kinship axis is evident in the cinema too – there was never a Soviet film made about Catherine the Great.

The plan for *Ivan the Terrible*, then, was to vindicate by historical parallel Stalin's autocracy, reign of terror and 'iron ring' as a progressive force against disunity and elitist exploitation: Stalin evidently identified with the sixteenth-century autocrat – perhaps they were both just misunderstood. The epic that finally emerged from the cutting room, however, turned around and completely subverted this ideological basis: shamelessly stylised, thematically abstract, and littered with ambiguities, *Ivan the Terrible* represents what is now widely acknowledged as a brilliant work of art in a time of simple presentation of images, and a celebration of form in an industry obsessed only with content.

Before we turn to the film itself, it is worth taking a quick look at Eisenstein's previous feature, *Aleksandr Nevskii* [1938] both as a precursor to *Ivan*, and as the film that may or may not have saved its director's career – if not his life. The historical parallels of Nevskii and Stalin are plain for all to see: a great and charismatic individual leader from the masses, with the ability to inspire his people and, rather topically, defend his beloved homeland from invading Germanic knights, Nevskii is clearly modelled in part on Stalin's idealised self-image. The film also has the linear plotline and exemplary self-confident positive hero demanded by the constraints of socialist realism, and so at first glance seems out of keeping with Eisenstein's previous works, all of which had focused on the *collective* as the prime force behind historical progress.

In this context, however, it is vital to note that *Nevskii* employs a number of subtle devices to counteract this apparent submission to state sponsored restrictions on film art. In particular, the heavily stylised acting demanded of Nikolai Cherkasov in the lead role results in a far from naturalistic portrayal of the hero, and this signification of the figure, rather than the personality, does diminish the specifically heroic role of Nevskii. Furthermore, by far the most impressive scenes of the feature remain the great battles, where it

is the masses – faceless and undifferentiated – who are seen as very much the driving force behind (capitalised) History. In combination with its privileging of a majestic, almost operatic form, we can see how *Nevskii* rebuffs socialist realism from the inside, and as such mirrors Eisenstein's notorious self-criticism over the failure of his projected *Bezhin Meadow* feature, in which he claims that his 'mistakes' are 'rooted in one deep-seated intellectual and individualist illusion ... an illusion *that Stalin tirelessly exposes* – the illusion that one may accomplish truly revolutionary work on one's own, outside the fold of the collective, outside of a single iron unity with the collective'.[29]

More importantly, however, *Nevskii* does in fact mark a break with Eisenstein's earlier work in several interesting ways. For example, the use of non-actors for their looks – 'typage' – was replaced by an acknowledged star of the Red Screen, Nikolai Cherkasov. Furthermore, although the heroic character of Nevskii himself remains more of a generalised type, we are introduced to two of his acolytes, Gavrilo Olekhich and Vasilii Buslai, and the film's exploration of their rivalry marks a shift in the director's focus on psychology, from that of the spectator to that of his own creations. As Richard Taylor points out: 'for the first time in an Eisenstein film we see characters who display signs of individual human emotion and motivation.[30] In opposition to the previously impenetrable ego of earlier positive heroes, Eisenstein is already beginning to probe beneath the surface of the male psyche, and, with characteristic directness, he homes in on men's emotional dealings with love and war. The figures of Gavrilo and Vasilii provide an opening into masculinity that we shall see the great director tear wide open in his final films about Tsar Ivan.

The phenomenal success of *Nevskii* resulted not only in critical acclaim and the Stalin Prize, but also, and most importantly for Eisenstein, in his being granted what amounted to creative *carte blanche* for the production of what the director quite possibly knew would be his last and greatest work: sole command of his subject with no other scenarist, and certainly no trace of the shadowy 'second unit cameraman'/Party agent who had dogged his progress throughout the production of *Nevskii*. This solitary work produced what may be seen as an intensely introspective film, which abounds with references to Eisenstein's own personal life as well as his times.

First and foremost, *Ivan the Terrible* really is a film about an individual and his immediate circle. From very early on, Eisenstein even makes a point of keeping off-screen the Moscow fire and riots that interrupt the wedding banquet – scenes that a younger Eisenstein

9 Between heaven and earth: Nikolai Cherkasov's tortured
tsar issues his challenge to a stern patriarchy in
Ivan the Terrible [*Ivan Groznii*, part one, 1945]

would have relished committing to celluloid. Cherkasov's stylised
acting, as in *Nevskii*, again downgrades the heroic role of the Tsar,
but on this occasion the director is more than willing to compen-
sate with lingering close-ups, and even a lengthy 'internal mono-
logue' at the foot of his dead wife's catafalque. The masses may still
be present in the siege of Kazan' and the march to call Ivan back
to the capital, but, especially in the latter instance, they now serve
quite literally only to emphasise the outline of the Tsar's personal
features; such elements have even prompted Peter Kenez to remark
that, 'unlike other products at the time, this one is fiercely individ-
ualistic ... Unlike any other director of a Soviet historical film,
Eisenstein created a complex and interesting character.'[31]

Furthermore, the switch from mass-centred to individualistic narrative is reflected in the film's composition. Eisenstein has almost completely abandoned conflictual montage – the juxtaposition of two shots to produce a third image in the mind of the spectator – in favour of 'internal' montage, involving complex *mise-en-scène* to produce an instantaneous mental suggestion. Internal montage was not only better suited to the needs of a faster, synchronised sound picture, but it also allows the focus to remain sharply on the inner workings of the character's mind, as he struggles to come to terms with his destiny as a man. Eisenstein's avowed intent was to make a film about a 'difficult personality', and for the first time in Stalinist cinema, we are presented with a genuinely self-reflexive male hero.

This hero, as we have seen, was clearly intended to be identified with Stalin, and yet there are all sorts of reasons to identify the Tsar with Eisenstein himself *as well*. In fact, the director is stamped all over the film: psychological trauma, religious angst, questions of power and impotence, and, especially for our purposes, the good and bad mother figures of Ivan's wife Anastasia, and his wicked aunt Efrosin'ia Staritskaia, who dominates much of the film's action and psychological drama. Meanwhile, Ivan's nagging self doubt, figured in the repeated questions 'Am I right?' and 'To whom can I turn?' is a world away from the self-affirming cry of 'I am Chapaev!', and indeed, it seems that the Tsar can only turn inwards upon himself. In terms of masculinity, and masculinity in crisis, this is where the figure of Ivan makes a radical departure from earlier positive heroes of socialist realism: rather than ignoring the tension in his psyche, both he, and the film itself, tackle it head on.

Of all the psychoanalytical issues raised by the film, however, the most important within our theoretical framework must be represented by the figure of Vladimir Staritskii. Ivan's cousin clearly figures a suppressed side of the Tsar's own character, and his portrayal as immature, camp and impotent has been interpreted as more than a hint at Eisenstein's own potential homosexuality – a side of himself that, according to Marie Seton, he considered artistic suicide.[32] Could this be a reason behind Ivan's persecution mania? Eisenstein was fascinated by Freudian theory, and Freud's celebrated case history of obsessional neurosis – more generally referred to as the case of the 'Rat Man'[33] – documents the analysis of a young soldier who, like Ivan, is tormented by seemingly irrational fears. If the Tsar does have clear echoes of the Rat Man, then we should also note that the Rat Man's persecution mania stemmed in large part from the threat of his own homosexual side – in much the same way as Vladimir is the most significant threat to Ivan's power and the stability of his unified

State. On top of this, and of particular relevance to a study of the male soldier hero, is the almost suffocating military background to the Rat Man's upbringing, and, perhaps most importantly, the idea that he felt that he had failed to emulate his father, who had enjoyed a distinguished military career.

In fact, Ivan fits very neatly into our earlier discussion of dominant notions of masculinity and statehood. Unlike the relatively secure Chapaev, his frantic attempts to secure a unified State/ego are constantly under threat of penetration. Again unlike Chapaev or the partisan hero in *The Rainbow*, his relation to inner and outer law is explicitly acknowledged in his relations with God, again reflecting Freud's ratty patient: 'Some masculine inward gazes will see a hero created by the transgression of the law. Others like the Rat Man's are directed at laws which cannot be broken with impunity.'[34] Finally, he is also bereft of a good object by the murder of his wife (a murder that he himself unwittingly – unconsciously? – perpetrates), paving the way for bouts of raging depression and unconscious sexual confusion figured by the threat of his cousin, the effete Vladimir. The logical conclusion of all this, and in fact the climax of the second part of the film, is that Vladimir must be killed off as the enemy within, a killing which is displaced onto the Freudian 'bad mother' Efrosin'ia. Despite Vladimir being, in comparison to his mother, a fairly minor character, his murder's privileging by the film in terms of suspense, *mise-en-scène*, and of course its climactic position, gives us a clear indication of the importance the director attaches to the event that crushes the focal point of the Boyar's plot – a plot that threatens to render Ivan impotent.

There can be little doubt that Eisenstein pulled out all the stops to make *Ivan the Terrible* a subtle, and yet blindingly effective, refutation of the strictures of socialist realism on form and content: quite apart from presenting us with an introspective – and therefore not particularly 'positive' – hero, the linear plot is continually side-tracked and complicated by the war with Sigismund, the betrayal of Kurbskii, and in particular the conflict with the heavenly tsar, and all set in fresco-like scenes and strained acting – an atmosphere of dark expressionism that is a far cry indeed from the single method's requisite 'shining future'. Especially by the second part, psychology has almost completely displaced action. The tension is unbearable, and what narrative there is amongst all the baroque spectacle is hinged explicitly on confusion of identity, pointing up even further Ivan's own inner crisis, which as we know is only resolved, if at all, by murder.

With the two parts put together, the atmosphere of confusion, paranoia, and real and perceived threats builds into the most

artistically satisfying (by western standards) Soviet film of the war. It is not only a film that succeeds, against heavy odds, in producing a rounded and lasting impression of masculinity under Stalinism and the shadow of war, but also an exquisite parable of a man at war, masculinity at war, and ultimately masculinity at war with itself. In these terms, surely Eisenstein's real masterstroke was the depiction of a problematic masculinity through the figure of the great patriarch himself. If nothing else, this may be read as a clear sign that critical mass had been reached and breached, and that the crisis of Soviet masculinity had finally been forced out into the open.

Postscript: the fate of men

So how exactly did masculinity on screen come to terms with this? The answer, as one may expect, is that it did not. The second part of *Ivan the Terrible* was committed to the shelf, and, with characteristic irony, work on the third part – featuring Ivan's eventual triumphant access to the sea – was halted. The conditions of the war, it seemed, had allowed for a certain, almost paradoxical liberation for the directors and screenwriters of the USSR, as Kenez remarks:

Films once again expressed genuine feeling and real pathos: the hatred for the enemy, the call for sacrifice and heroism, and the sorrow for the abused Soviet people were real and heartfelt. The directors believed in what they were saying. The period of the war was a small oasis of freedom in the film history of the Stalinist years.[35]

One of the reasons behind this short-lived freedom must be linked to the temporary re-emergence of pan-Slavism: in an effort to forestall German attempts to profit from Slavonic internecine feuding, Kenez points out, the 'friendship of peoples' was complemented even in their filmic deaths by them having 'the name of Stalin and the motherland on their lips, not that of the Communist Party'.[36] If Moscow's role as centre of world-wide revolution was indeed downgraded during the war (and this was not in fact always the case, as in films such as *She Defends the Motherland*) then this partial relaxation of centripetal forces would account for the emergence of a space within which to explore new meanings, and confront real issues. In a similar way, the unleashing of the energies binding the State against the invaders is matched by the emergence of a fragmented masculinity.

Is it any wonder, then, that the years following the Great Patriotic War are marked by what became known as a 'film-hunger'? The Soviet State needed to clamp down ruthlessly on these freshly

emerged centrifugal forces, and as a result numerous campaigns were launched against any deviant cultural trends, including of course any representation of self-reflexive masculinities. As such, part two of *Ivan the Terrible* was not released until 1958 – well into the Khrushchev 'thaw' period – by which time other films were also able to explore more openly the theme of quite what it means to be a man.

One such film dealing specifically with the Soviet soldier hero, as we have mentioned, was Sergei Bondarchuk's *The Fate of a Man* [Sud'ba cheloveka, 1959]. Although it was withdrawn from distribution soon after its release, official disapproval of the film was most probably directed primarily at its overtly negative treatment of the Stalin era and the Great Patriotic War, rather than its engagement with the subject of masculinity per se. Based on a novella by Sholokhov, the film recounts the exploits of Andrei Sokolov, whose apparently idyllic life in the 1930s was torn apart by his experiences of the War: his imprisonment in, and subsequent escape from, a Nazi prisoner of war camp; the loss of his family; and his adoption of an orphan boy.

Sylvie Dallet has described Bondarchuk as 'brave enough to create an unhappy hero',[37] which would suggest that Sokolov is atypical as a thaw hero. Meanwhile, Graham Roberts has put forward the idea that 'the kind of masculinity which Sokolov represents can be read as a sign of the Soviet Union's new-found self-confidence under Khrushchev'.[38] In the context of this study, I would suggest that Sokolov *is* a fairly typical thaw hero, but not necessarily in the way Roberts suggests. Whilst it is true to say that he possesses all the attributes of a 'real' Soviet man – Roberts mentions his courage, sense of comradeship, patriotism and 'ability to drink like a fish'[39] – these are all qualities that he has learned under Stalinism, and not really new at all. Most notable is his drinking prowess, but again he has always been a hard drinker – first of all to celebrate his life, then, paradoxically, to save it, and ultimately just to forget, and get through it.

Certainly, by the end of the War, Sokolov is plagued by anxiety and self-doubt – at best, he is resigned to his fate, or else revels in happy memories of an idyllic past that looks suspiciously reminiscent of a scene from a Pyr'ev comedy. Such nostalgia can only serve to diminish the optimism provided by the constancy of the Soviet male's most praiseworthy attributes, but, in the final analysis, whether the future turns out to be bright or not, Sokolov as a survivor knows he has to face more uncertain times ahead, and will never be able to answer his first question of why life is the way it is.

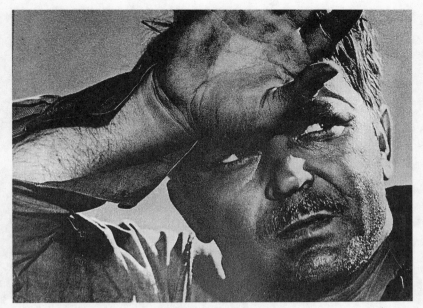

10 Stumbling towards uncertain times: Sergei Bondarchuk's
Andrei Sokolov represents post-Stalinist masculinity at the end of its
tether in *Fate of a Man* [*Sud'ba cheloveka*, 1959]

Such a lack of resolution, then, means that the film does in fact
raise many more questions than it cares to answer, and looks for-
ward to, if anything, the so-called 'slice of life' (*bytovoi*) genre that
was to come to prominence particularly under Brezhnev. A good
example of this is the theme of orphanhood, an obvious reference to
the dichotomy of the Stalin era between the promotion of the family
unit as the basic cell of society, and the downgrading of blood ties in
favour of the Great Family of the Soviet State. Sokolov was himself
an orphan brought up by the Soviet family, under the paternal eye
of his symbolic father Stalin. Now, however, it is Sokolov himself
who must take on the uncertain parenting of the next generation:
the film's optimism, then, lies in the idea that the model sons of the
country are at last able to assume the self-image of a father.
Although the death of Stalin signalled the end of a very specific and
virulent form of patriarchy, it was the experiential crucible of war
that furnished the first opportunity to question the type of hege-
monic masculinity figured by the soldier hero. Self-assurance – a
cover for a multitude of internal anxieties – has given way to self-
awareness, and a more honest treatment not only of the internal
workings of the male psyche, but also those of the country as a
whole.

Brothers in arms

Notes

1 Cited by Leonid Kozlov in Richard Taylor and Derek Spring (eds), *Stalinism and Soviet Cinema* (London: Routledge, 1992), p. 130.

2 Evgeny Dobrenko, '"Iazyk prostranstva, szhatogo do tochki", ili estetika sotsial'noi klaustrofobii', *Iskusstvo kino* 1996, no. 9 (September), 108–17 (117, my italics).

3 Abram Terts, 'Chto takoe sotsialisticheskii realizm?', in *Fantasticheskii mir Abrama Tertsa* (New York: Inter-Language Literary Associates, 1967), pp. 401–46 (p. 438).

4 Evgenii Zamiatin, 'Genealogicheskoe derevo Uellsa', in *My: Roman, povesti, rasskazy, p'esy, stat'i i vospominaniia*, ed. E. B. Skorospelova (Kishinev: Literatura artistike, 1989), pp. 603–8 (p. 605).

5 'O literature, revoliutsii, entropii i o prochem', in Zamiatin, *My*, pp. 510–16 (p. 511).

6 *Ibid.*

7 See our discussion of *Valerii Chkalov*, above (chapter 2). It is also worth noting that, even in the more conservative tradition of portraiture, Lenin is generally shown to be *doing something* – more often than not chairing some meeting, or writing one of his many articles.

8 Richard Taylor and Ian Christie (eds), *The Film Factory: Russian and Soviet Cinema in Documents 1896–1939* (London: Routledge, 1994), p. 353.

9 Antony Easthope, *What A Man's Gotta Do: The Masculine Myth in Popular Culture* (London: Routledge, 1992), p. 41.

10 In this regard, we should bear in mind Katerina Clark's perceptive comments on the Stakhanovites and Arctic fliers, that 'the distance between them and the father of fathers is so great that the acme of self realization for them is to become his model sons'. Katerina Clark, *The Soviet Novel: History as Ritual*, 3rd edn (Bloomington and Indianapolis: Indiana University Press, 2000), p. 128.

11 Taylor and Christie (eds), *Film Factory*, pp. 334–5; in fact, the original Russian translates more correctly as 'The whole country *will watch Chapaev*' – imparting a certain menace to the headline (thanks to Julian Graffy for pointing out this mixture of 'marketing and social engineering').

12 Taylor and Christie (eds), *Film Factory*, p. 358.

13 Graham Dawson, *Soldier Heroes: British Adventure, Empire and the Imagining of Masculinities* (London: Routledge, 1994), p. 24.

14 Dawson, *Soldier Heroes*, p. 11.

15 See Easthope, *What A Man's Gotta Do*, pp. 35–49.

16 Easthope, *What A Man's Gotta Do*, p. 51; Susan Faludi, *Stiffed: The Betrayal of the Modern Man* (London: Chatto and Windus, 1999), p. 585.

17 James von Geldern, 'The Centre and the Periphery: Cultural and Social Geography in the Mass Culture of the 1930s', in Stephen White (ed.), *New Directions in Soviet History* (Cambridge: Cambridge University Press, 1992), pp. 62–80 (p. 66).

18 See especially the *Daily Telegraph* story 'Homosexual Orgies "Spawn Spy Ring"', cited in Easthope, *What A Man's Gotta Do*, p. 103. The fact that the story was later found to be untrue only highlights the level

of hysteria surrounding the need to defend the male ego/castle/state from penetration. Not too long ago, I also came across a front-page banner headline in the similarly right-wing *Mail on Sunday* (19 December 1999) which screamed 'Tory Defector Slams Gay Slur': in this instance we may note how the use of 'slur', whilst acknowledging the rumour as unfounded, at the same time keeps the story circumscribed within the discursive formation that figures homosexuality as defective.

19 This literature is far too extensive to detail here: for the purposes of our argument, see in particular Peter Middleton, 'Are Men Rats? Freud's *History of an Obsessional Neurosis*', in *The Inward Gaze: Masculinity and Subjectivity in Modern Culture* (London: Routledge, 1992), pp. 78–109; one of Middleton's conclusions is that Freud's analysis of the male ego assumes the same structure, of an impenetrable fortress surrounded by battle rhetoric. See also Lynne Segal, *Slow Motion: Changing Masculinities, Changing Men* (London: Virago, 1997), pp. 261–71.

20 Segal, *Slow Motion*, p. 265.

21 Easthope, *What A Man's Gotta Do*, p. 68.

22 Taylor and Christie (eds), *Film Factory*, p. 335.

23 Richard Taylor, 'Red Stars, Positive heroes and Personality Cults', in Taylor and Spring (eds), *Stalinism and Soviet Cinema*, pp. 69–89 (p. 77).

24 Clark, *Soviet Novel*, p. 127.

25 As we saw in chapter 3, this exemplifies the key moment of (mis)recognition at the heart of Lacan's 'mirror stage': Jacques Lacan, 'The Mirror Stage as Formative of the Function of the I as Revealed in Psychoanalytic Experience', in *Ecrits: A Selection*, trans. Alan Sheridan (London: Tavistock, 1977), pp. 1–7 (p. 2).

26 Peter Kenez, *Cinema and Soviet Society from the Revolution to the Death of Stalin*, 2nd edn (London and new York: I. B. Tauris, 2001), p. 177.

27 Lynne Attwood (ed.), *Red Women on the Silver Screen: Soviet Women and Cinema from the Beginning to the End of the Communist Era* (London: Pandora Press, 1993), p. 68.

28 For a full history of the making of *Ivan the Terrible*, see L. Kozlov in Taylor and Spring (eds), *Stalinism and Soviet Cinema*, pp. 109–30.

29 Quoted in Marie Seton, *Sergei M. Eisenstein: A Biography*, rev. edn (London: Dennis Dobson, 1978), pp. 372–3 (my italics).

30 Richard Taylor, *Film Propaganda: Soviet Russia and Nazi Germany*, rev. edn (London: I.B. Tauris, 1998), p. 87.

31 Kenez, *Cinema and Soviet Society*, p. 182.

32 Seton, *Sergei M. Eisenstein*, p. 438.

33 Sigmund Freud, 'Notes Upon a Case of Obsessional Neurosis: The "Rat Man"', in Angela Richards (ed.) *Case Histories II*, trans. James Strachey, *Penguin Freud Library, vol. 9* (Harmondsworth: Penguin, 1979), pp. 31–128.

34 Middleton, *The Inward Gaze*, p. 81.

35 Kenez, *Cinema and Soviet Society*, p. 182.

36 Kenez, *Cinema and Soviet Society*, p. 179.

37 Sylvie Dallet, 'Historical Time in Russian, Armenian, Georgian and Kirghiz Cinema', trans. Mark Rolland, in Anna Lawton (ed.), *The Red Screen: Politics, Society, Art in Soviet Cinema* (London: Routledge, 1992), pp. 303–14 (p. 305).

38 Graham Roberts, 'From Comrade to Comatose: Men and Masculinity in Soviet Cinema', *Cinema and Ideology: Strathclyde Modern Language Studies, new series*, I (1996) 70–84, p. 76.

39 Roberts, 'From Comrade to Comatose', p. 75.

Conclusions

Cinema is an illusion, but it dictates its own laws to life itself. (Stalin)[1]

A film is a social document. This is not to say that any film automatically reflects the finest details of the society in which it is produced. However, the unparalleled degree of state control over Soviet cinema of the Stalin era means that the films produced under such a system must, to a greater or lesser extent, reflect the concerns and issues at stake as the Soviet Union – even as it nosedived into the 'terror' – declared the first stages of socialism achieved, and awaited the establishment of an earthly paradise in the socialist Utopia.

The field of our study, as well as the nature and potential limitations of our (and other) methods of enquiry, was established in the opening chapter. In this particular case, I have attempted a marriage of psychoanalytic and Bakhtinian theory to explore the discursive pressures exerted on the psyche of the model New Soviet Man – *as man* – by the radical remasculinisation of Stalinist culture, following the Cultural Revolution and the establishment of socialist realism as the single method in all Soviet art.

It would be difficult to argue that Soviet culture had ever been anything other than phallocentric, but it is equally important to recognise the distinctions between Soviet cinema of the 1920s – a time of radical avant-gardist experimentation, as well as cautious liberalism in the market place – and that of the Stalin era. If, in the 1920s, the Soviet cinema industry was called upon to help forge a new society, in the 1930s Soviet film-makers were conscripted to perform a higher task – the forging of an alternate reality that was to be more real than life outside the cinema. In a similar way, if

1920s Soviet cinema can be seen to be informed by patriarchal assumptions, then in socialist realist cinema of the Stalin era, such assumptions are, more often than not, put on clear display, masquerading as eternal values and truths.

The practicalities of effecting such a shift were discussed in chapter 2. Heralded as early as the first Party Conference on Cinema in March 1928, the exigencies of increasing both ideological vigilance and productivity themselves implicitly looked forward to the Stalinist era of fantastical feats and the cult of heroes. A steady diet of ideologically sound superheroes was, in a sense, seen as an ideal recipe for a popular and yet enlightening cinema, and represents an attempt to resolve the apparent dichotomy of political correctness and commercial viability rather neatly.

We also discussed the scapegoating of experimental cinema as 'unintelligible to the masses', and the subsequent realignment of film production under a single state organisation, Soiuzkino, and with newly-trained scenarists to provide intelligible scripts to be followed without deviation by the directors. The centralisation of the film industry, then, was paralleled by a certain centralisation of meaning as discursive forces became more and more centripetal and monologising. It is no coincidence that this centralisation also took place at the same time as the abandonment of the ideal of international socialism, when a regime that had settled for the construction of socialism in just one country was preparing to invest its border guards with cult heroic status as a supremely hegemonic form of masculinity.[2]

The border guards have been important for our study for a number of reasons.[3] First of all, by their status as exemplary 'sons' in the Great Soviet Family, they point us towards an idealised Stalinist model of masculinity. We can see, therefore, how the attempts to centralise the film industry and the production of meaning itself were accompanied by a kind of centralisation of paradigmatic masculinity in terms of the word of the Father, Stalin, as what Tony Crowley refers to as 'the final word' in monoglot discursive formations.[4] Secondly, the border guards' function as protecting the perceived unity of the socialist state is, as we saw in chapter 5, closely related to the type of subjectivity allotted the paradigmatic New Soviet Man in cultural production of the Stalin era. The monoglot denial of ambiguity in socialist realist discourse is projected onto a disavowal of split subjectivity on the part of the male heroes of the genre. We took this argument one stage further, however, to suggest that the apparent unity of psychic impulse and physical action displayed by the New Soviet Man made him an extreme example of the 'myth of masculinity' in modern western culture.

For psychoanalysis, this myth arises from the development of the ego following the misrecognition of a unified self-image at the 'mirror stage', which propels the child towards social interaction within the symbolic order.[5] Our analysis of the male heroes of Stalinist musical comedies would suggest that the development of the 'sons' of the Great Soviet Family in Stalinist cinema was arrested at precisely this point, in the imaginary order.

In keeping with this notion, it is important to note that, above all else, the New Soviet Man had to *look the part*: the 'word icons' noted by Katerina Clark were central to his portrayal.[6] This was surely connected in large part with the role the New Soviet Man was to play in the heavily display-oriented culture of Stalin's USSR, which was attempting to prove, if not to the world at large, then to itself, the superiority of Soviet life. This culture of display was epitomised in the Moscow landmarks built during the period: the *Maiakovskaia* metro station and the Hotel *Moskva* in particular. At the heart of the capital was the Kremlin, which housed the man who presumed to be the 'father of the nation', Stalin himself. The importance of Stalin-as-father to our study, as well as to a broader context, has been underlined by Hans Günther, who comments that 'such immortalising of the heroic "youth," or infantilizing of society, is a characteristic tendency of all totalitarian regimes'.[7]

In addition to this, the privileging of the fairy tale narrative in Stalinist cinema not only furnished the genre with a formula for the mass production (and therefore commercial viability) of intelligible scripts, but was also to play its part in the socialisation of the nation's 'children'.[8] The films of Grigorii Aleksandrov and Ivan Pyr'ev, as we have seen, rely on a folk rendering of simple morality tales, in which honest socialist labour provides the key to romantic fulfilment. Furthermore, in psychoanalytic terms, such fulfilment figures the *completion of the self*, and the status of Stalinist musical comedies as bastard cousins of Hollywood romances is bolstered up by Robert Lapsley and Michael Westlake's Lacanian reading of the latter, in which they insist that 'like the infant's anticipated yet never attained unity, the lovers' dream of harmonious wholeness belongs to the imaginary'.[9]

The fairy tales portrayed in the films of Aleksandrov and Pyr'ev were awarded official prizes time and time again, and the musical comedy may be seen as the privileged cinematic genre of the Stalin era. Our analysis of Aleksandrov's musicals aimed to elucidate their close kinship to folk and fairy tale forms, but in the end we were especially struck by what seems to be a significant point in terms of our discussion of the infantilisation of Soviet youth. Following Bettelheim's psychoanalytic reading of the 'happy end' as figuring

the harmonious mother-child dyad extended in perpetuity, we noted the conspicuous absence of the 'Father of the People', Stalin, from this most Oedipal of scenarios.

Although Stalin's is a presence that circumscribes all Aleksandrov's narratives, the effacement of the father figure from the Soviet Oedipus is an essential element in the director's utopian vision of the earthly paradise. This return to Eden is anticipated implicitly in the very fabric of Soviet socialist realism, and especially in the wording of the 1936 Constitution, which we discussed with particular reference to *Circus* and its centrepiece *Song of the Motherland*; we have also seen the spectacular display of the All-Union Exhibition of Agriculture – which stands at the centre of the country, but represents the nation as a whole – as a 'preview of the coming attractions of socialism'.[10]

Furthermore, such an abundant depiction bears a clear relation to the myth – retroactively constructed and circumscribed within the male psychic economy – of a pre-oedipal Edenic plenitude. Although such plenitude is purely mythical, for psychoanalysis, as we saw in chapter 1, it serves to mask the originary condition of lack – what Lacan refers to as *la chose* – and spurs desire, which is in turn articulated through fantasy, and the search for the *objet petit a* as an elusive object that will somehow complete the unified self misrecognised at the mirror stage.[11]

In a sense, however, we are already jumping the gun, as these formations require as a first principle the separation of the mother and child. The agent of this separation – and it can be absolutely anything that acts, in the child's eyes, to part him from his mother – is always referred to by Lacan as the 'Name-of-the-Father'. As we have seen, however, the reality of such a separation is effaced in the utopian schema of Aleksandrov's musicals, and this may be taken as a type of the 'foreclosure of the Name-of-the-Father', seen by Lacan as precipitating the child into psychosis.[12] It is clearly an intriguing thought that the reverse side of the decisive certainty displayed by the male heroes of these most Utopian films of the Stalin era, appears to be a certain imprisonment in the quasi-psychotic monoglot world of 'Soviet reality', with not only its attendant paranoia, but also the concomitant incapacity for sexual relations that we saw at work in Pyr'ev's *kolkhoz* comedies.

In her discussion of Lacanian theory, Anika Lemaire points out the pitfalls involved in a lack of distinction between the child and the mother: 'if ... the child is everything to her [the mother] and merges with her in a diffuse unity, then the child cannot dispose of his own individuality'.[13] Such an effacement of personality must remind us not only of the undifferentiated features of the positive hero,[14] but

also Igor Kon's assertion that one way in which the State sought 'fully to "deindividualise" the individual, to emasculate the individual's autonomy' was in the rooting out and disparaging of 'all that was erotic in human beings'.[15]

Bearing this in mind, the apparent lack of sexuality in Pyr'ev's musicals may be interpreted simply as a function of the New Soviet Man's lack of individual subjectivity. It is certainly true to say that the positive hero, as 'model son', was unable to challenge Stalin, thereby assuming the self-image of a father. However, it is also possible to take a closer look at the symbolic equation of *woman=Motherland*, and recognise that any sexual encounter for Pyr'ev's men would not only break the taboo on incest, but, on a deeper level, would also involve an encounter with *la chose* – the fundamental and originary lack at the centre of Lacanian existence – thereby exposing the *objet petit a* as merely a lure for the promotion of desire. Faced with the unmasking of their lack, therefore, Pyr'ev's heroes appear to rebel against the conventions of romantic comedy, turning away from the kiss – towards which the sequences of shots are clearly pointing – and throwing themselves headlong back into the (misrecognised) security of *desire*. In fact, such a 'revolt' is indeed only 'apparent'.

First of all, there awaits a convenient escape route for the hero whenever sexuality is even merely hinted at – the calls to work, which we noted towards the end of chapter four, always arise just at the right moment to summon the New Soviet Man away from any romantic entanglement, and these calls are always more than eagerly obeyed. Just as our heroes are about to confront the truth behind the non-existence of the *objet petit a*, then, a new object of desire is presented to them in the form of the construction of socialism – a form in which it is all too easy to believe.

If the condition of 'socialism' is to be equated with the earthly paradise so often predicted in Soviet socialist realism, then we should also note that Stalin himself was so closely identified with 'socialism' as to render him, too, an object of desire. The construction of the socialist Utopia was so tied in with the construction of Stalin's so-called 'cult of personality', that he was represented as a kind of earthly god. This also furnishes a motive behind Stalin's physical absence from the musical comedies made under his dictatorship, not only because no man may look upon God's face and live, but also insofar as the Lacanian *objet petit a* – as a fictitious lure for fantasy and desire – is in itself fundamentally unobtainable.

This may seem to be rather a complicated scenario, but it has been brilliantly encapsulated by the East German playwright Heiner Müller. Müller's remarks – made with reference to the GDR,

although I believe the comparison with the Stalinist Soviet Union holds good – liken the pervasively teleological *zeitgeist* of his nation to a waiting-room at an unnamed station:

There would be an announcement: 'The train will arrive at 18.15 and depart at 18.20' – and it never did arrive at 18.15. Then came the next announcement: 'The train will arrive at 20.10.' And so on. You went on sitting there in the waiting room, thinking, 'It's bound to come at 21.05.' That was the situation. Basically a state of messianic anticipation. There are constant announcements of the Messiah's impending arrival, and you know perfectly well that he won't be coming. And yet somehow, it's good to hear him announced all over again.[16]

Once again, a parallel may be drawn to the function of the Hollywood romance, which works to keep alive the myth that the object of desire is in fact obtainable, in exactly the same way as socialist realist musical comedies promulgate above all else the myth of a Utopia accessible in this lifetime. This function of either genre – the pure stimulation of fantasy, and the maintenance of desire – could explain on a textual level the otherwise unaccountable popularity of them both. At the same time, it provides a more sophisticated analysis of the institution of cinematic spectatorship than those based on a straightforward 'mirror stage' identification process.[17]

In the same way that narrative resolution – whether in the writing of history or in the cinema – always works towards the establishment of a moral, our Stalinist musicals serve to give voice to audience doubts ('What if ... ?') only to allay them. The genre simultaneously challenges and reaffirms the status quo, which is typical of the wider conservatism of Stalinist art. The *embourgeoisement* of Soviet cinema, literature, fine and plastic arts after the radical – and, it seems, radically unpopular – '*épater* le bourgeois' ethic of pre-revolutionary and 1920s Russian artists should perhaps not be seen so much as a process of 'varnishing reality', so much as one of 'varnishing the (Lacanian) Real'. The varnishing coat of monoglot discourse, then, may be seen as holding the chaotic flux of life in a kind of stasis – easily observed, measured and evaluated from a (characteristically male) Euclidean point.

The final chapter of this study examined in more detail the parallels between psychoanalytical models of the male ego and Bakhtinian accounts of the discourses of nationhood. Characteristic of both, we found, was the existence of centripetal forces or libidinal energy, binding diversity into a fragile and illusory unity. Through an examination of the collapsing subjectivity of that most hegemonic form of masculinity, the soldier hero, I hope to have shown how the experience of war – which necessitates, in man as in nation, an

unleashing of these binding forces from the centre to the periphery – allows gaps to be opened up in the strongholds of the ego and the capital, within which space is created for ambiguities of meaning – the realm of the unconscious.

As such, the chapter on soldier heroes represented, more than anything else, a kind of testing ground for the methods and theories formulated in the earlier sections of the study. In this case, we saw the cast-iron self-assurance of Chapaev become the insecure self-awareness of Andrei Sokolov, along a path that is marked perhaps most clearly by Eisenstein's artistry in creating Ivan the Terrible as both tyrant and victim of his own intra-psychic tyranny. The hazy mistiness of Bondarchuk's *Fate of a Man* – along with its hero Sokolov's own lack of masterful clarity – is characteristic of the culture of the Khrushchev generation which, as Svetlana Boym points out, 'launched its attack on the grand epic style of the Stalinist edifice and created melodies of its own'.[18]

This return of a certain degree of individuality and split subjectivity demonstrates, perhaps better than any other example, the relaxation of the extreme monologising centripetal forces at work in Stalinist culture. The 'ice of classicism' which Abram Terts had lamented covering the 'river of art' had indeed, to some extent, 'thawed out'.[19] Emblematic of the 'thaw' is perhaps that new paradigm of masculinity, Sokolov, whose final assumption of the symbolic role of father marks a turning point in the history of the New Soviet Man.

Notes

1 Quoted by Richard Taylor in 'But Eastward, Look, The Land Is Brighter: Towards a Topography of Utopia in the Stalinist Musical', in Diana Holmes and Alison Smith (eds), *100 Years of European Cinema: Entertainment or Ideology?* (Manchester: Manchester University Press, 2000), pp. 11–26 (p. 24); quotation referenced back to Dmitrii Volkogonov, 'Stalin', *Oktiabr'*, 11 (1998), 16–129.

2 On the cult of the border guard, see Katerina Clark, *The Soviet Novel: History as Ritual*, 3rd edn (Bloomington and Indianapolis: Indiana University Press, 2000) p. 116; on the relation of the border guards to Stalinist culture, see James von Geldern, 'The Centre and the Periphery: Cultural and Social Geography in the Mass Culture of the 1930s', in Stephen White (ed.), *New Directions in Soviet History* (Cambridge: Cambridge University Press, 1992), pp. 62–80 (p. 66).

3 As they were for Soviet cinema itself: 'In the 1930s, more films were made about border guards than about workers,' Peter Kenez, *Cinema and Soviet Society from the Revolution to the Death of Stalin*, 2nd edn (London and New York: I. B. Tauris, 2001), p. 149.

4 Tony Crowley, 'Bakhtin and the History of the Language', in Ken Hirschkop and David Shepherd (eds), *Bakhtin and Cultural Theory* (Manchester: Manchester University Press, 1989), pp. 68–90 (p. 81).

5 Jacques Lacan, 'The Mirror Stage as Formative of the Function of the I as Revealed in Psychoanalytic Experience', in *Ecrits: A Selection*, trans. Alan Sheridan (London: Tavistock, 1977), pp. 1–7; see also Antony Easthope, 'The Masculine Ego', in *What A Man's Gotta Do: The Masculine Myth in Popular Culture* (London: Routledge, 1992), pp. 33–58.

6 Clark, *Soviet Novel*, pp. 58–63.

7 Hans Günther, 'Wise Father Stalin and his Family in Soviet Cinema', trans. Julia Trubikhina, in Thomas Lahusen and Evgeny Dobrenko (eds), *Socialist Realism Without Shores* (Durham and London: Duke University Press, 1997), pp. 178–89 (p. 178).

8 For a general introduction to the social uses of fairy tales, see in particular Jack Zipes, *Happily Ever After: Fairy Tales, Children and the Culture Industry* (London: Routledge, 1997), p. 66; Bruno Bettelheim, *The Uses of Enchantment: The Meaning and Importance of Fairy Tales* (New York: Alfred A. Knopf, 1976), p. 5.

9 Robert Lapsley and Michael Westlake, 'From *Casablanca* to *Pretty Woman*: The Politics of Romance', *Screen* 33:1 (Spring, 1992), 27–49 (p. 30).

10 Sheila Fitzpatrick, *Stalin's Peasants: Resistance and Survival in the Russian Village after Collectivization* (New York and Oxford: Oxford University Press, 1994), p. 262. Moira Ratchford also points out the role of the 1936 Constitution in portraying a Socialist 'Garden of Eden': Moira Ratchford, '*Circus* of 1936: Ideology and Entertainment Under the Big Top', in Andrew Horton (ed.), *Inside Soviet Film Satire: Laughter With a Lash* (Cambridge: Cambridge University Press, 1993), pp. 83–93 (p. 86).

11 For clarification of both this originary lack, and the duplicitous function of the *objet petit a*, which 'both masks the absence of absolute *jouissance* and makes it possible to believe it exists', see Lapsley and Westlake, 'From *Casablanca* to *Pretty Woman*', pp. 32–3.

12 See Lacan, 'On a Question Preliminary to Any Possible Treatment of Psychosis', in *Ecrits*, pp. 179–225; for clarification, see Anika Lemaire, *Jacques Lacan*, trans. David Macey (London and New York: Routledge and Kegan Paul, 1977), especially chapter 24, 'Psychosis' (pp. 230–46). A more extensive body of Lacan's seminars on psychoses has been trans.lated by Russell Grigg and published as *Seminar 3: The Psychoses* (London: Routledge, 1993).

13 Lemaire, *Jacques Lacan*, p. 234.

14 Noted in a general sense by Clark, who points out that the positive hero 'was, in fact, so deindividualised that he could be transplanted wholesale from book to book, regardless of the subject matter' (*Soviet Novel*, p. 47); more specifically Moira Ratchford complains that the figure of Martynov, in *Circus*, 'comes off as a very wooden and one-sided character, resembling one of *the many faceless workers* on billboards throughout the Soviet Union' ('*Circus* of 1936', p. 88); see chapter 3 of this volume for a revision of Ratchford's comment.

15 Igor Kon, 'Sexuality and Culture', in Igor Kon and James Riordan (eds), *Sex and Russian Society* (Bloomington and Indianapolis: Indiana University Press, 1993), pp. 15–44 (p. 24).

16 Quoted by Charity Scribner, in 'From the Collective to the Collection: Curating Post-Communist Germany', *New Left Review* 237 (September/October, 1999), 137–49 (p. 147); quotation referenced

back to Heiner Müller and Jan Hoet, 'Insights into the Process of Production – A Conversation', *Documenta IX*, 96–7 (my italics).

17 For a detailed analysis of the shifting trends in psychoanalytic theories of audience identification, see Robert Lapsley and Michael Westlake, *Film Theory: An Introduction* (Manchester: Manchester University Press, 1988), pp. 67–104.

18 Svetlana Boym, *Common Places: Mythologies of Everyday Life in Russia* (Cambridge, Mass. and London: Harvard University Press, 1994), p. 115.

19 Abram Terts, 'Chto takoe sotsialisticheskii realizm?', in *Fantasticheskii mir Abrama Tertsa* (New York: Inter-Language Literary Associates, 1967), p. 438.

Bibliography

Abercrombie, Nicholas, Stephen Hill and Bryan S. Turner (eds), *Dominant Ideologies* (London: Unwin Hyman, 1990)

Altman, Rick (ed.), *Genre: The Musical* (London: Routledge and Kegan Paul, 1981)

Attwood, Lynne, *The New Soviet Man and Woman: Sex Role Socialisation in the USSR* (Basingstoke: Macmillan Press, 1990)

Attwood, Lynne (ed.), *Red Women on the Silver Screen: Soviet Women and Cinema from the Beginning to the End of the Communist Era* (London: Pandora Press, 1993)

Attwood, Lynne, *Creating the New Soviet Woman: Women's Magazines as Engineers of Female Identity, 1922–53* (Basingstoke: Macmillan Press, 1999)

Aumont, Jacques, *Montage Eisenstein*, trans. Lee Hildreth, Constance Penley and Andrew Ross (Bloomington: Indiana University Press, 1987)

Bakhtin, Mikhail, *Speech Genres and Other Late Essays*, trans. Vern W. McGee, ed. Caryl Emerson and Michael Holquist (Austin: University of Texas Press, 1986)

Barthes, Roland, *The Rustle of Language*, trans. Richard Howard (Oxford: Basil Blackwell, 1986)

Barthes, Roland, *Mythologies*, trans. Annette Lavers (London: Vintage, 2000)

Benjamin, Walter, *Illuminations*, trans. Harry Zohn, ed. Hannah Arendt (London: Fontana Press, 1992)

Berger, John, *Ways of Seeing* (London: BBC and Penguin, 1972)

Berger, Maurice, Brian Wallis and Simon Watson (eds), *Constructing Masculinity* (New York: Routledge, 1995)

Bettelheim, Bruno, *The Uses of Enchantment: The Meaning and Importance of Fairy Tales* (New York: Alfred A. Knopf, 1976)

Boym, Svetlana, *Common Places: Mythologies of Everyday Life in Russia* (Cambridge, Mass. and London: Harvard University Press, 1994)

Bridger, Sue (ed.), *Women and Political Change: Perspectives from East-Central Europe. Selected Papers from the Fifth World Congress of Central and East European Studies, Warsaw, 1995* (Basingstoke: Macmillan Press, 1999)

Buckley, Mary, *Women and Ideology in the Soviet Union* (Hemel Hempstead: Harvester Wheatsheaf, 1980)

Bulgakova, Oksana, 'The Hydra of the Soviet Cinema: The Metamorphosis of the Soviet Film Heroine', in Attwood (ed.), *Red Women*, pp. 149–74

Caughie, John, Annette Kuhn and Mandy Merck (eds), *The Sexual Subject: A Screen Reader in Sexuality* (London: Routledge, 1992)

de Certeau, Michel, *The Writing of History*, trans. Tom Conley (New York: Columbia University Press, 1988)

de Certeau, Michel, *The Practice of Everyday Life*, trans. Steven Rendall (Berkeley: University of California Press, 1984)

de Certeau, Michel, *Heterologies: Discourse on the Other*, trans. Brian Massumi (Manchester: Manchester University Press, 1986)

Chartier, Roger, *Cultural History* (Cambridge: Cambridge University Press, 1988)

Christie, Ian, 'Canons and Careers: The Director in Soviet Cinema', in Taylor and Spring (eds), *Stalinism and Soviet Cinema*, pp. 142–70

Christie, Ian and Richard Taylor (eds), *Eisenstein Rediscovered* (London: Routledge, 1993)

Clark, Katerina, *The Soviet Novel: History as Ritual*, 3rd edn (Bloomington and Indianapolis: Indiana University Press, 2000)

Clark, Katerina, 'Aural Hieroglyphics? Some Reflections on the Role of Sound in Recent Russian Films and its Historical Context', in Condee (ed.), *Soviet Hieroglyphics*, pp. 1–21

Clements, Barbara Evans, Barbara Alpern Engel and Christine D. Worobec (eds), *Russia's Women: Accommodation, Resistance, Transformation* (Berkeley: University of California Press, 1991)

Clover, Carol J., *Men, Women and Chain Saws: Gender in the Modern Horror Film* (London: BFI Publishing, 1992)

Cohan, Stephen, '"Feminizing" the Song-and-Dance Man: Fred Astaire and the Spectacle of Masculinity in the Hollywood Musical', in Cohan and Hark (eds), *Screening the Male*, pp. 46–69

Cohan, Stephen and Ina Rae Hark (eds), *Screening the Male: Exploring Masculinities in Hollywood Cinema* (London: Routledge, 1993)

Collins, Jim, 'Toward Defining a Matrix of the Musical Comedy: The Place of the Spectator Within the Textual Mechanisms', in Altman (ed.), *Genre: The Musical*, pp. 134–45

Condee, Nancy (ed.), *Soviet Hieroglyphics: Visual Culture in Late Twentieth-Century Russia* (Bloomington and London: Indiana University Press and BFI Publishing, 1995)

Connell, R. W., *Masculinities* (Cambridge: Polity Press, 1995)

Costlow, Jane T., Stephanie Sandler and Judith Vowles (eds), *Sexuality and the Body in Russian Culture* (Stanford: Stanford University Press, 1993)

Crowley, David, 'Bakhtin and the History of the Language', in Hirschkop and Shepherd (eds), *Bakhtin and Cultural Theory*, pp. 68–90

Dallet, Sylvie, 'Historical Time in Russian, Armenian, Georgian and Kirghiz Cinema', trans. Mark Rolland, in Lawton (ed.), *Red Screen* pp. 303–14

Dalton, Margaret, *Andrei Sinyavskii and Julii Daniel': Two Soviet "Heretical" Writers* (Würzburg: Jal-Verlag, 1973)

Daniels, Robert V. (ed.), *The Stalin Revolution: Foundations of the Totalitarian Era*, 3rd edn (Lexington, Mass.: D. C. Heath and Co., 1990)

Danilov, Viktor and N. V. Teptsov, 'Collectivisation: The Results', in Daniels (ed.), *Stalin Revolution*, pp. 114–29

Davis, Sarah, *Popular Opinion in Stalin's Russia: Terror, Propaganda and Dissent, 1934–1941* (Cambridge: Cambridge University Press, 1997)

Dawson, Graham, *Soldier Heroes: British Adventure, Empire and the Imagining of Masculinities* (London: Routledge, 1994)

Dean, Mitchell, *Critical and Effective Histories: Foucault's Methods and Historical Sociology* (London: Routledge, 1994)

Derrida, Jacques, *The Post Card: From Socrates to Freud and Beyond*, trans. Alan Bass (Chicago and London: University of Chicago Press, 1987)

Dobrenko, Evgenii, '"Iazyk prostranstva, szhatogo do tochki", ili estetika sotsial'noi klaustrofobii', *Iskusstvo kino* 1996, no. 9 (September), 108–17

Dunham, Vera, *In Stalin's Time* (Cambridge: Cambridge University Press, 1976)

Dyer, Richard, *Only Entertainment* (London: Routledge, 1992)

Dyer, Richard, 'Don't Look Now: The Male Pin-Up', in Caughie, Kuhn and Merck (eds), *Sexual Subject*, pp. 265–76

Eagleton, Terry, *Literary Theory: An Introduction* (Oxford: Blackwell, 1983)

Easthope, Antony, *What A Man's Gotta Do: The Masculine Myth in Popular Culture* (London: Routledge, 1992)

Easthope, Antony (ed.), *Contemporary Film Theory* (London and New York: Longman, 1993)

Eisenstein, Sergei, *Notes of a Film Director*, trans. X. Danko (New York: Dover Publications, Inc., 1970)

Eisenstein, Sergei, *The Film Sense*, ed. and trans. Jay Leyda (London: Faber and Faber Ltd, 1977)

Eisenstein, Sergei, *Eisenstein: Selected Writings, 1922–34, Vol. I*, ed. and trans. Richard Taylor (Bloomington: Indiana University Press, 1987)

Eisenstein, Sergei, *Selected Works, vol. III: Writings, 1934–47* (London: BFI Publishing, 1996)

Enzensberger, Maria, '"We Were Born to Turn a Fairy Tale Into Reality": Grigori Alexandrov's *The Radiant Path*', in Taylor and Spring (eds), pp. 97–108

Faludi, Susan, *Backlash: The Undeclared War Against Women* (London: Vintage, 1992)

Faludi, Susan, *Stiffed: The Betrayal of the Modern Man* (London: Chatto and Windus, 1999)

Femia, Joseph V., *Gramsci's Political Thought: Hegemony, Consciousness, and the Political Process* (Oxford: Clarendon, 1981)

Fitzpatrick, Sheila, *Stalin's Peasants: Resistance and Survival in the Russian Village After Collectivisation* (New York and Oxford: Oxford University Press, 1994)

Foucault, Michel, *The History of Sexuality, vol. 1: An Introduction*, trans. Robert Hurley (Harmondsworth: Penguin, 1990)

Freud, Sigmund, *The Essentials of Psychoanalysis: The Definitive Collection of Sigmund Freud's Writing*, trans. James Strachey, ed. Anna Freud (Harmondsworth: Penguin, 1986)

Freud, Sigmund, *Art and literature*, trans. James Strachey, ed. Albert Dickson, *Penguin Freud Library, vol. 14* (Harmondsworth: Penguin, 1990)

Freud, Sigmund, *The Interpretation of Dreams*, trans. James Strachey, ed. James Strachey, Alan Tyson and Angela Richards, *Penguin Freud Library, vol. 4* (Harmondsworth: Penguin, 1991)

Freud, Sigmund, *Case Histories II*, trans. James Strachey, ed. Angela Richards, *Penguin Freud Library, vol. 9* (Harmondsworth: Penguin, 1991)

Freud, Sigmund, *Two Short Accounts of Psychoanalysis*, trans. and ed. James Strachey (Harmondsworth: Penguin, 1991)

Frow, John, 'Michel de Certeau and the Practice of Representation', *Cultural Studies* 5:1, 52–60

Gasiorowska, Xenia, *Women in Soviet Fiction, 1917–1964* (Madison: University of Wisconsin Press, 1968)

von Geldern, James 'The Centre and the Periphery: Cultural and Social Geography in the Mass Culture of the 1930s', in White (ed.), *New Directions in Soviet History*, pp. 62–80

von Geldern, James, and Richard Stites (eds), *Mass Culture in Soviet Russia: Tales, Poems, Songs, Movies, Plays and Folklore, 1917–1953* (Bloomington: Indiana University Press, 1995)

Gill, Graeme, *Stalinism*, 2nd edn (Basingstoke: Macmillan Press, 1998)

Grosz, Elizabeth, *Jacques Lacan: A Feminist Introduction* (London: Routledge, 1990)

Günther, Hans, 'Wise Father Stalin and his Family in Soviet Cinema', in Lahusen and Dobrenko (eds), *Socialist Realism Without Shores*, pp. 178–90

Hirschkop, Ken and David Shepherd (eds), *Bakhtin and Cultural Theory* (Manchester: Manchester University Press, 1989)

Holland, Barbara (ed.), *Soviet Sisterhood* (Bloomington: Indiana University Press, 1985)

Holmes, Diana and Alison Smith (eds), *100 Years of European Cinema: Entertainment or Ideology?* (Manchester: Manchester University Press, 2000)

Horton, Andrew (ed.), *Inside Soviet Film Satire: Laughter With a Lash* (Cambridge: Cambridge University Press, 1993)

Hosking, Geoffrey, *A History of the Soviet Union* (London: Fontana Press/Collins, 1985)

Jefferson, Anne and David Robey (eds), *Modern Literary Theory: A Comparative Introduction* (London: Batsford, 1986)

Jenkins, Keith, *Rethinking History* (London: Routledge, 1991)

Kaplan, Cora, *Sea Changes: Essays on Culture and Feminism* (London: Verso, 1986)

Kelly, Catriona and David Shepherd (eds), *Russian Cultural Studies: An Introduction* (Oxford: Oxford University Press, 1998)

Khrushchev, Nikita, *Khrushchev Remembers*, trans. Strobe Talbot (London: Sphere Books, 1971)

Kenez, Peter, *Cinema and Soviet Society from the Revolution to the Death of Stalin*, 2nd edn (London and New York: I. B. Tauris, 2001)

Kochan, Lionel and Richard Abraham, *The Making of Modern Russia*, 2nd edn (Harmondsworth: Penguin, 1983)

Kon, Igor and James Riordan (eds), *Sex and Russian Society* (Bloomington and Indianapolis: Indiana University Press, 1993)

Kozlov, Leonid, 'The Artist and the Shadow of Ivan', in Taylor and Spring (eds), *Stalinism and Soviet Cinema*, pp. 109–30

Lacan, Jacques, *Ecrits: A Selection*, trans. Alan Sheridan (London: Tavistock, 1977)

Lacan, Jacques, *The Four Fundamental Concepts of Psycho-analysis*, trans. Alan Sheridan, ed. Jacques-Alain Miller (London: Vintage, 1998)

Lahusen, Thomas and Evgeny Dobrenko (eds), *Socialist Realism Without Shores* (Durham and London: Duke University Press, 1997)

Lapsley, Robert and Michael Westlake, *Film Theory: An Introduction* (Manchester: Manchester University Press, 1988)

Lapsley, Robert, and Michael Westlake, 'From *Casablanca* to *Pretty Woman*: The Politics of Romance', *Screen* 33:1 (Spring 1992), 27–49

Lawton, Anna, *The Red Screen: Politics, Society, Art in Soviet Cinema* (London: Routledge, 1992)

Lemaire, Anika, *Jacques Lacan*, trans. David Macey (London and New York: Routledge and Kegan Paul, 1977)

Lewin, Moshe, 'Collectivisation: The Reasons', in Daniels (ed.), *Stalin Revolution*, pp. 97–114

Leyda, Jay, *Kino: A History of the Russian and Soviet Film* (London: George Allen and Unwin, 1960)

Liljestrom, Marianne, Eila Mantysaari and Arja Rosenholm (eds), *Gender Restructuring in Russian Studies: Conference Papers – Helsinki, August 1992* (Tampere: University of Tampere, 1993)

Lourie, Richard, *Letters to the Future: An Approach to Sinyavsky-Tertz* (Ithaca: Cornell University Press, 1975)

Mamatova, L. Kh. ed. *Kino: Politika i liudi (30-e gody): K 100-letiiu mirovogo kino* (Moscow: Materik, 1995)

Mandel, William, *Soviet Women* (New York: Anchor Books, 1975)

Mar'iamov, Grigorii, *Kremlevskii tsenzor: Stalin smotrit Kino* (Moscow: 'Kinotsentr', 1992)

Mathewson, Rufus W. Jr., *The Positive Hero in Russian Literature* (Stanford: Stanford University Press, 1975)

Mayne, Judith, *Kino and the Woman Question: Feminism and Soviet Silent Film* (Columbus: Ohio State University Press, 1989)

Mayne, Judith, *Cinema and Spectatorship* (London: Routledge, 1993)

Middleton, Peter, *The Inward Gaze: Masculinity and Subjectivity in Modern Culture* (London: Routledge, 1992)

Mitchell, Juliet, *Psychoanalysis and Feminism* (Harmondsworth: Penguin, 1974)

Mulvey, Laura, 'Visual Pleasure and Narrative Cinema', *Screen* 16:3 (1975), 6–18

Neale, Steve, 'Masculinity as Spectacle', in Caughie, Kuhn and Merck (eds), *Sexual Subject*, pp. 277–87

Orr, Linda, 'The Revenge of Literature: A History of History', *New Literary History* 18:1 (1986), 1–22

Paglia, Camille, *Sexual Personae: Art and Decadence from Nefertiti to Emily Dickson* (Harmondsworth: Penguin, 1992)

Petrone, Karen, 'Gender and Heroes: The Exploits of Soviet Pilots and Arctic Explorers in the 1930s', in Bridger (ed.), *Women and Political Change*, pp. 7–26

Propp, Vladimir, *Morphology of the Folktale*, trans. Lawrence Scott, 2nd edn (Austin: University of Texas Press, 1968)

Propp, Vladimir, *Theory and History of Folklore* trans. Ariadna Y. Martin, Richard P. Martin *et al.*, ed. Anatoly Liberman (Manchester: Manchester University Press, 1984)

Punter, David (ed.), *Introduction to Contemporary Cultural Studies* (London: Longman, 1986)

Ratchford, Moira, '*Circus* of 1936: Ideology and Entertainment Under the Big Top', in Horton (ed.), *Inside Soviet Film Satire*, pp. 83–93

Riasanovsky, Nicholas V., *A History of Russia*, 4th edn (Oxford: Oxford University Press, 1984)

Roberts, Graham, 'From Comrade to Comatose: Men and Masculinity in Soviet Cinema', in *Cinema and Ideology*, Strathclyde Modern Language Studies, New Series, No. 1 (Glasgow: Dept. of Modern Languages, University of Strathclyde, 1996)

Rutherford, Jonathan, *Men's Silences* (London: Routledge, 1992)

Sacks, Michael Paul and Jerry G. Pankhurst (eds), *Understanding Soviet Society* (Boston: Unwin Hyman, 1988)

Schnitzer, Luda, Jean Schnitzer and Marcel Martin (eds), *Cinema in Revolution: The Heroic Era of the Soviet Film*, trans. David Robinson (New York: Da Capo, 1987)

Scribner, Charity, 'From the Collective to the Collection: Curating Post-Communist Germany', *New Left Review* 237 (September/October 1999), 137–49

Segal, Lynne, *Slow Motion: Changing Masculinities, Changing Men*, rev. edn (London: Virago, 1997)

Seidler, Victor, *Rediscovering Masculinity* (London: Routledge, 1989)

Seton, Marie, *Sergei M. Eisenstein: A Biography*, rev. edn (London: Dennis Dobson, 1978)

Simpson, Mark, *Male Impersonators: Men Performing Masculinity* (London: Cassell, 1994)

Solzhenitsyn, Alexander, *One Day in the Life of Ivan Denisovich*, trans. Ralph Parker (Harmondsworth: Penguin, 1963)

Stites, Richard, *The Women's Liberation Movement in Russia: Feminism, Nihilism and Bolshevism 1860–1930* (Princeton: Princeton University Press, 1978)

Stites, Richard, *Revolutionary Dreams: Utopian Vision and Experimental Life in the Russian Revolution* (Oxford: Oxford University Press, 1989)

Stites, Richard, *Russian Popular Culture: Entertainment and Society Since 1900* (Cambridge: Cambridge University Press, 1992)

Struve, Gleb, *Russian Literature Under Lenin and Stalin, 1917–1953* (Norman: University of Oklahoma Press, 1971)

Sturrock, John (ed.), *Structuralism and Since: From Levi Strauss to Derrida* (Oxford: Oxford University Press, 1979)

Sutton, Martin, 'Patterns of Meaning in the Musical', in Altman (ed.), *Genre: The Musical*, pp. 190–6

Taylor, Richard, 'Ideology as Mass Entertainment: Boris Shumyatsky and Soviet Cinema in the 1930s', in Taylor and Christie (eds), *Inside the Film Factory*, pp. 193–216

Taylor, Richard, 'Ideology and Popular Culture in Soviet Cinema: *The Kiss of Mary Pickford*', in Lawton (ed.), *Red Screen*, pp. 42–65

Taylor, Richard, 'The Illusion of Happiness and the Happiness of Illusion: Grigorii Aleksandrov's *The Circus*', *The Slavonic and East European Review*, 74 (1996), 601–20

Taylor, Richard, *Film Propaganda: Soviet Russia and Nazi Germany*, rev. edn, (London: I. B. Tauris, 1998)

Taylor, Richard, 'Singing in the Steppes for Stalin: Ivan Pyr'ev and the Kolkhoz Musical in Soviet Cinema', *Slavic Review* 58:1 (Spring, 1999), 143–59

Taylor, Richard, 'But Eastward, Look, The Land Is Brighter: Towards a Topography of Utopia in the Stalinist Musical', in Holmes and Smith (eds), *100 Years of European Cinema*, pp. 11–26

Taylor, Richard, and Ian Christie (eds), *The Film Factory: Russian and Soviet Cinema in Documents, 1896–1939* (London: Routledge, 1994)

Taylor, Richard, and Ian Christie (eds), *Inside the Film Factory: New Approaches to Russian and Soviet Cinema* (London: Routledge, 1991)

Taylor, Richard, and Derek Spring (eds), *Stalinism and Soviet Cinema* (London: Routledge, 1993)

Terts, Abram, *Fantasticheskii mir Abrama Tertsa* (New York: Inter-Language Literary Associates, 1967)

Turovskaya, Maya, 'I. A. Pyr'ev i ego muzykal'nye komedii: k probleme zhanra', *Kinovedcheskie zapiski*, 1 (1988), 111–46

Turovskaya, Maya, 'Woman and the "Woman Question" in the USSR', in Attwood (ed.), *Red Women*, pp. 133–40

Turovskaya, Maya, 'The Strange Case of the Making of *Volga-Volga*', trans. Andrey Andreyev, in Horton (ed.), *Inside Soviet Film Satire*, pp. 75–82

Turovskaya, Maya, '*Volga-Volga* i e vremia', *Iskusstvo kino* 3 (1998), 59–64

Unknown (eds), *The Woman Question: Selections from the Writings of Karl Marx, Frederick Engels, V. I. Lenin, Joseph Stalin* (New York: International Publishers, 1951)

Viola, Lynne, *Peasant Rebels Under Stalin: Collectivisation and the Culture of Peasant Resistance* (New York and Oxford: Oxford University Press, 1996)

Voloshinov, Valentin N., 'Discourse in Life and Discourse in Poetry: Questions of Sociological Poetics', in Ann Shukman (ed.), *Bakhtin School Papers*, Russian poetics in translation, vol. 10 (Oxford: RPT Publications, 1983), pp. 5–30

Voloshinov, V. N., *Marxism and the Philosophy of Language*, trans. Ladislav Matejka and I. R. Titunik (Cambridge, Mass. And London: Harvard University Press, 1973)

White, Hayden, 'The Value of Narrativity in the Representation of Reality', *Critical Inquiry*, 1980–81, 5–27

White, Stephen (ed.), *New Directions in Soviet History* (Cambridge: Cambridge University Press, 1992)

Williamson, Judith, *Decoding Advertisements: Ideology and Meaning in Advertising* (London: Marion Boyars, 1978)

Zamiatin, Evgenii, *My: Roman, povesti, raskazi, p'esy, stat'i i vospominaniia*, ed. E. B. Skorospelova, (Kishinev: Literatura artistike, 1989)

Zhdanov, Andrei, 'Rech' sekretaria TsK VKP (b) A. A. Zhdanova', in *Pervyi vsesoiuznyi s"ezd sovetskikh pisatelei 1934: stenograficheskii otchet* (Moscow: Sovetskii pisatel', 1990), pp. 2–5

Zipes, Jack, *Breaking the Magic Spell: Radical Theories of Folk and Fairy Tales* (London: Heinemann, 1979)

Zipes, Jack, *Happily Ever After: Fairy Tales, Children, and the Culture Industry* (London: Routledge, 1997)

Zizek, Slavoj, *The Sublime Object of Ideology* (London and New York: Verso, 1989)

Zizek, Slavoj (ed.), *Everything You Always Wanted to Know About Lacan (But Were Afraid to Ask Hitchcock)* (London and New York: Verso, 1992)

Zizek, Slavoj, 'When the Party Commits Suicide', *New Left Review* 238 (November/December, 1999),

Index

Note: page numbers given in **bold** refer to illustrations; 'n' after a page reference indicates a note number on that page.